SCOTLAND

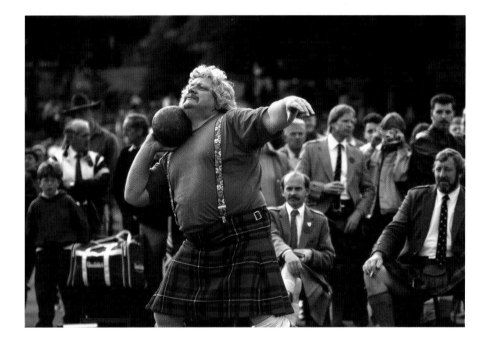

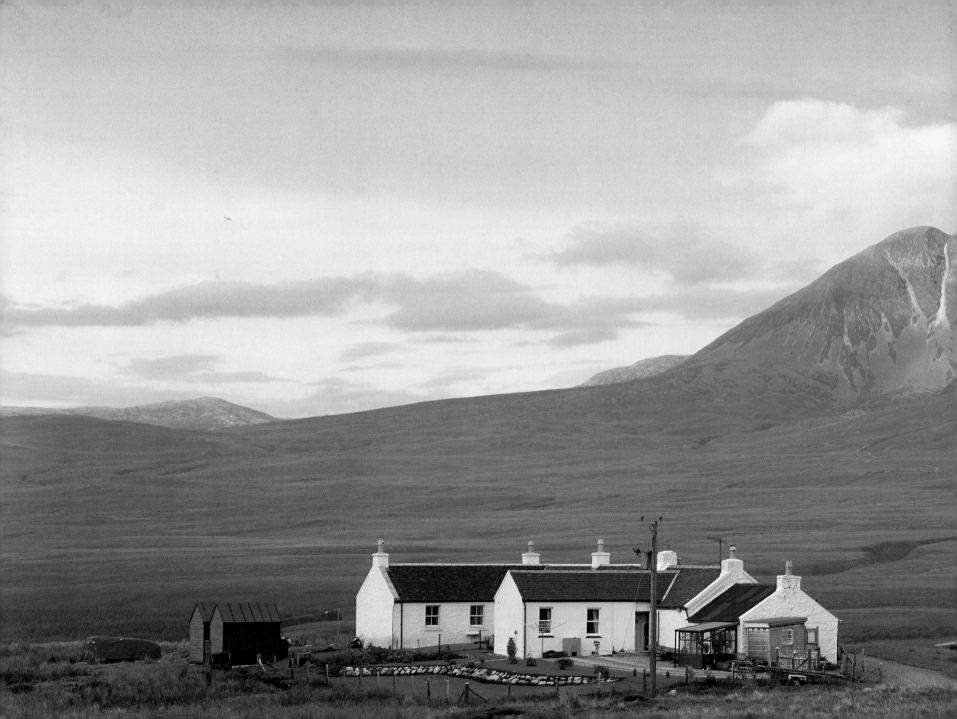

SCOTLAND

DAVID LYONS

CHARTWELL
BOOKS, INC.

CHARTWELL BOOKS, INC.
A Division of
BOOK SALES, INC.
114 Northfield Avenue
Edison, New Jersey 08837

ISBN-13: 978-0-7858-2303-2
ISBN-10: 0-7858-2303-4

© 2004 Compendium Publishing,
43 Frith Street, London, Soho, W1V
4SA, United Kingdom

Printed and bound in China

Design: Tony Stocks and
Danny Gillespie

Text and captions by Sandra Forty

PAGE ONE: The annual Highland Games at the Braemar Gathering is held every September in the Princess Royal Park. Many of the events, such as putting the shot, require great feats of strength.

PAGE TWO/THREE: The Paps of Jura as seen from the north coast of Islay. These three mountains dominate the southern part of the island as well as the western coast of Kintyre. The Paps are *Beinn Shiantaidh* (Holy Mountain), *Beinn an Oir* (Mountain of Gold), and *Beinn a'Chaolais* (Mountain of the Sound). In the same group but not considered to be a Pap is *Corra Bheinn* (Steep Mountain).

BELOW: North Uist, Western Isles. Built to hug the land and withstand the elements this croft at Malacleit looks remote but secure.

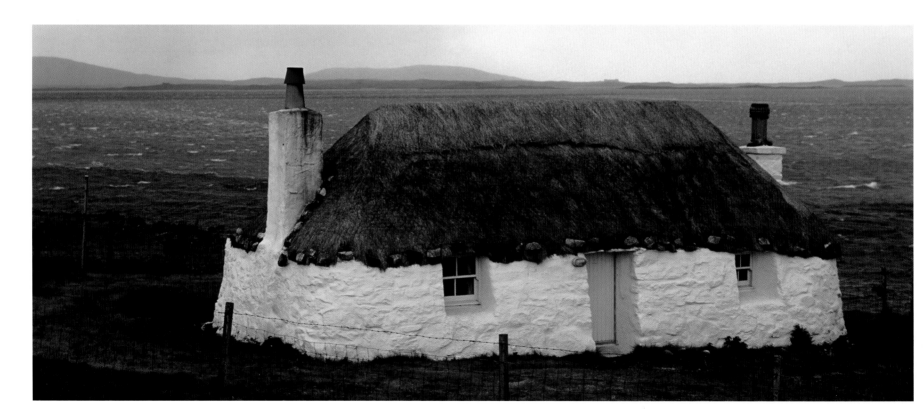

Contents

Introduction

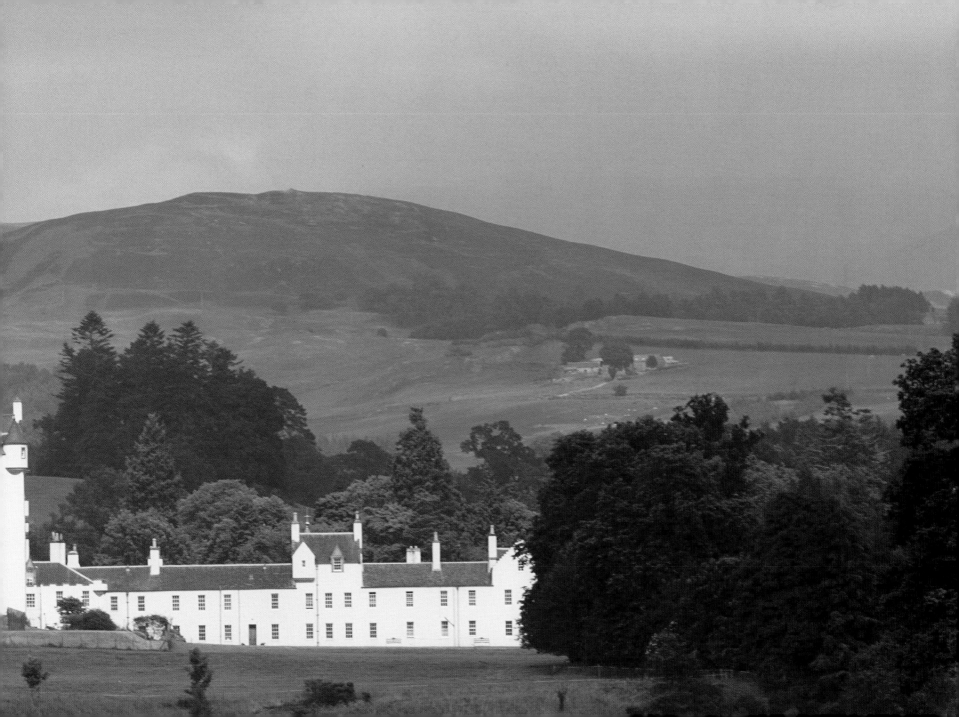

The history of Scotland is intricately linked with its geography—the mountains act as barricades against invaders as well as guardians of the Highlands. But the high mountains make living off the land a lifestyle that only the toughest people can survive. Furthermore, Scotland is fringed with hundreds of islands, many of them inhabited, and many of them remote. In winter many islanders and high-lying settlements are completely cut off from the rest of the world—unsurprisingly this makes the people toughly independent and unbiddable, so it is no surprise that many famous explorers, adventurers, soldiers, and inventors are Scottish.

Recorded Scottish history with all its drama and pagentry is only one part of the story, as even a glance through these pages will show that Scotland also has an extensive and important legacy of prehistoric settlements. Across the entire country, Highlands and islands included, our distant ancestors left mysterious and often massive remains. Stone circles, dolmens, standing stones, brochs, and early settlements show that prehistoric Scotland had thriving and vibrant societies often living on the edges of lochs or by trhe sea or high up on hillsides in what we now consider to be inhospitable places; however, climate changes and livelihoods were different then. Much of their lives can only be guessed at—archaeologists can infer a lot from prehistoric remains, but most of the day-to-day detail is lost in the mists of time. To visit such prehistoric sites and gaze at the stones is the best way to absorb some of our ancient ancestors' aura.

THE FIRST PEOPLE

The earliest evidence of people in Scotland is from the remains of campsites dating from about 6000 BC. These point to itinerant communities of fishermen and hunters from the earliest mesolithic period. The next group were neolithic peoples (c.4000–2500 BC) who, in the main, left burial and ritual sites, particularly in the Orkneys. The next peoples were the Beaker folk, named after their pottery, although they were also responsible for many of the stone circles and standing stones. Bronze age people (c.2500–700 BC) were the first metal workers and so have left more evidence of their existence through metal artefacts and pottery from c.700 BC. They were followed by Iron Age Picts who lived north of the Firth of Forth, with Celts to the south.

PREVIOUS PAGE: Blair Castle on Tayside is the seat of the Duke of Atholl. The oldest part of the building is Comyn's Tower which dates from c.1269. At the end of the eighteenth century the building was completely renovated to become a Georgian-style mansion; then, during Victoria's reign, it was "medievalized" with additional towers, turrets, and crow-stepped gables.

RIGHT: Map of Scotland today.

FAR RIGHT: Prehistoric standing stone at Ballochroy on the Kintyre peninsula—Argyll with the Paps of Jura in the distance. This is the third and largest of an alignment of ancient standing stones running northeast, southwest. This shows the setting sun at the winter solstice leading some to speculate that this was a prehistoric observatory that could determine the exact day of the solstice.

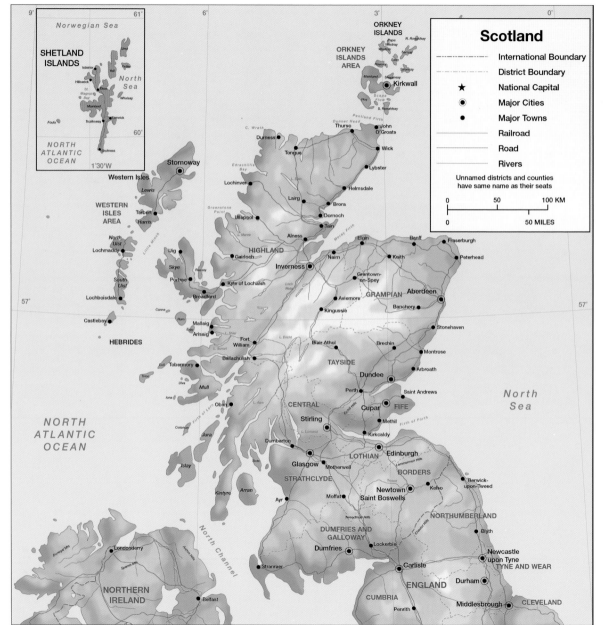

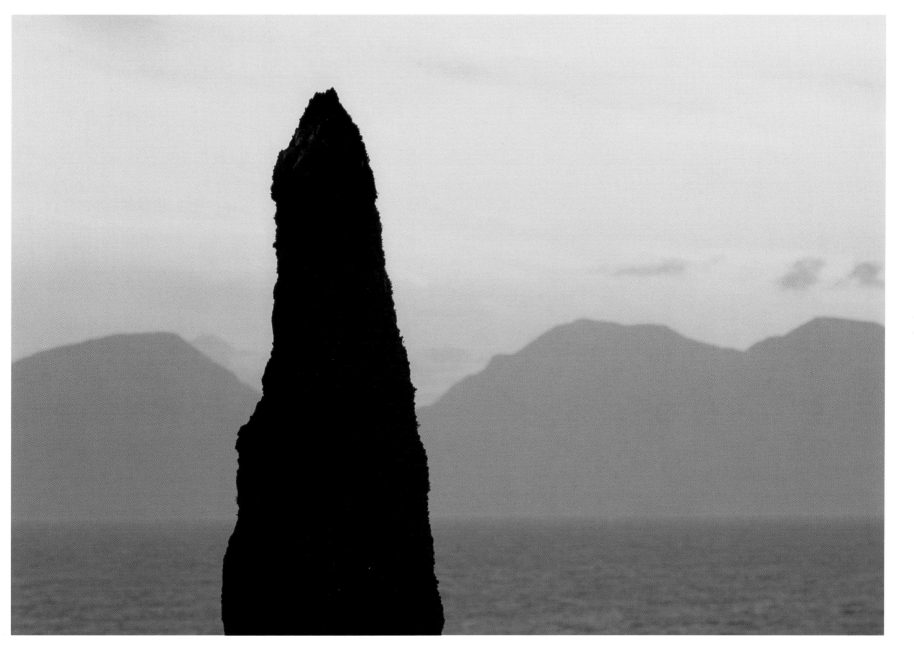

The first written record directly about Scotland is from the Roman historian Tacitus in 1 AD, who called the inhabitants "Picts" and remarked that they were "fierce enemies."

THE ROMAN CONQUEST

The Romans conquered much of Britain by 80 AD but they only got a toehold on southern Scotland. They marched as far as Perthshire but could not subjugate the aggressive and independent peoples they found there. An interesting historical rumor is that the son of a Roman general stationed at the village of Fortingall was one Pontius Pilate, who later found fame and notoriety in the Holy Land. Thanks to the Romans the northern part of Scotland was named "Caledonia," and for the first time common interest encouraged traditionally warring clans to start to unite against their enemy. The Romans were forced to build walls to keep them out: first, and best known, is Hadrian's Wall completed in 123 AD; the later Antonine Wall was historically less long-lived. The Romans abandoned Scotland at the end of the second century as they withdrew into southern England and then out of Britain altogether.

Without the Romans the way was open for various warlords and rulers who each tried to establish control (with varying degrees of success) over their particular area of Scotland. By 843 AD the king of Dalriada had gathered under his control all the lands north of the Forth river and called his domain "Scotia."

The Vikings started serious raiding in the tenth and eleventh centuries and proved a serious hazard to people living on ssea lochs, coasts, or navigable rivers throughout Scotland and the islands.

CHRISTIANITY COMES TO SCOTLAND

It was the Romans that first brought Christianity to Scotland—but when they left, the folk reverted to paganism. The first recorded evidence of Christianity in Scotland appears in Galloway in the late fourth or early fifth century. The mission of Saint Columba from Ireland (563 AD) reintroduced the faith. Slowly Christianity spread across Scotland incorporating many of the local beliefs and traditions into the Christian calendar until the old Celtic religions were completely subsumed by the new. Churches and religious foundations appeared in greater numbers and were strengthened by the arrival of feudalism in the twelfth century. Power over the land was divided between the wealth of the church and the strength of the mighty clans.

THE OLD ENEMY—THE WARS BETWEEN ENGLAND AND SCOTLAND

Through the long early years and throughout the Middle Ages the English and Scots fought long and bitter battles invading each other's countries for ultimate control, with the advantage swinging back and forth. The dread "Hammer of the Scots"—Edward I—was, in particular, instrumental in imposing English control and Scottish King John de Baliol, acknowledged Edward as his overlord. Rebellion was swiftly fomented: first by "Braveheart"

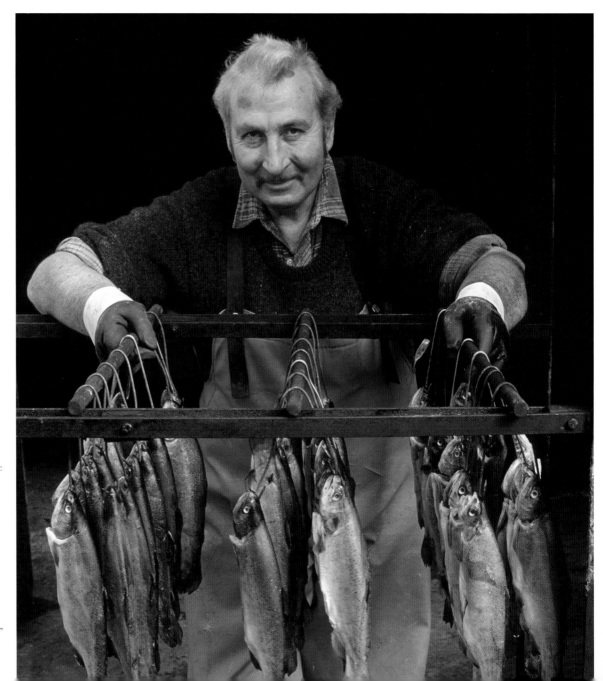

William Wallace, who defeated the English at Stirling. Edward I returned in forces and first defeated Wallace at Falkirk and then had him hanged, drawn, and quartered in 1305. After Wallace's horrible end it took one of Scotland's great heroes to win back Scotland's freedom. Robert Bruce was crowned King of Scotland in 1306; Edward died in 1307 and was succeeded by his weaker son, Edward II. Bruce allied with France—the start of a long friendship—and in 1314 defeated the English at the famous victory of Bannockburn. He had driven the English out of Scotland from everywhere except Stirling.

UNION WITH ENGLAND

The Stewart line came to the Scottish throne in 1371. Eventually, in 1502, the Stuart (same line different spelling) James IV of Scotland married Margaret Tudor, the daughter of King Henry VII of England and the two kings signed a treaty of perpetual peace—a great achievement given the centuries of hostilities between the two countries. In 1542, James V of Scotland's only legitimate heir, Mary, Queen of Scots, was crowned queen at one week old. She would lead a short but exciting life full of intrigue and scandal. It would be, however, her insistence on returning Scotland to Catholicism that led to her forced abdication in favor of her son James VI. Mary fled to England where she was eventually executed at Fotheringay Castle in 1587.

Wild she may have been, but it was because of Mary that the crowns of England and Scotland were united in March 1603 when her son James VI of Scotland also became James I of England as the only legitimate heir to the English crown on the death of the childless Queen Elizabeth I.

Despite political unity conflict was never far away. The English Civil War swept Oliver Cromwell to power and his iron grasp over Britain. When Cromwell had King Charles I executed, the Scots declared Charles's son King which provoked Cromwell to send his brutal armies into Scotland to reunite the two lands. However, on Cromwell's death, an English king was restored to the monarchy and the Scots felt betrayed by their loss of independence and agitated for a return of a Jacobite king. The Jacobite Rebellion in 1715 declared James Edward Stuart king, but the Scottish clans would not unite to support him and they were ultimately doomed to fail. The most charismatic rebel was Bonnie Prince Charlie who led 3,000 Highlanders to Edinburgh to reinstate his father as king of Scotland. But many Scots supported the Hanoverian claim to the thrones of England and Scotland. The rebellion ended in bloodshed on Culloden Moor in 1746 when the Highlanders were slaughtered by the disciplined and better equipped government troops.

PROSPERITY AND PEACE

Scottish attempts to establish an independent crown were effectively over and slowly the two old enemies established a working peace. With the arrival of the Industrial Revolution in the early nineteenth century the Scots were at the forefront of technology and innovation, particularly in the fields of engineering and industry. The latter brought prosperity to much of Scotland and, as the British Empire grew in wealth, so did Scotland. Throughout the twentieth century and especially through two world wars, Scots and English fought side by side, still competitive but properly comrades. In 1996 the independent Scottish Parliament was established and Scots are once again able to promulgate much of their own legislation.

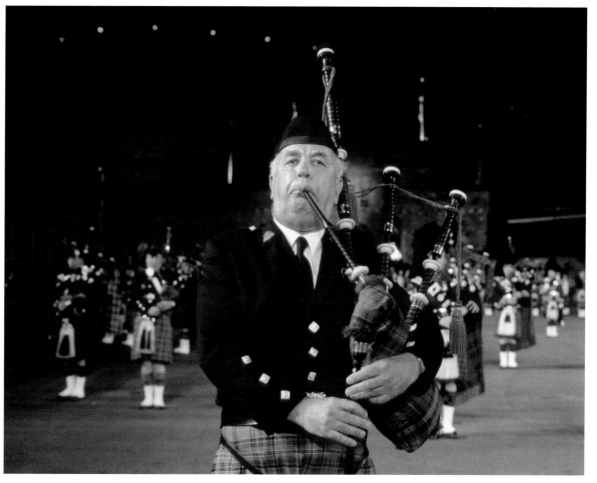

LEFT: Fish strung up ready for smoking at Taynuilt, Strathclyde. Nearby Loch Etive is famed for its beauty and fishing.

RIGHT: The Great Highland Bagpipe is a sheepskin air bag into which are bound five pipes: a bass drone, two tenor drones, the mouthpiece and the chanter on which the tune is played. The chanter is a nine-holed pipe—one for the players's thumb and eight for his fingers. Some form of pipes are used in France, Greece, India, Ireland, Italy, Persia, Russia, and Spain, but in Scotland they have become part of the country's culture. Each British Army Highland regiment has its own pipers and pipebands.

Borders, Dumfries, and Galloway

The Border country has a turbulent and colorful history. Over the centuries the border between England and Scotland has fluctuated many times with people on both sides of the boundary guarding their homes and livelihoods with particular vigor. The countryside is has everything—magnificent border castles, wild mountains, and heather-clad moors, plus over 200 miles of dramatic coastline. Above all this is Robert Burns country; Scotland's national poet lived and loved around the Borders and Dumfries (where he lived from 1791 until his death in 1796), leaving plenty of evidence of his turbulent life. Another famous son of the area is John Paul Jones, the father of the American Navy, who came from the village of Kirkbean in Kirkcudbrightshire.

In the fifteenth and sixteenth centuries the border lands were terrorized by the Border Reivers. To keep out these cattle-rustling, murdering gangs of thugs, people on both sides of the border built fortified tower houses and town fortifications as well as castles for their protection. In such lawless times life could be short and violent. The legacies of such times provide the countryside with a rich array of interesting buildings and artifacts all of them crammed with history and the romance of the past.

Life is very different nowadays: thankfully peaceful and safe. The largest town in the region is Dumfries which is also the administrative, commercial and shopping center for the entire area

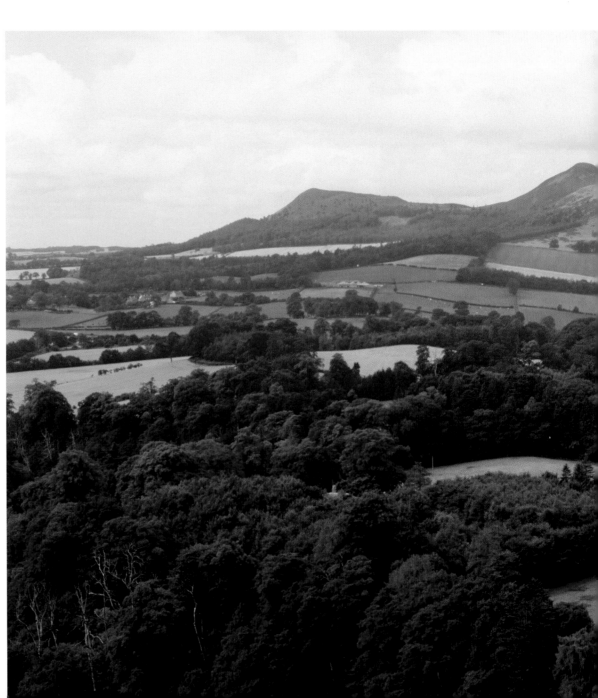

LEFT: "Scot's View" over the Eildon Hills and the River Tweed in the Borders. In the centre is the Eildon Hill North hill fort.

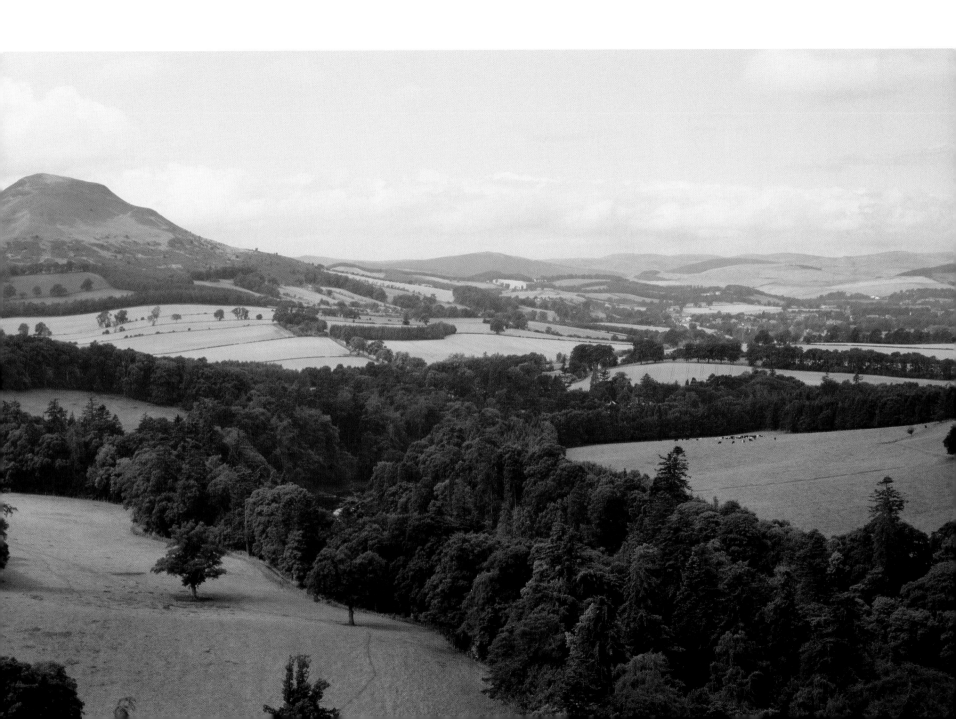

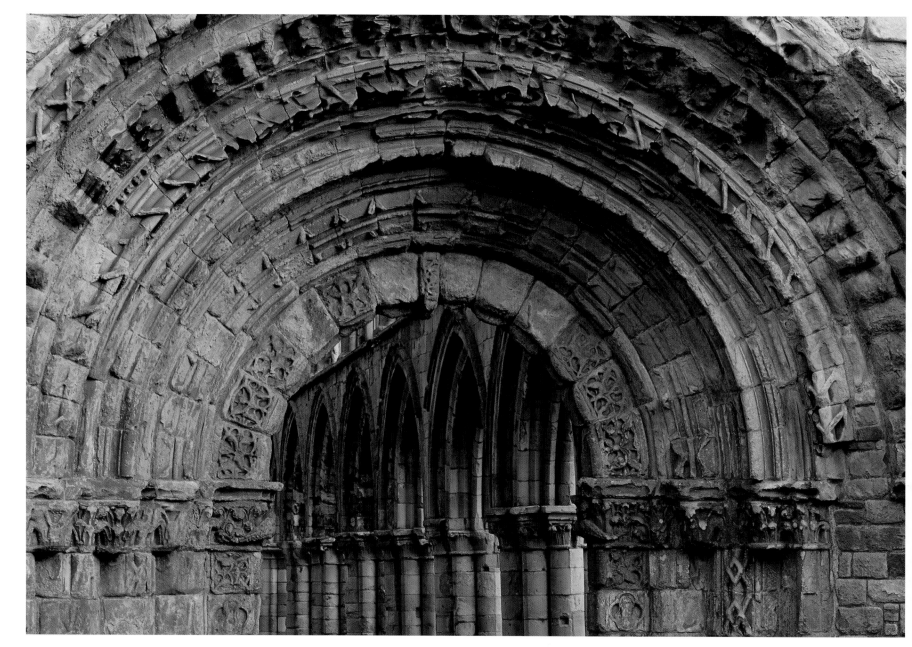

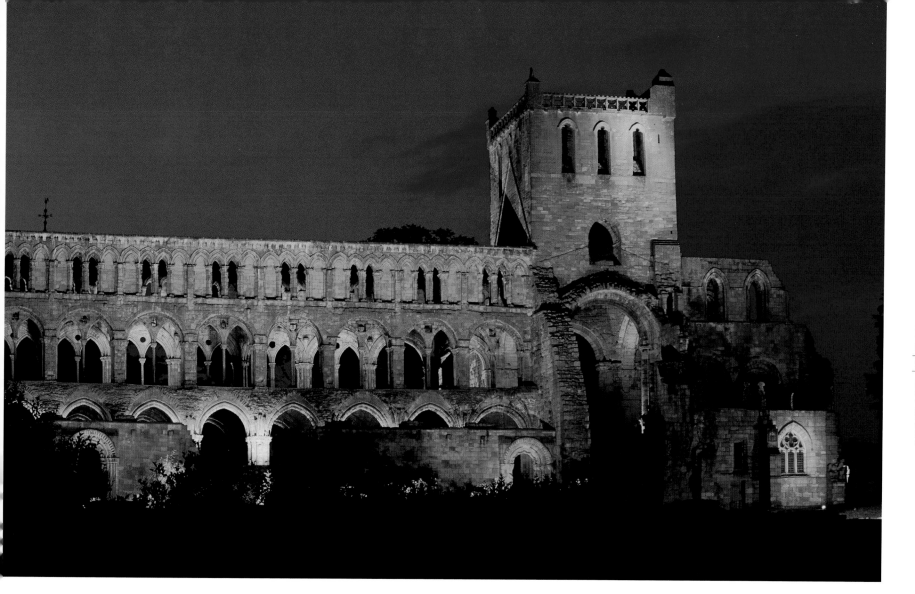

LEFT: The west door and nave arches of Jedburgh Abbey. The Augustinian Abbey was founded by David I in 1138 for the members of the order from St Quentin's Priory at Beauvais, France. Despite mistreatment from waves of English invaders the mostly Romanesque and early Gothic abbey remains remarkably intact.

ABOVE: Evidence such as Celtic ornamented stonework has been found to show that a church was built in Jedburgh as early as the ninth century. Jedburgh Abbey was subsequently built on the site of the earlier church.

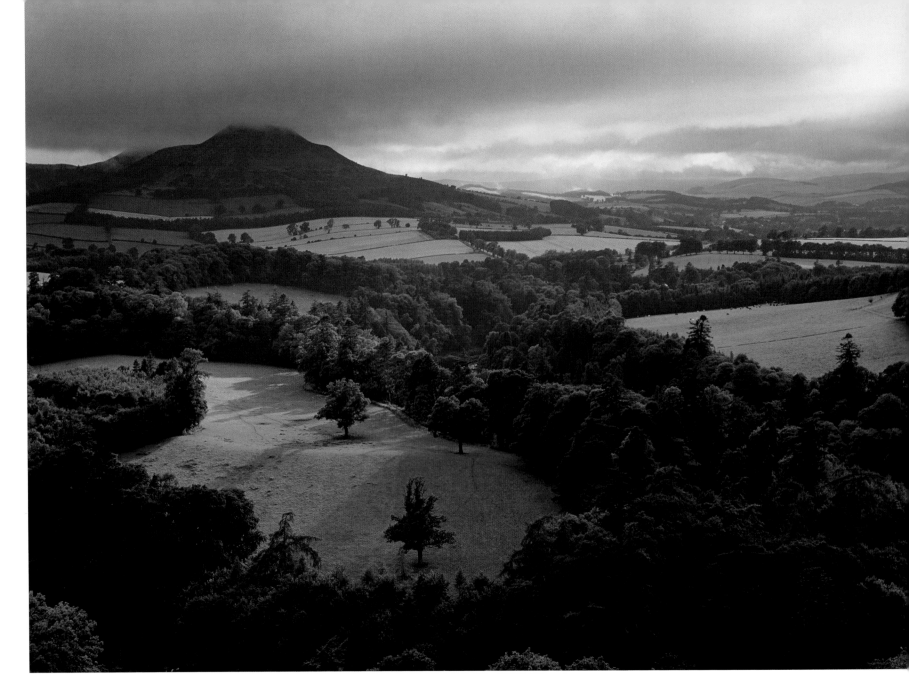

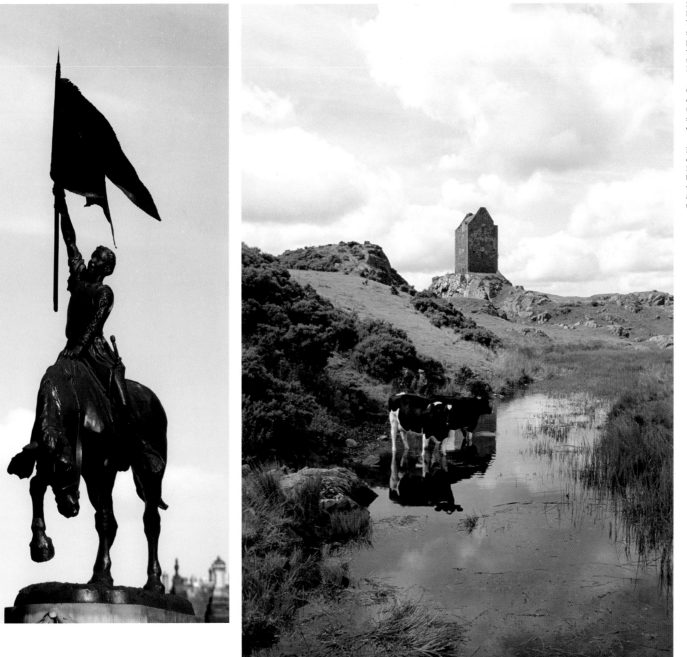

LEFT: The location known as "Scott's View" looks out over the Eildon Hills and the River Tweed. Sir Walter Scott is reported to have said, "I can stand on the Eildon Hills and point out 43 places famous in war and verse." Legend says that the three peaks of the Eildon Hills were split by the wizard Michael Scott.

CENTRE: Following their victory at the Battle of Flodden Field in 1513, the English set fire to Selkirk. This statue was erected in 1913 showing the sole Selkirk survivor with a captured English standard.

FAR LEFT: Smailholm Tower is a sixteenth century fortified tower house built by a Border farmer as a defense against local brigands. On three sides it stands on a rock while the fourth is protected by a ditch; it is almost 60ft high with 10ft thick walls. The tower was restored in the 1980s.

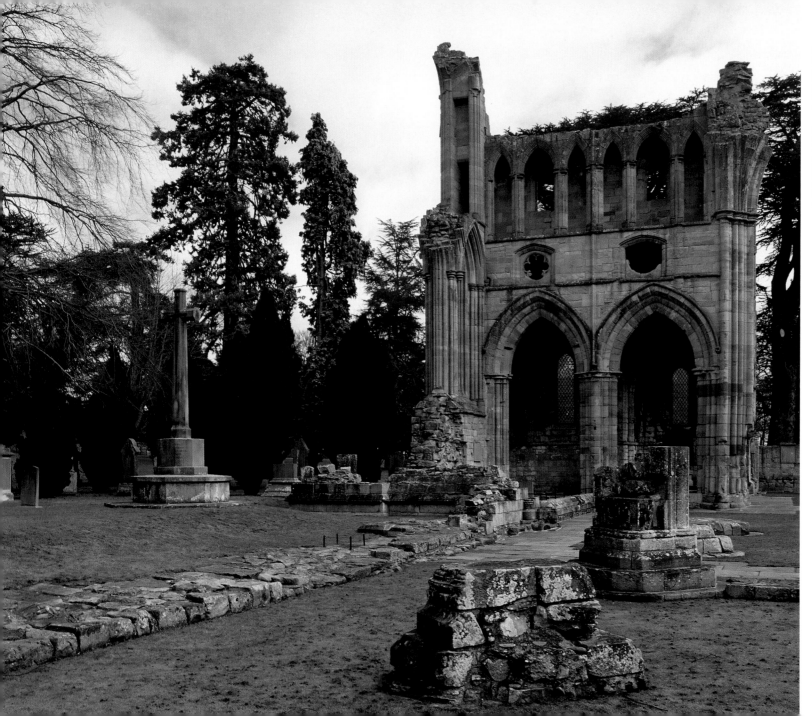

LEFT: The ruins of Dryburgh Abbey sits in a horseshoe bend of the River Tweed. It was founded in 1152 for the monks of Alnwick, Northumberland. Thanks to its proximity to the England-Scotland border it was destroyed by English troops in 1322, 1344, and 1385.

RIGHT: The original church at what is now Coldingham Priory was founded by Edgar, King of the Scots in 1098. In the early twelfth century it gained in importance when it became a Benedictine priory for monks from Durham. It has been variously damaged by the English—King John in 1216, soldiers in 1544, and then Cromwell in the seventeenth century.

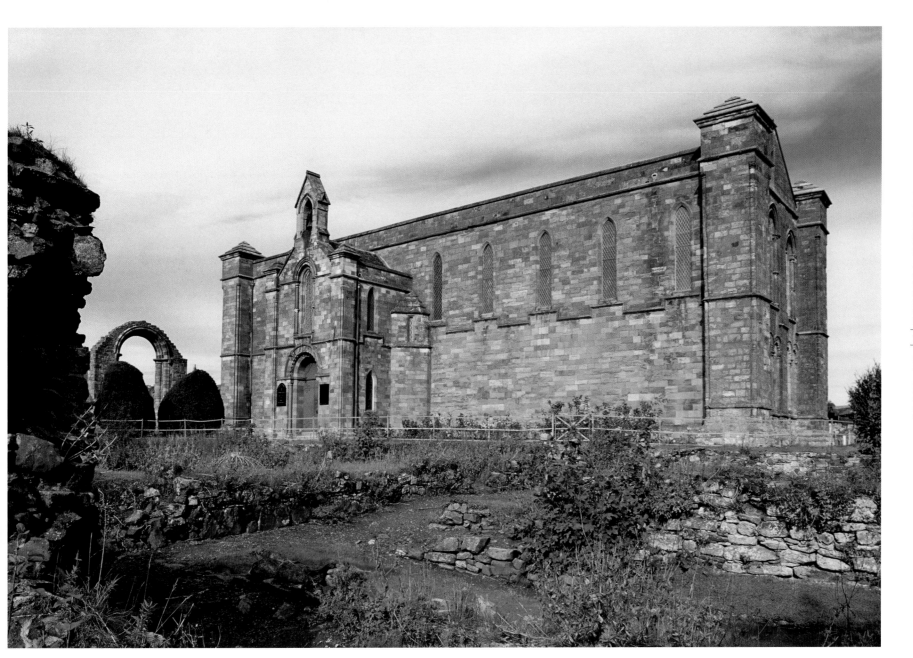

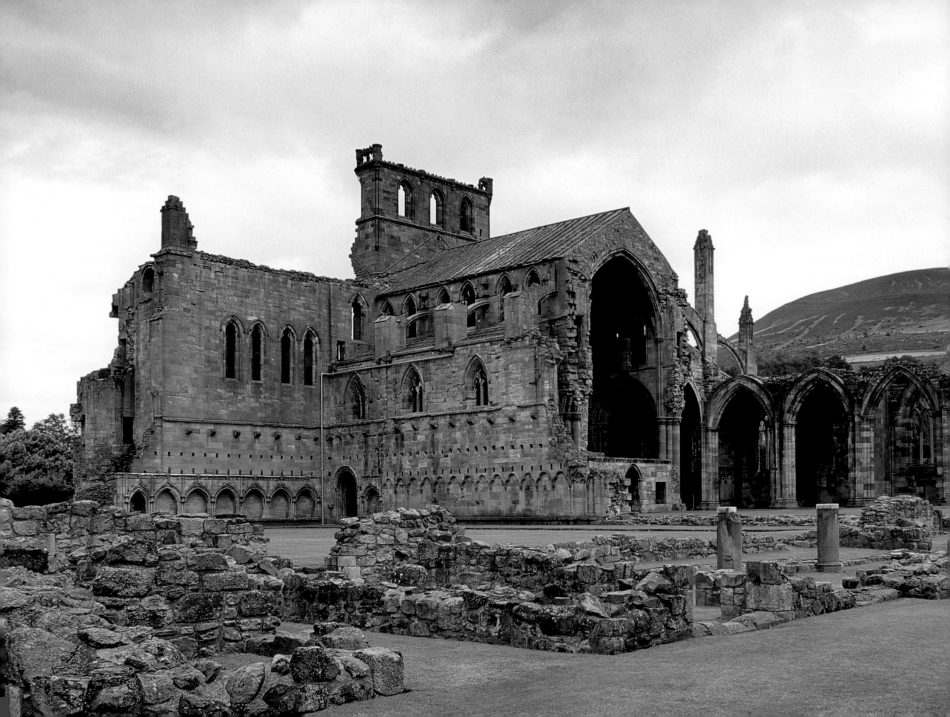

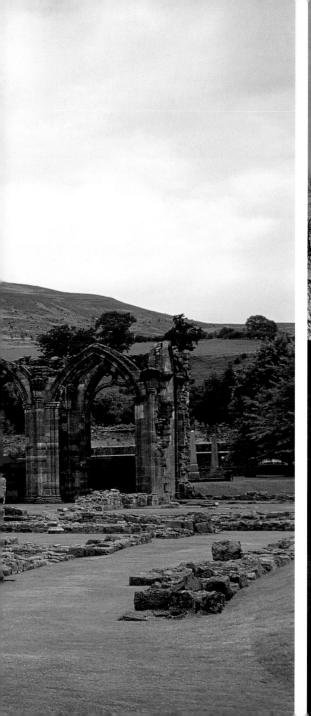

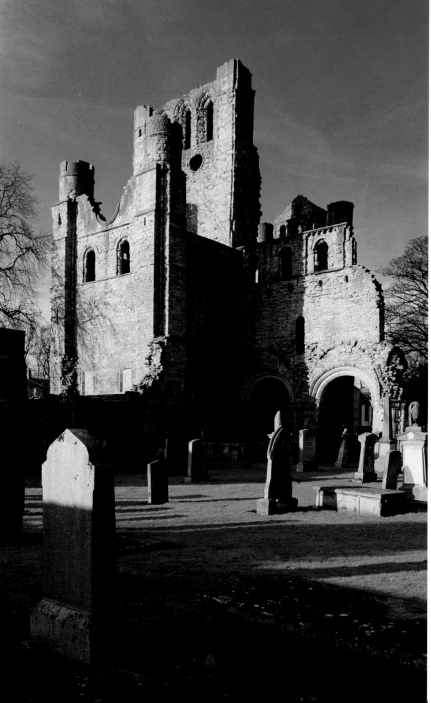

LEFT: Kelso Abbey was founded by David I and built in transitional Romanesque style in 1128. The remains are now believed to be just the western end remnants of a much bigger institution. The abbey was destroyed in 1545.

FAR LEFT: The impressive ruins of Melrose Abbey stand over the remains of a seventh century monastery inhabited by monks originally from the religious communities of Iona and Lindisfarne. The later abbey was founded by David I in 1136 for the Cistercian order.

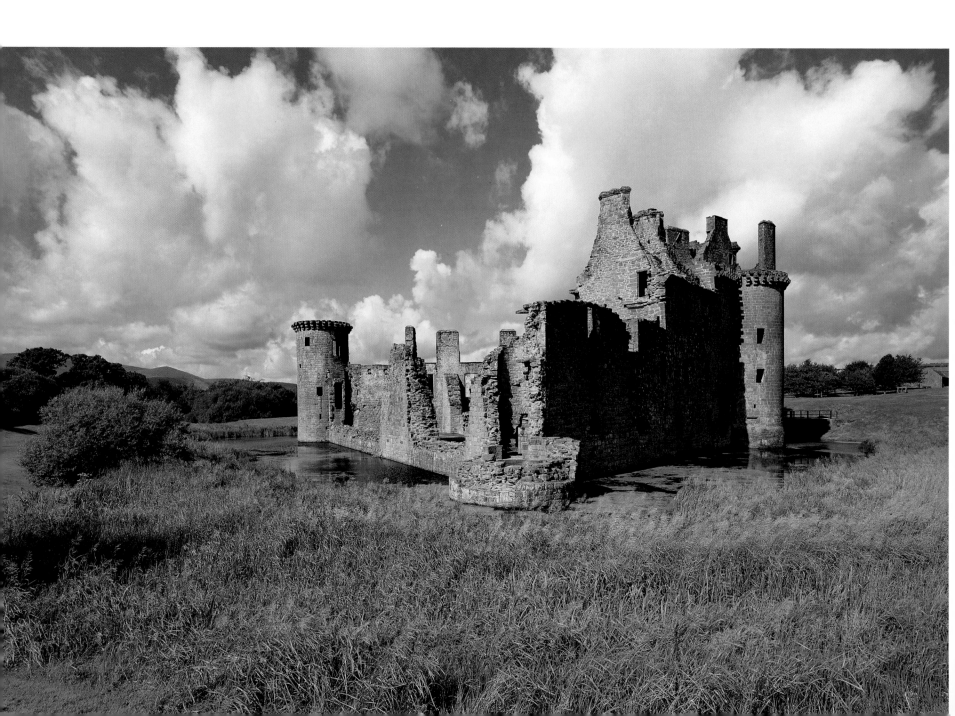

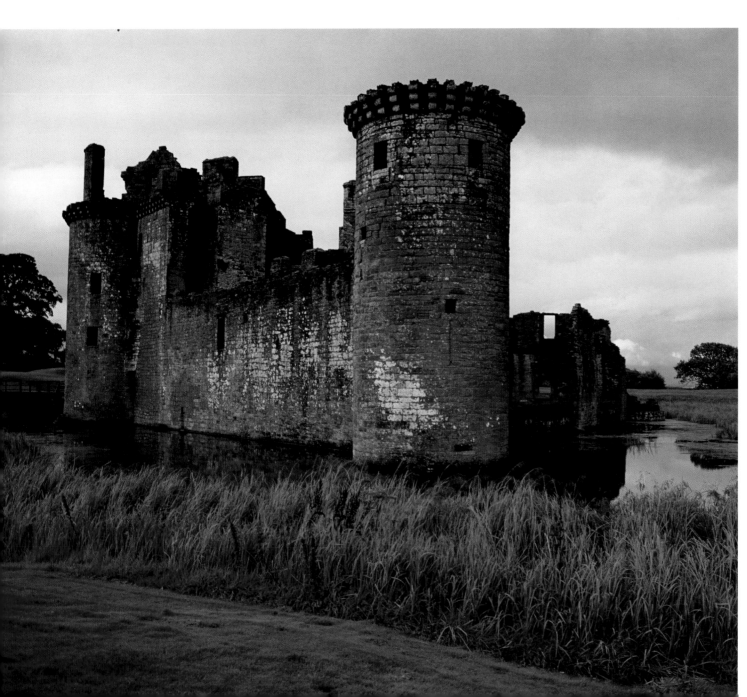

LEFT: Caerlaverlock is the only castle in Britain to be built on a triangular pattern. Each corner has a tower with the massive main gatehouse tower double in height. Its formidable fortifications include what is now a picturesque moat.

FAR LEFT: The romantic ruins of Caerlaverlock castle. Built between 1290 and 1300, Caerlaverlock was beseiged and taken by the English King Edward I in 1300. When the constable he placed in charge changed sides 12 years later, it became Scottish again but the castle was dismantled on the orders of Robert Bruce to prevent the English retaking possession. It was rebuilt to the original design in the fifteenth century.

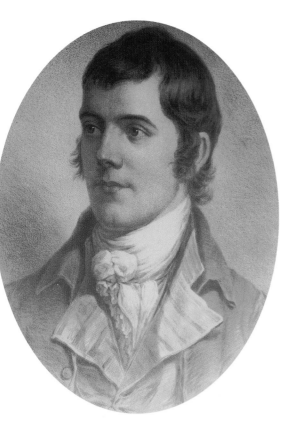

ABOVE: The poetry of Robert Burns (1759–1796), Scotland's national bard, is recited and enjoyed around the world, most notably at New Year when *Auld Lang Syne* is sung as the clock strikes twelve. This portrait by Archibald Skirving shows Burns as a young man.

RIGHT: The interior of Robert Burns's humble cottage in Dumfries. He moved here in 1791 and took a job with the Excise, but his excessive drinking and generally debauched behavior led him to an early death. He died from rheumatic fever at the age of 38 on July 21, 1796, just as his wife Jean was giving birth to their ninth child.

FAR RIGHT: The landscape at Carsphairn in Kirkcudbrightshire is typical of the Scottish lowlands and is fertile farming country.

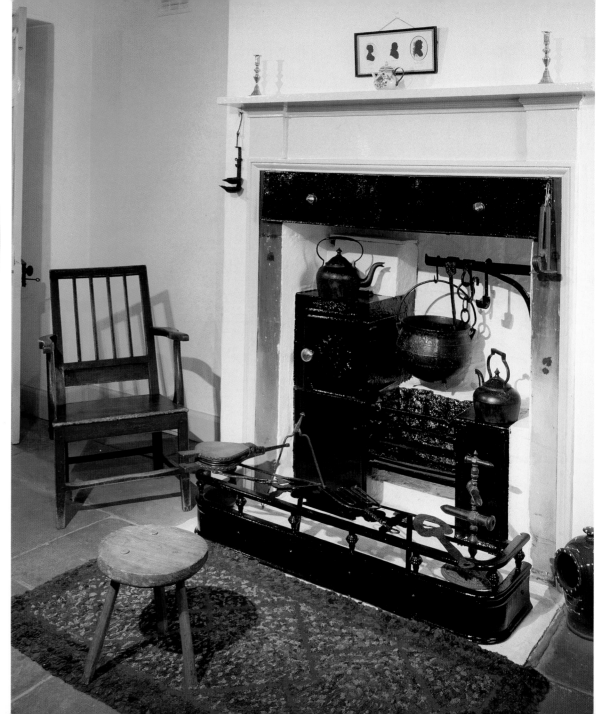

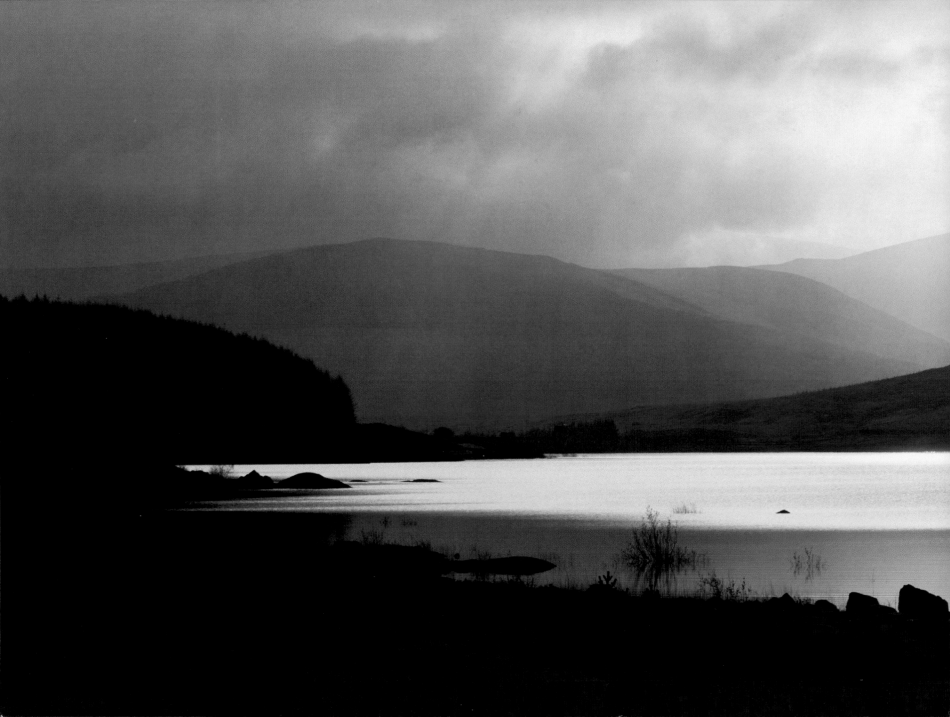

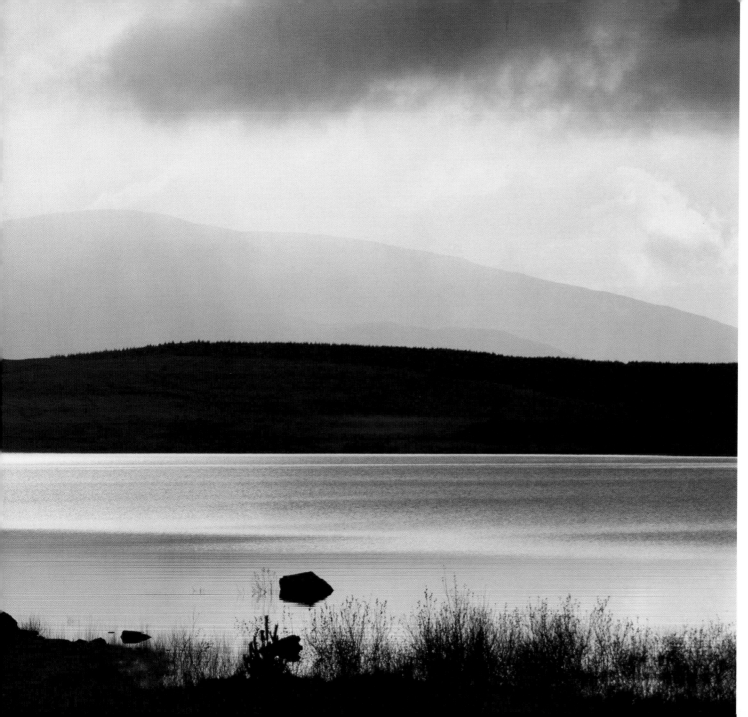

LEFT: Clatteringshaws Loch was formed by damming the Black Water of Dee so as to feed the Galloway Hydro-Electric Power Scheme. The loch is in the Galloway Forest Park. Nearby stands Bruce's Stone, where Robert Bruce is supposed to have rested in 1307 after fighting the English.

RIGHT: The border town of Dumfries lies on the River Nith and is known as the "Queen of the South." Dumfries was created as a royal burgh by William the Lion in 1186; its traditional industries knitwear and hosiery founded the town's prosperity.

FAR RIGHT: The picturesque Deeside town of Kirkcudbright has become something of an artists' colony. Throughout the later Middle Ages it was an important port and then again in the seventeenth and eighteenth centuries.

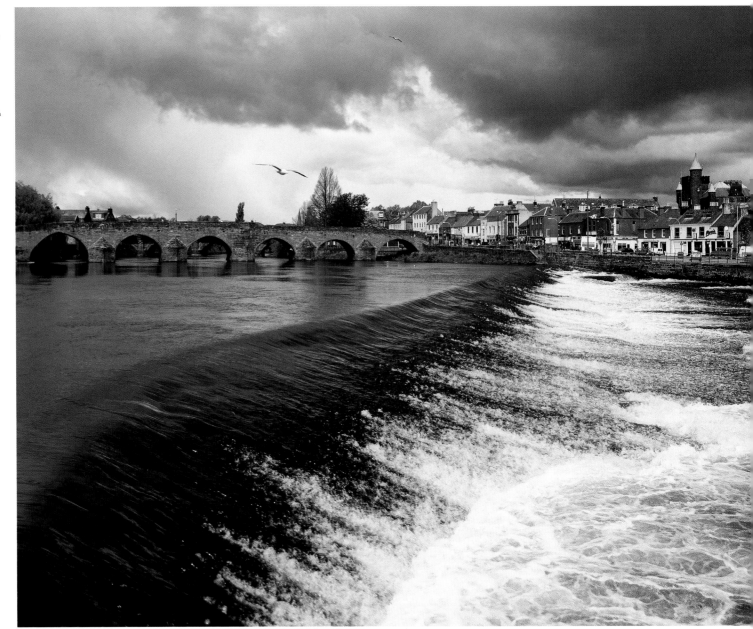

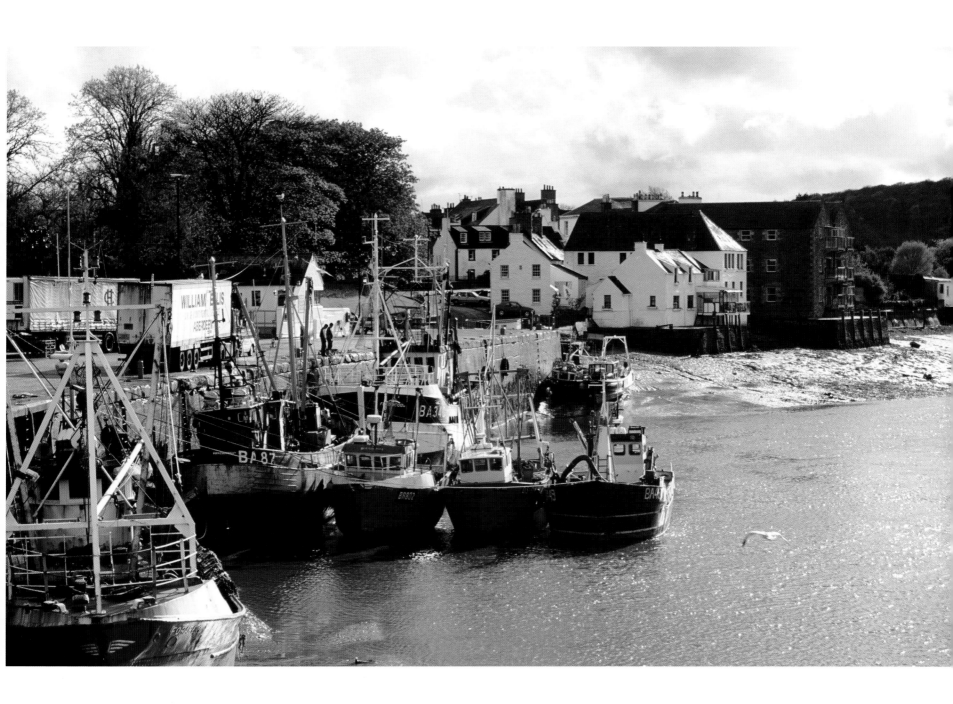

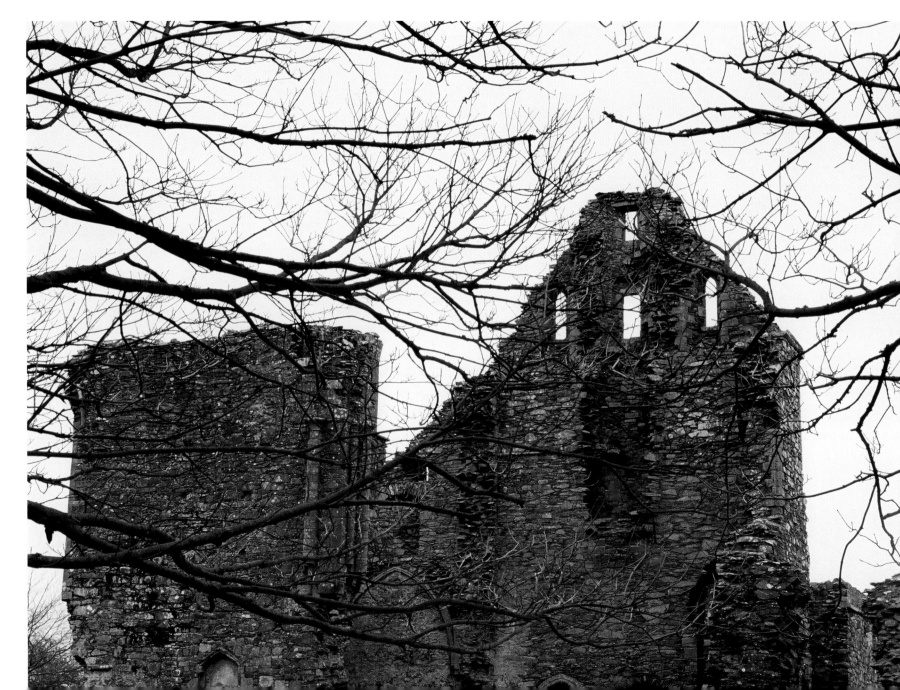

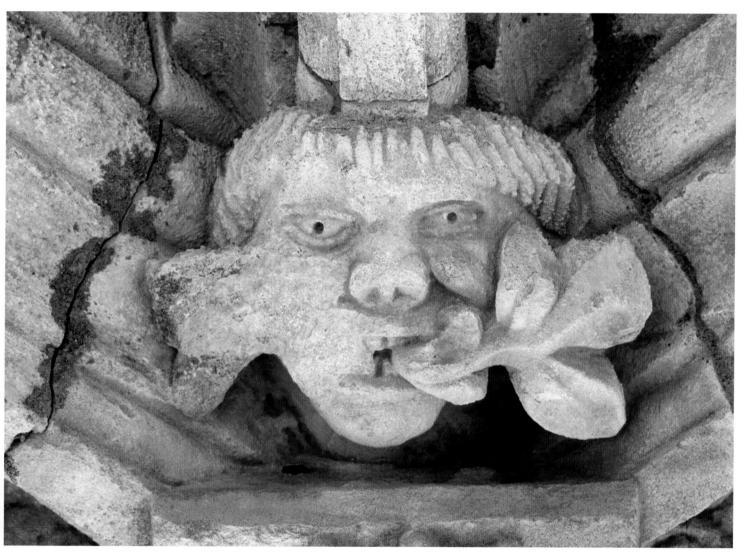

LEFT: A ceiling detail from inside the fifteenth century Chapter House at Glenluce. The adjoining Glenluce Abbey was founded in 1190 by Roland, Lord of Galloway as a daughter house of the great Cistercian abbey at Dundrennan.

LEFT: Glenluce Abbey founded in 1190 by Roland, Lord of Galloway, as a daughter house of the Cistercian Abbey at Dundrennan. When plague was ravaging the land, the thirteenth-century wizard Michael Scott is believed to have lured the dreadful lurgey into the abbey where he tricked it into a vault and locked it away.

RIGHT: In the center of Dumfries and Galloway is the small town of Castle Douglas. Here it is seen across nearby Carlingwark Loch.

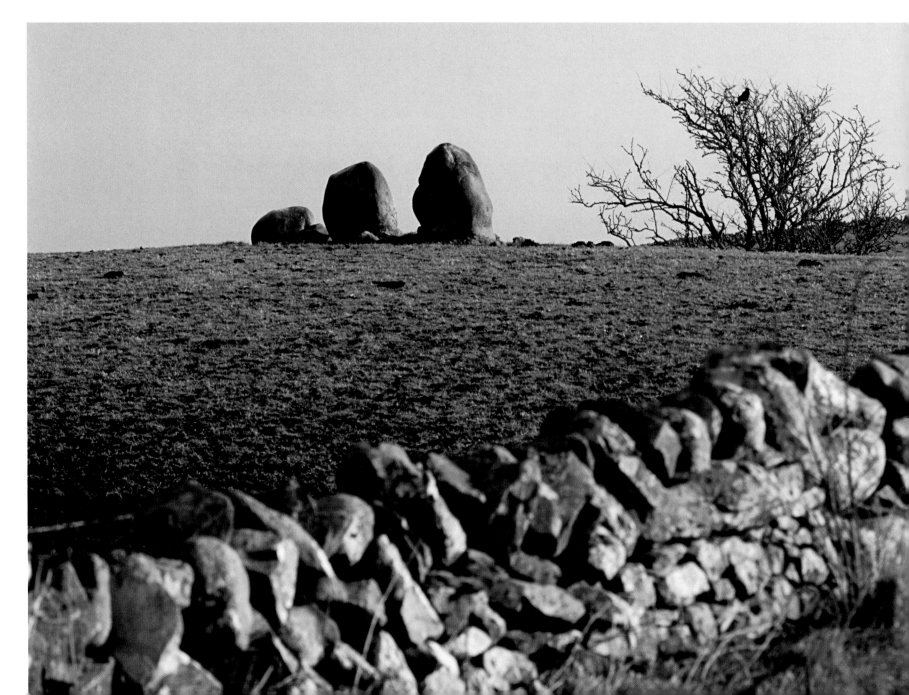

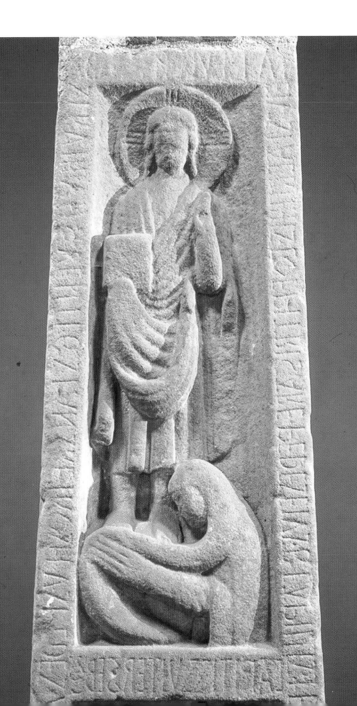

LEFT: Detail of the Ruthwell Cross, an early c. seventh century Christian relic showing Mary Magdelene washing Christ's feet. The cross stands 18ft high and is richly carved with figures, animals, birds and vines as well as the longest runic inscription in Britain.

FAR LEFT: Silhouetted against the skyline are the three large outliers of the Bronze Age stone circle at Torhousekie. The circle itself consists of 19 stones standing on a man-made earth platform making a circle of a little over 60ft in diameter.

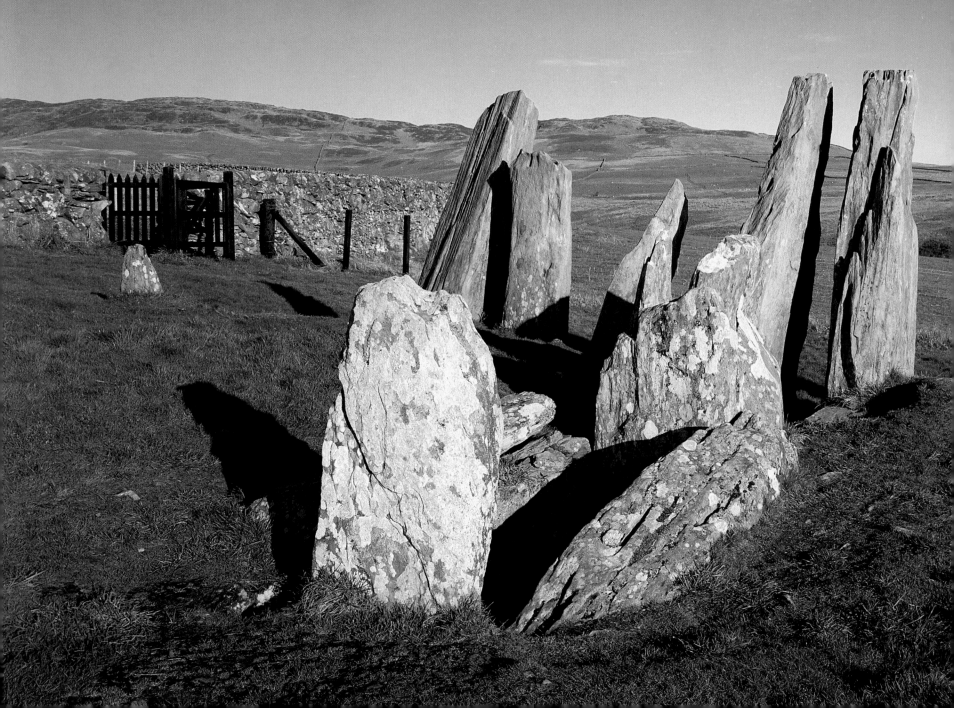

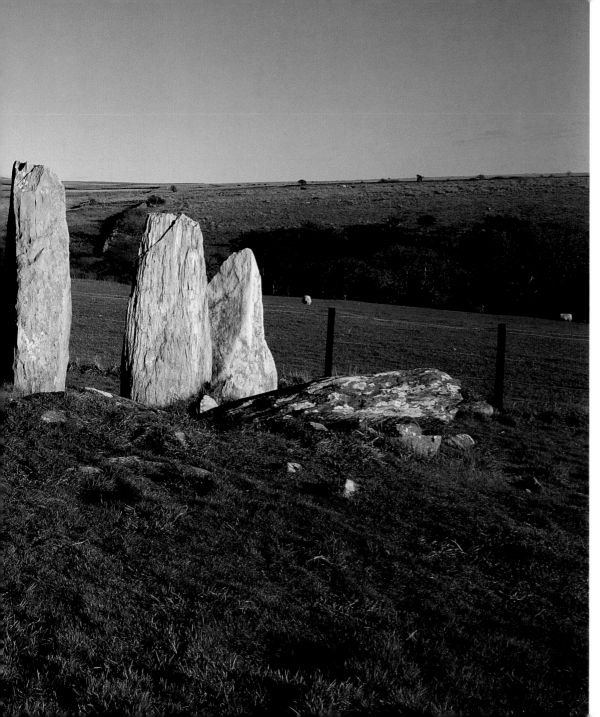

Left: Overlooking Wigtown Bay lies Cairnholy I neolithic chambered long cairn. The principal remains are eight huge upright stones, the original entrance to the burial chamber. Excavations in 1949 found evidence of numerous cremations and various grave goods—the most important of which was a jadeite axe. The cairn itself was originally 130ft long by 35ft wide.

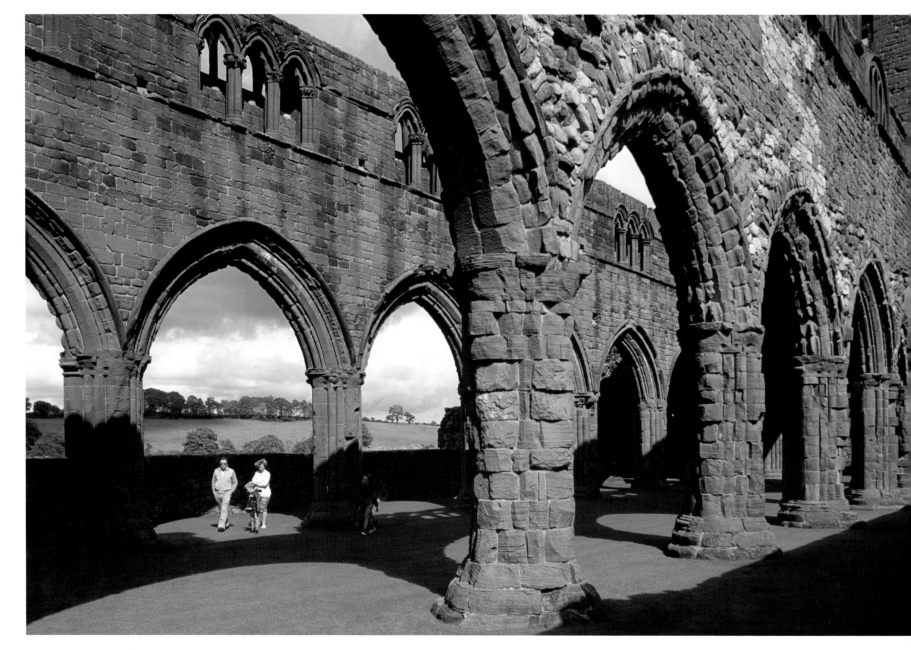

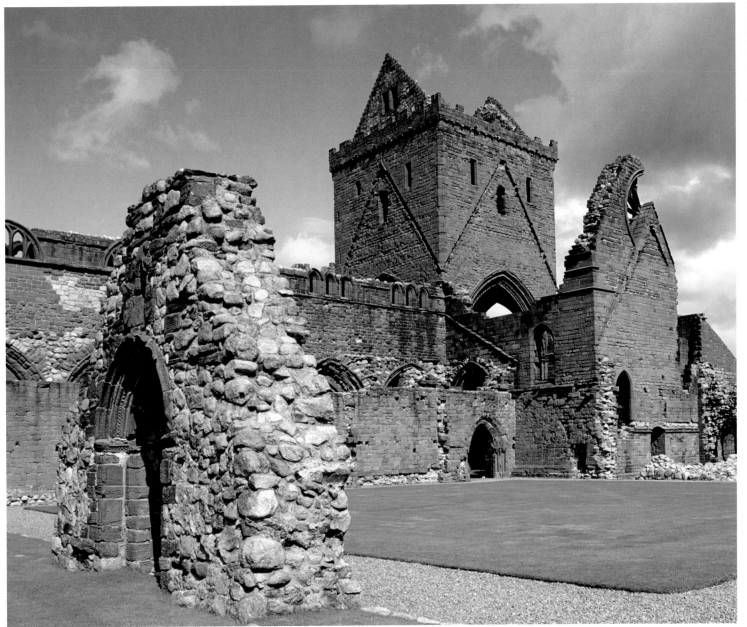

LEFT: Sweetheart Abbey. The abbey was named in 1289 when Lady Devorgilla died. She was interred in front of the high altar with a silver and ivory casket containing the embalmed heart of her husband, John Balliol, who had died 20 years earlier. She had carried him around with her all that time.

FAR LEFT: The nave arches at Sweetheart Abbey—also known as New Abbey—was the last of 12 pre-Reformation Cistercian foundations in Scotland. The abbey was founded in 1273 by Devorgilla, Lady of Galloway and mother of John Balliol who was (fleetingly) King of Scotland and founder of Balliol College Oxford.

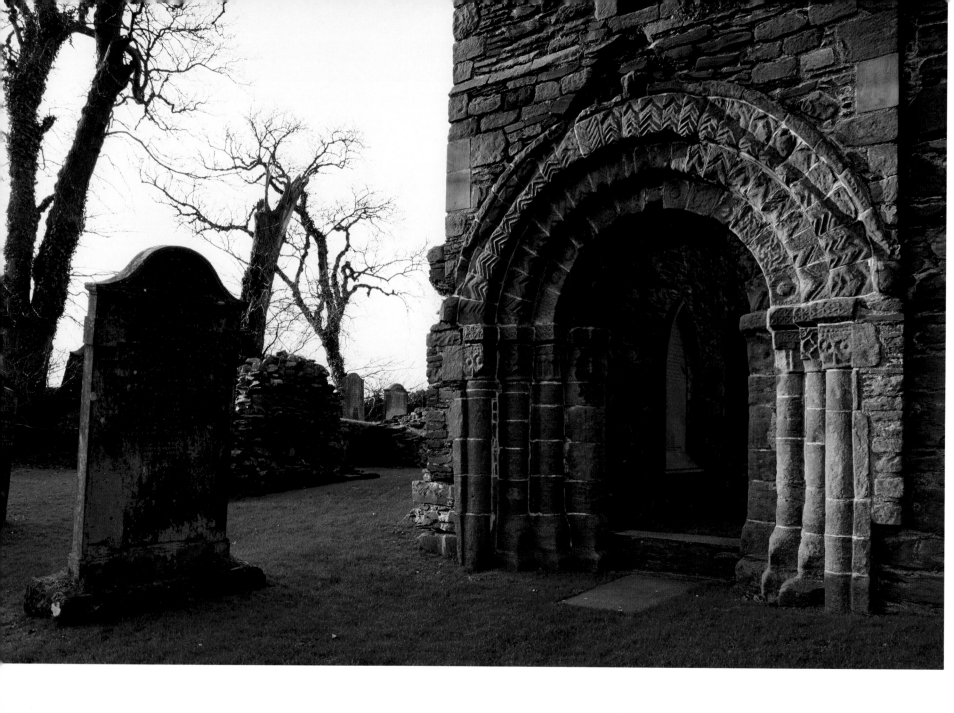

LEFT: Detail of the doorway and southwest corner of twelfth century Whithorn Abbey in Wigtownshire. St Ninian founded a priory and built the first church here in 397 AD, making this one of the oldest Christian sites in Britain.

RIGHT: Comlongon Castle was built around 1435 to dominate the northern side of the Solway Firth. The great tower contains an unbroken spiral staircase that starts at the entrance and passes through four floors before going on to the parapet.

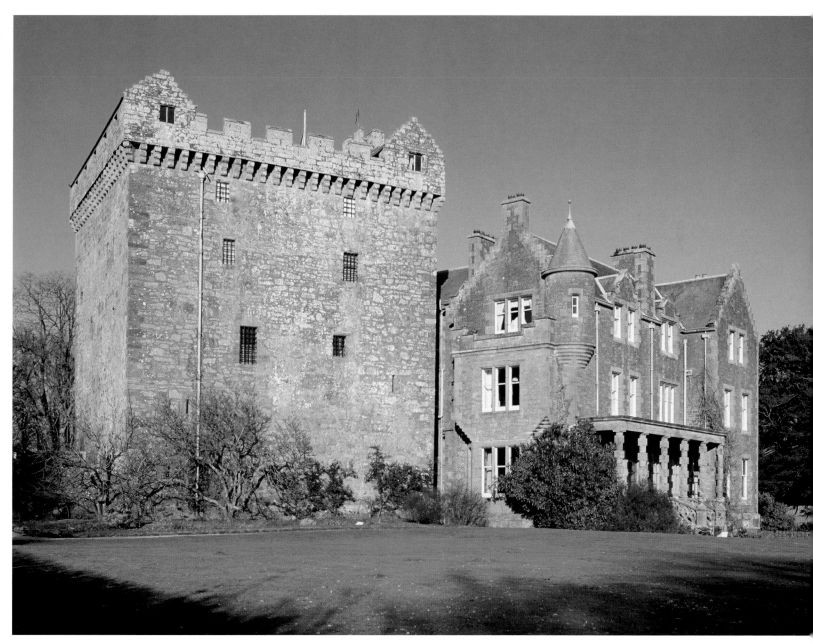

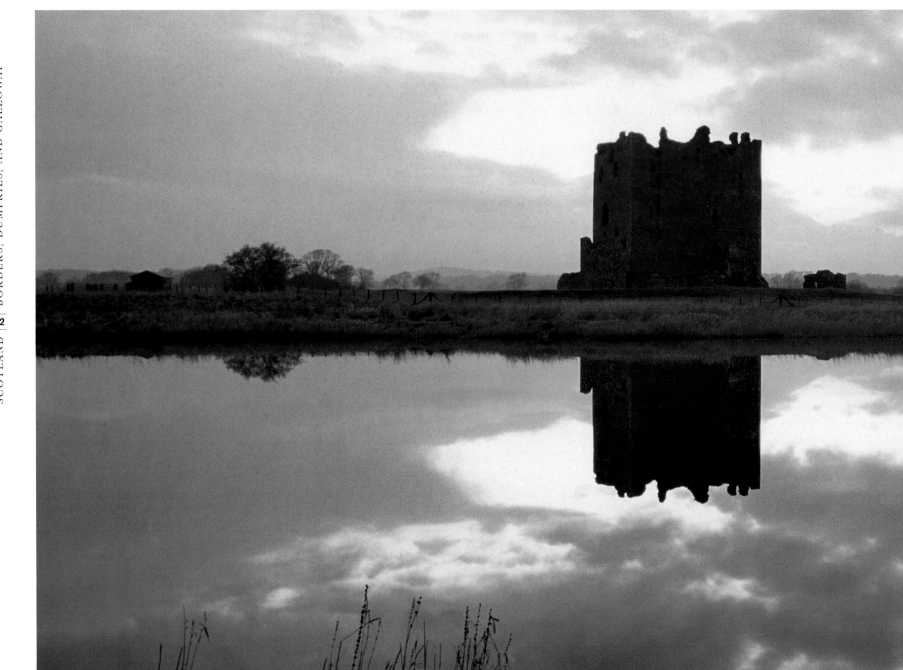

LEFT: Threave Castle reflected in the still waters of the River Dee. The forbidding great tower was built in about 1370 for Archibald "the Grim," third Earl of Douglas. It has walls 10ft thick that used to rise four stories to 70ft high. In around 1454, when the earls were in serious conflict with the king, they built an outer "artillery wall" 18ft high on the mainland east and south sides.

Glasgow and Strathclyde

Glasgow was founded in about 540 AD—well before the first stones were gathered together in Edinburgh—because it was an important ford across the wide River Clyde. In time the Clyde became the most important stretch of water in Scotland and the source of much of Glasgow's wealth when the city became a great trading center. Geographically Glasgow is in the Lowlands, but it is the gateway to the West Highlands. It prospered with the Industrial Revolution. Glasgow developed a navigable port and very soon much wealth came via the Clyde and the important shipyards.

For all its age and prosperity, Glasgow is Scotland's second city, but it has become one of the most cosmopolitan places in Europe—a vibrant place full of excitement and culture. Glasgow is undoubtedly one of the finest Victorian cities in Britain, thanks to its nineteenth century prosperity and also in no small measure to the legacy of magnificent buildings designed by Charles Rennie Mackintosh, one of Britain and the world's great designers, a master of the Arts & Crafts movement.

The hinterland of Strathclyde occupies the lowlands of southwest Scotland. There was probably a kingdom here by the middle of the fifth century but it was not until the eleventh century that Strathclyde was absorbed into the kingdom of Scotland. The one-time center of the kingdom of Strathclyde was Dumbarton; situated on a volcanic plug it is the longest surviving stronghold in Britain.

There are numerous islands off the west coast of Scotland, none more important than Islay which the Clan Donald made the center of their vast Lordship of the Isles.

RIGHT: The view across Mull over Loch na Lathaich towards the sheer cliffs of Ardmeanach. On the southern shore of the loch is the deserted township of Suidhe where Saint Columba is supposed to have rested.

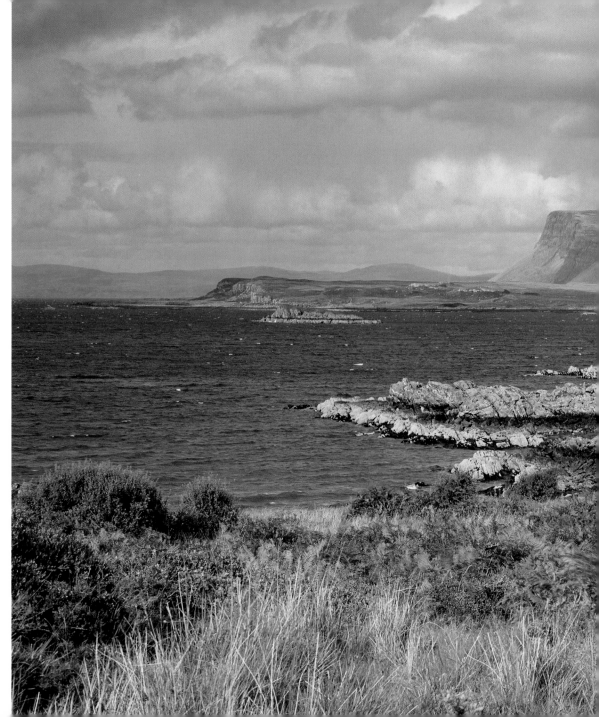

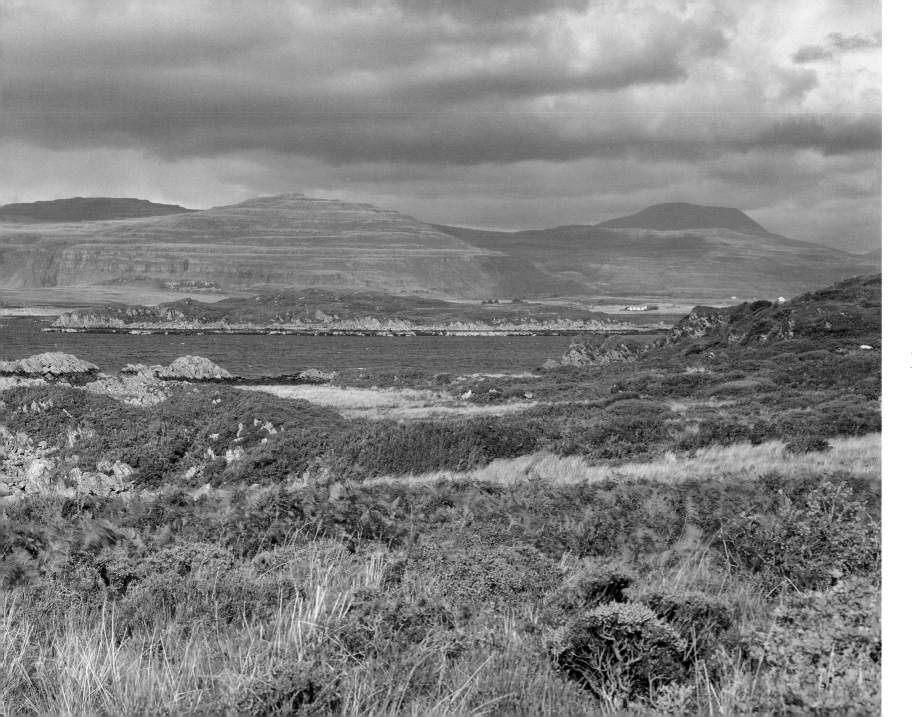

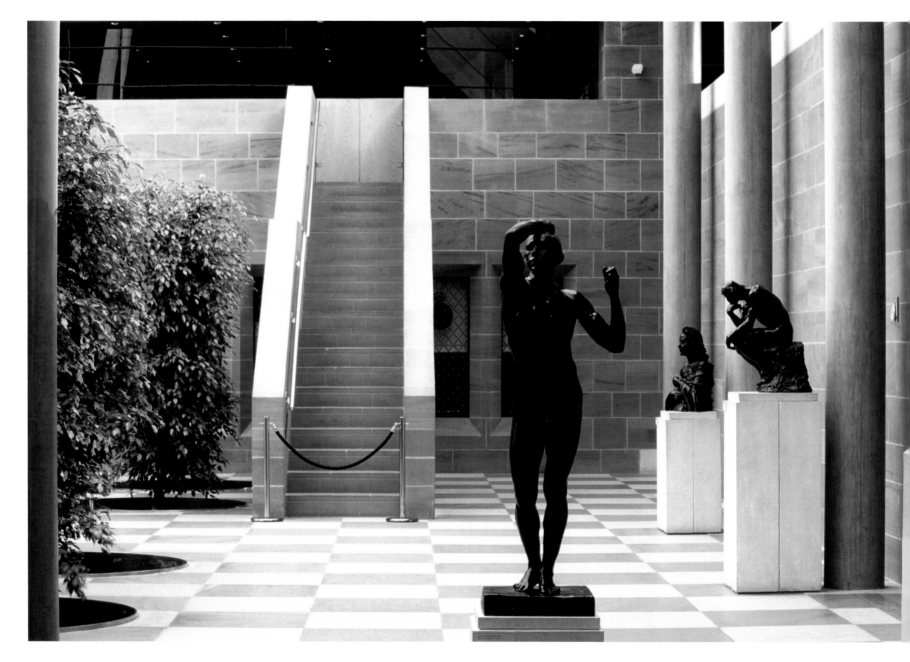

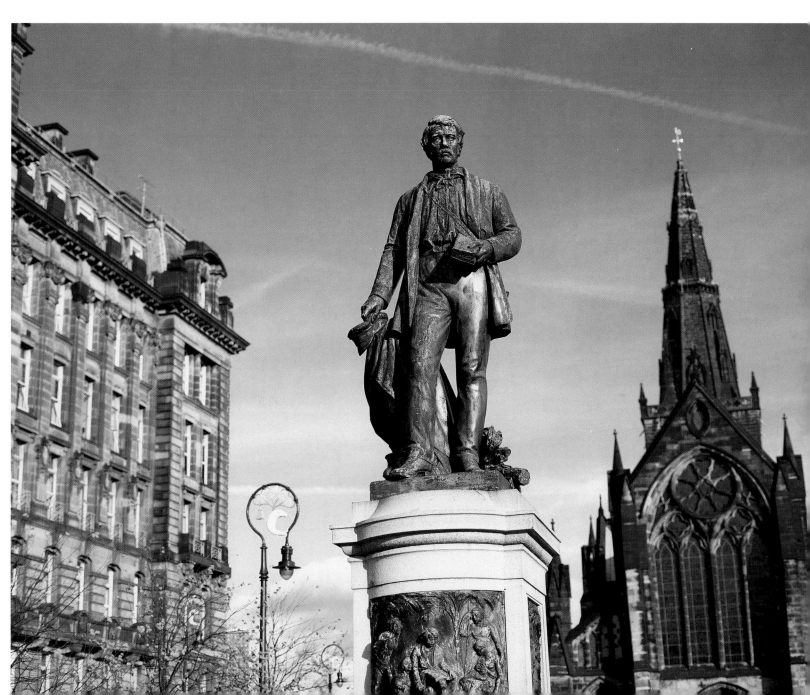

LEFT: Glasgow is home to the fabulous Burrell Collection which includes Auguste Rodin's "The Age of Bronze" and "The Thinker."

RIGHT: In Cathedral Square stands the statue of the explorer David Livingstone, sculpted by John Mossman in 1875–79. Livingstone came from Blantyre, eight miles south of Glasgow, but became famous for his explorations across Africa, and in particular for being the first European to see "the smoke that thunders"—he named them the Victoria Falls. He died in Africa and his body was sent back to England where he was buried, a national hero, in Westminster Abbey.

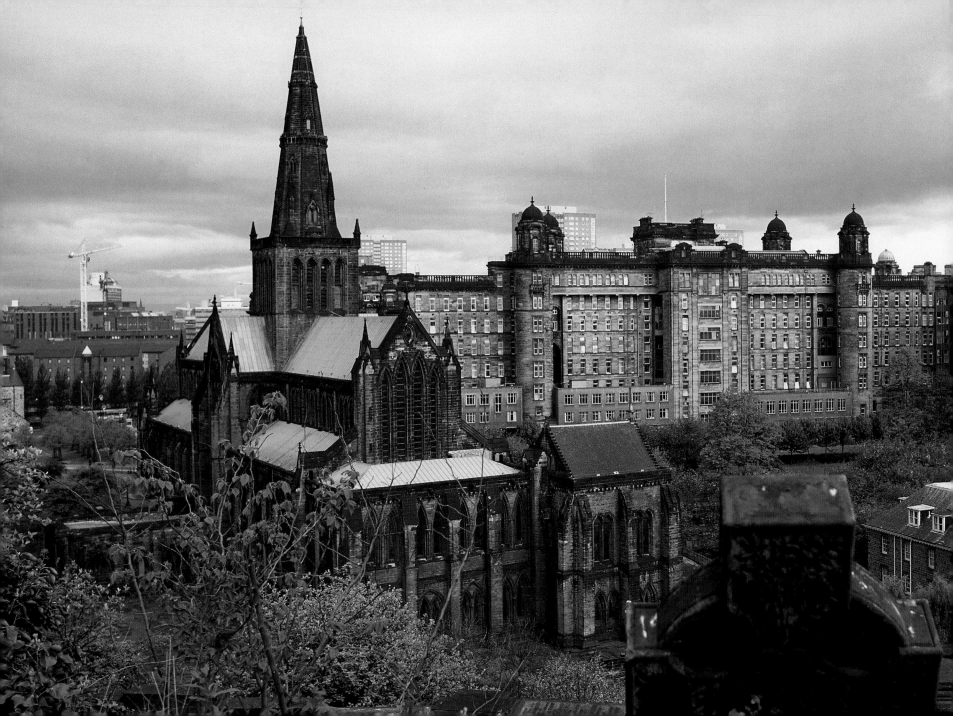

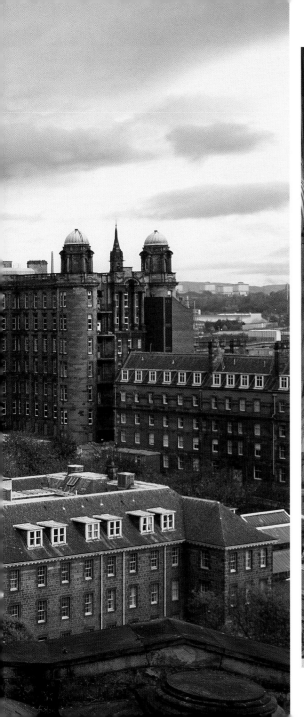

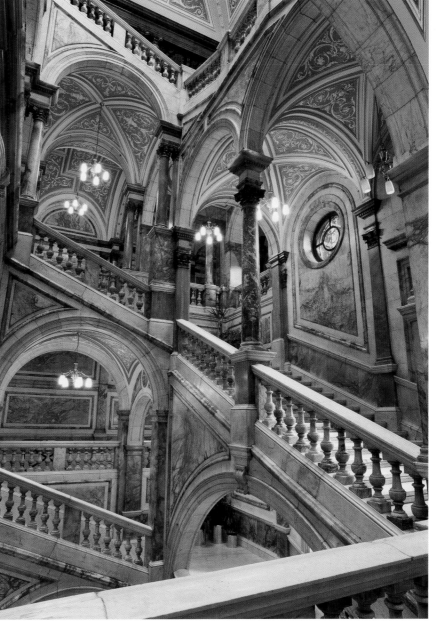

LEFT: Reflecting Glasgow's prosperity and taste during the Victorian era, the City Chambers are truly magnificent, as this Italian marble Renaissance-style staircase shows.

FAR LEFT: The Glasgow skyline still retains its Victorian aspect. At left is St Mungo's Cathedral and the Royal Infirmary.

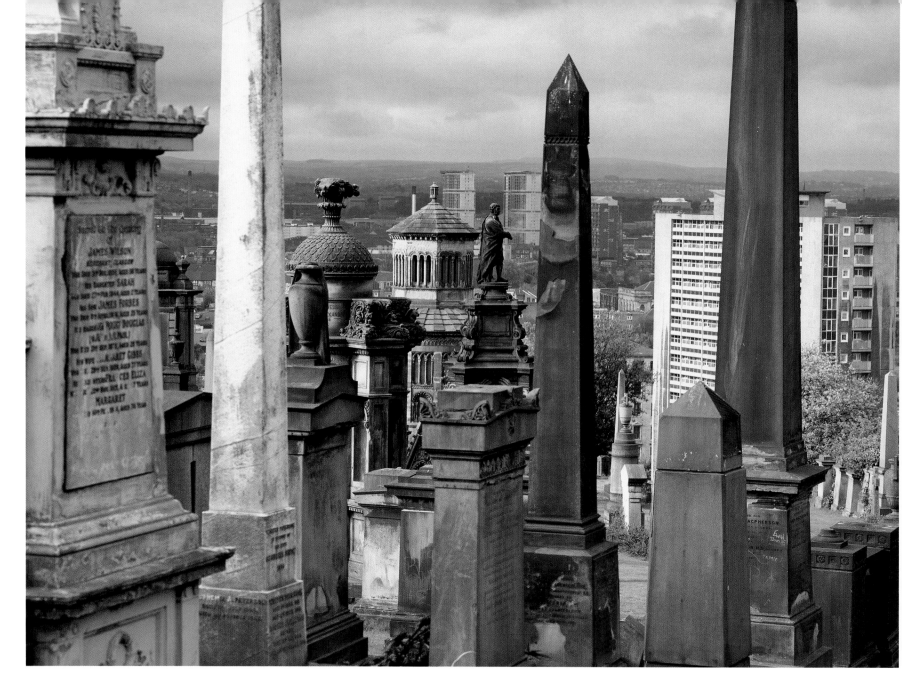

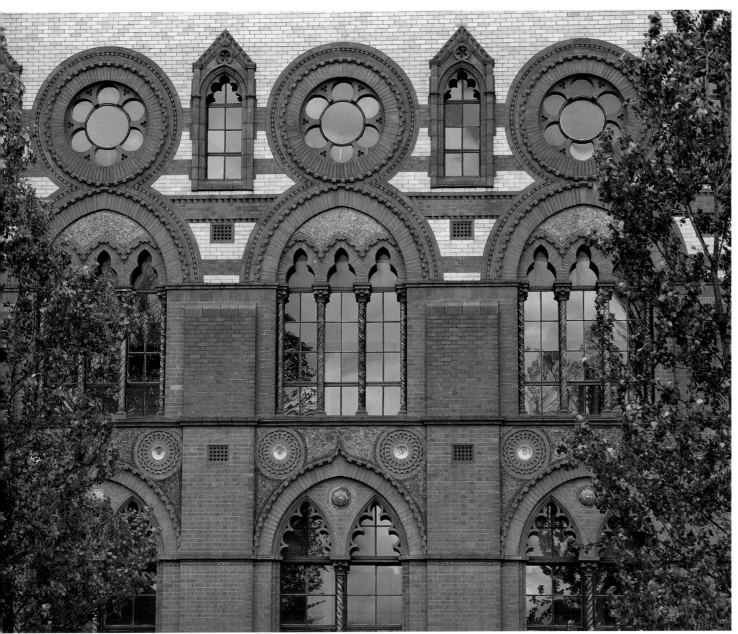

LEFT: On Glasgow Green is Templeton's Carpet Factory, a nineteenth century polychromatic brick building designed by William Leiper in the style of the Doge's Palace in Venice.

FAR LEFT: Glasgow's Gothic Necropolis has looked out over the city from its hill opposite St Mungo's cathedral since early Victorian times. The cemetery was modeled on Père Lachaise cemetery in Paris and contains about 3,500 tombs, many with reverential inscriptions, angelic statues, and imposing monuments.

OVERLEAF: From the protection of its own island, austere-looking Castle Stalker (Stalcair) guards Loch Linnhe. The original castle was built in 1320 by the MacDougal family but when Duncan Stewart of Appin became the owner he restored the castle in about 1450. James IV used the castle as a hunting lodge—"Stalcair" means hunter or falconer.

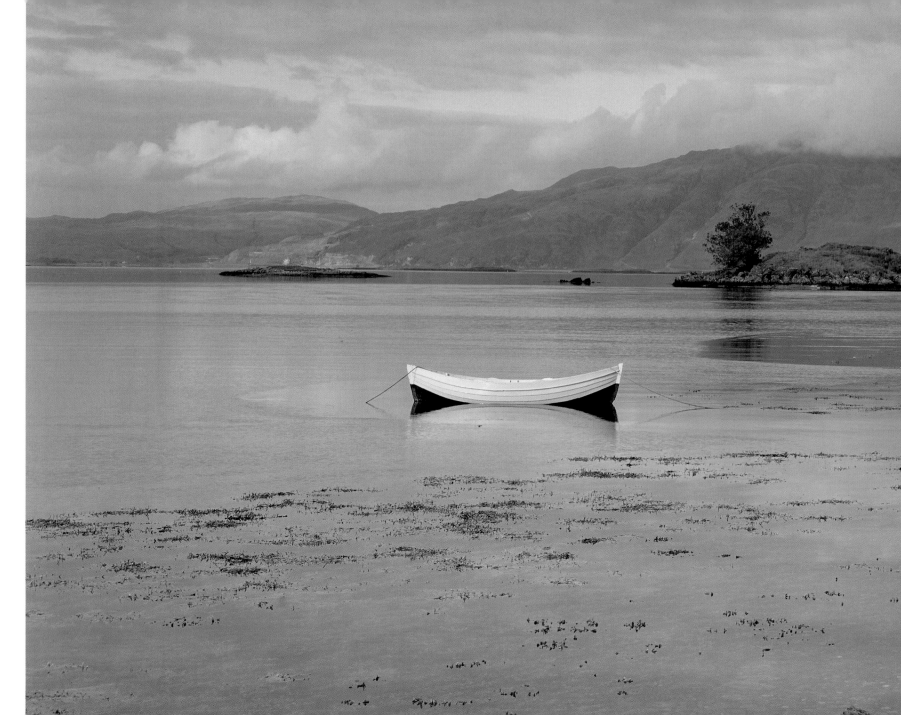

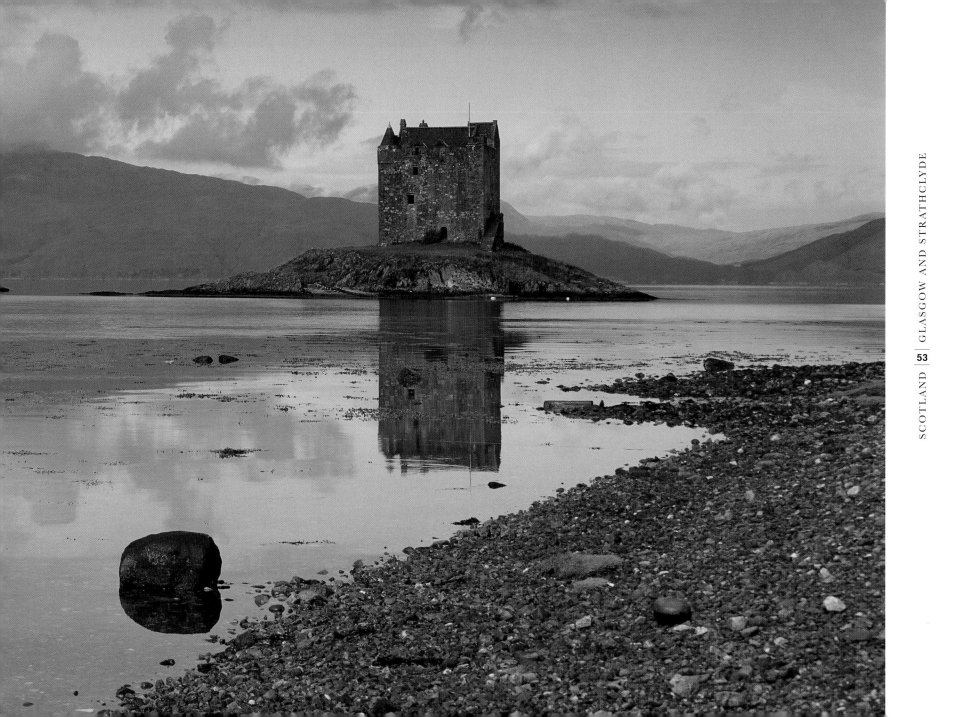

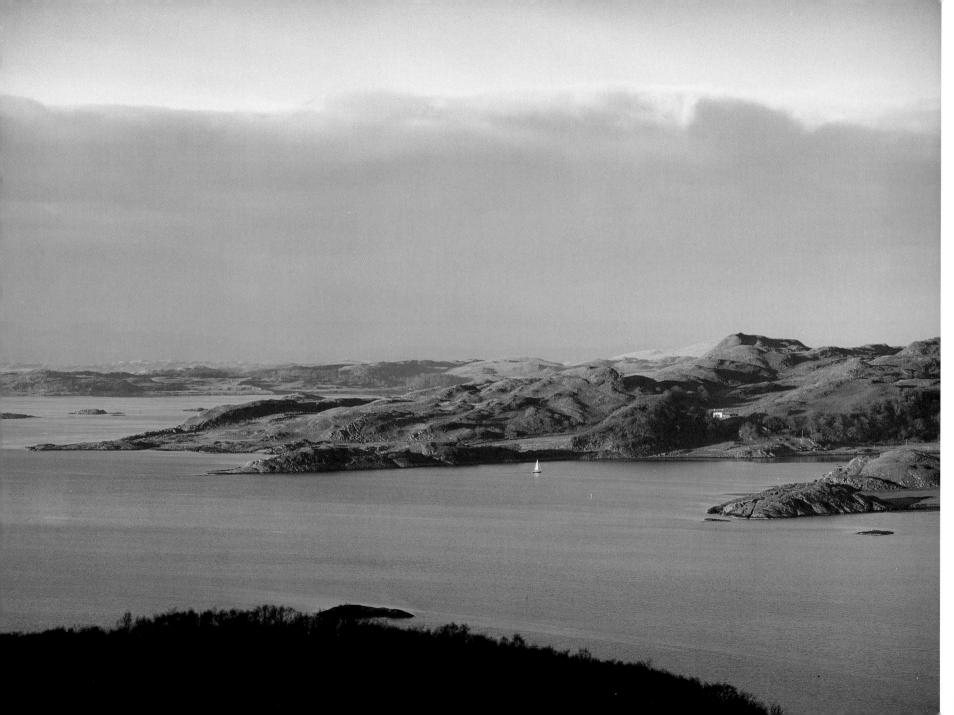

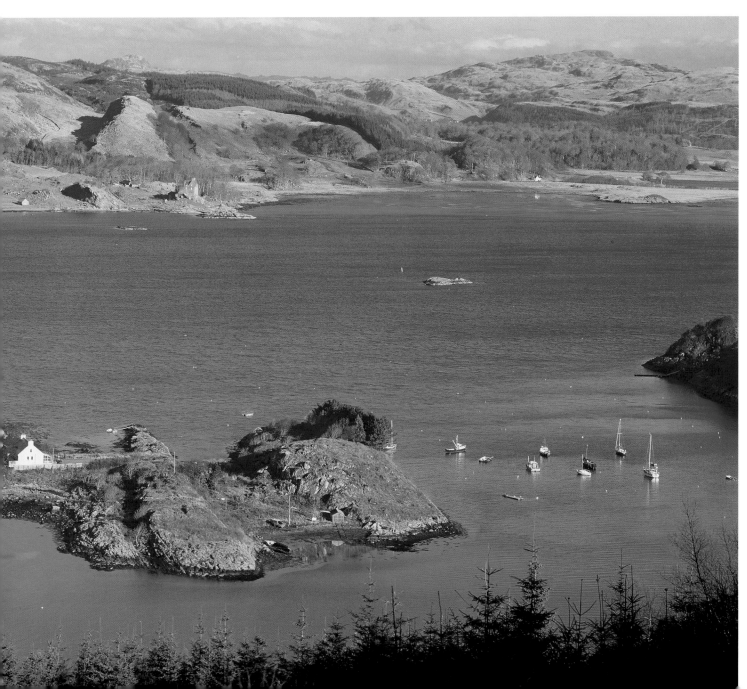

LEFT: Crinan harbor. Much of Crinan's significance is due to the Crinan Canal which runs for nine miles from Ardrishaig on Loch Fyne. It was engineered as a shortcut between the west coast and the Clyde estuary.

FAR LEFT: Loch Crinan is a sea-loch 4.5 miles long, which opens into the upper Sound of Jura. Before the opening of the canal the port of Crinan was called Portree—the King's Port. Fishing has always been an important industry.

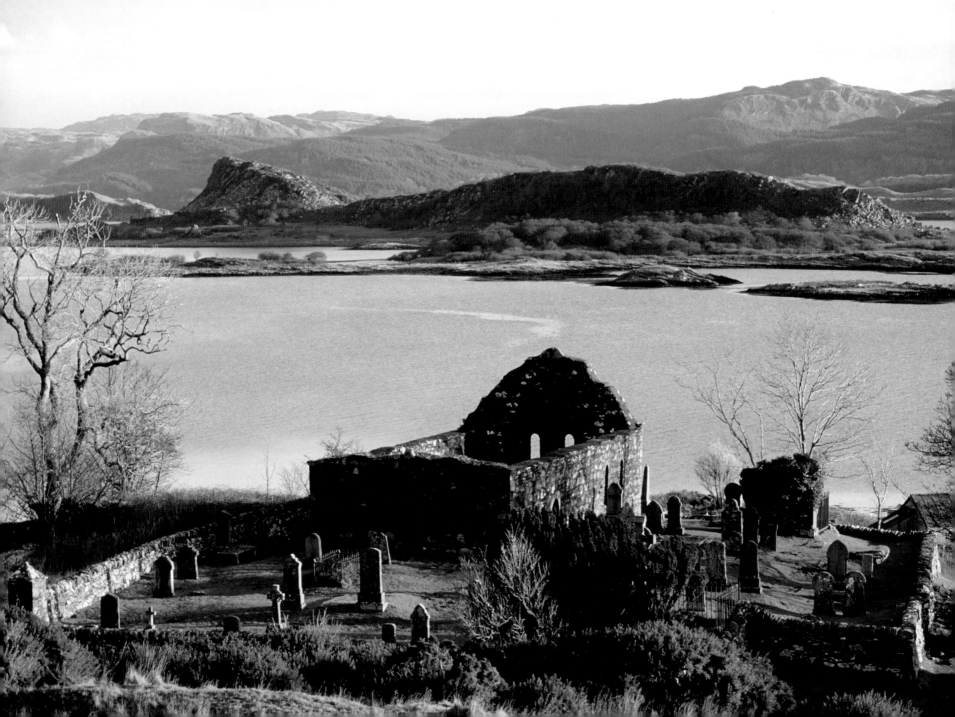

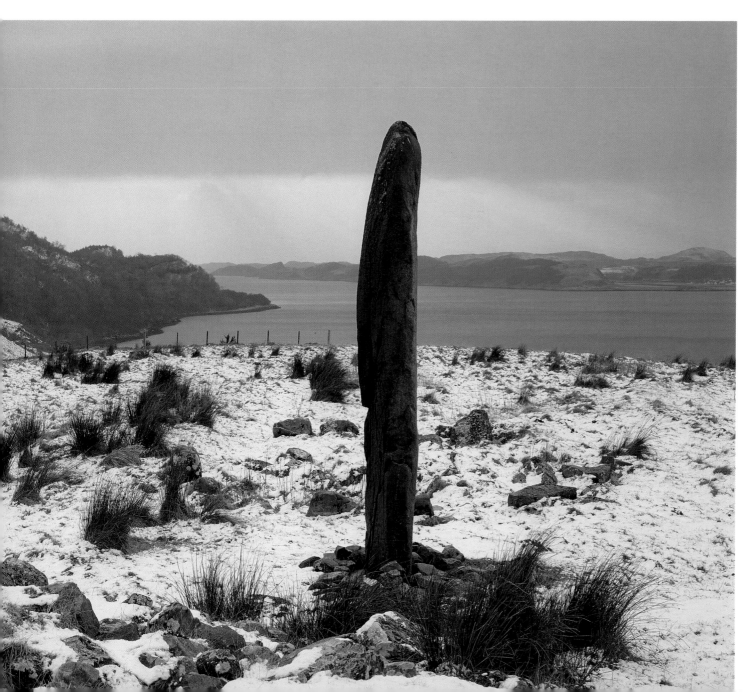

LEFT: Kintraw standing stone, Loch Craignish. The 15ft high stone and small kerb cairn are seen from the large kerb cairn. From here the midwinter sun flashes in the prominent notch of the Jura Hills beyond Loch Craignish.

FAR LEFT: Craignish Chapel stands on the western shore of Loch Craignish on an earlier Christian site. The loch contains a central chain of over 20 islands which run parallel to the shore.

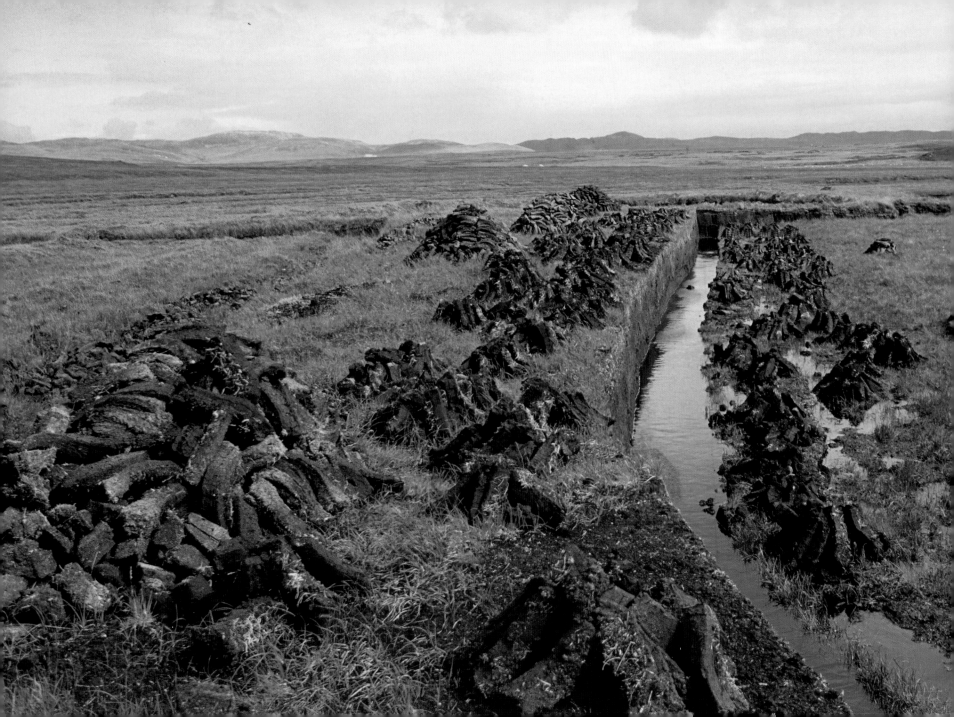

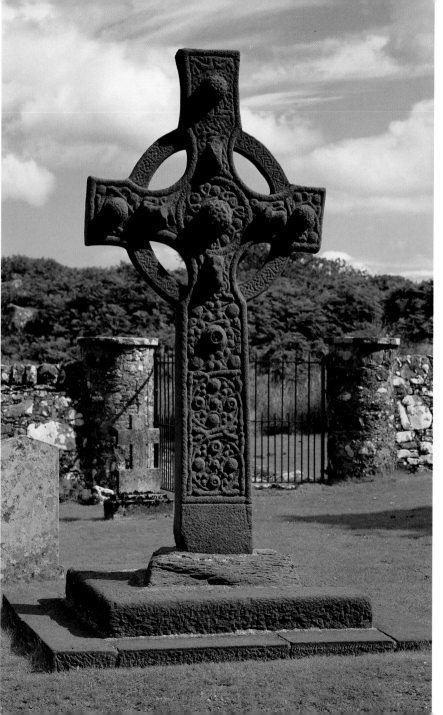

LEFT: On the Inner Hebridean island of Islay, in the southeast, lies Kildalton Church. In the churchyard is this fine example of a Celtic Christian cross. Made of bluestone, it was probably carved in the eighth century by a stonemason from the island of Iona.

FAR LEFT: Peat cutting near Glenegedale on Islay. The island has a surprisingly mild climate thanks to the Gulf Stream which washes the west coast.

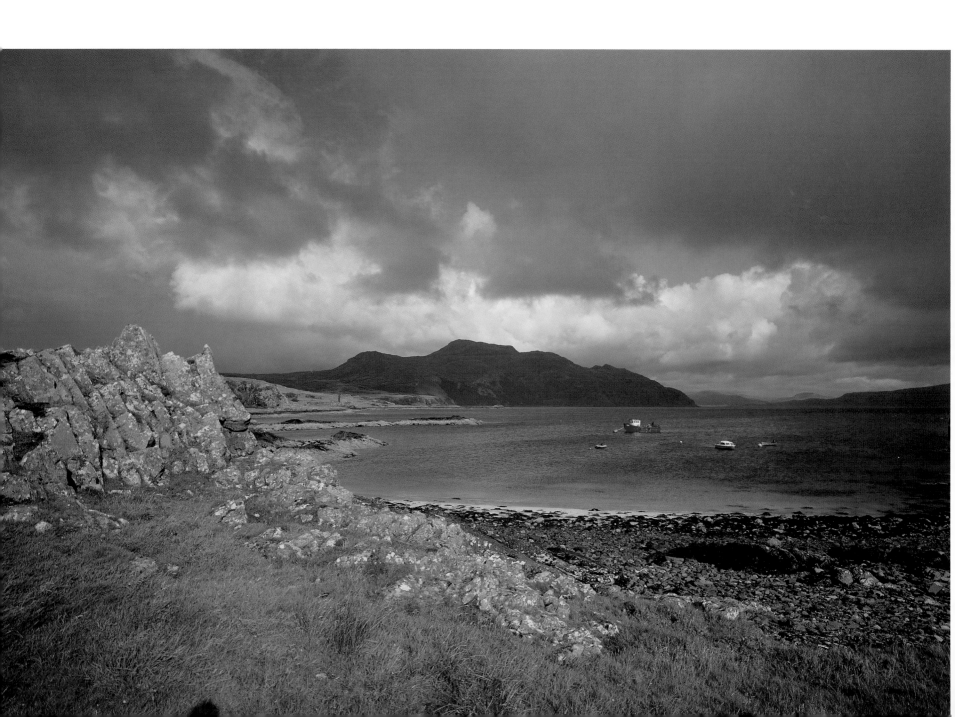

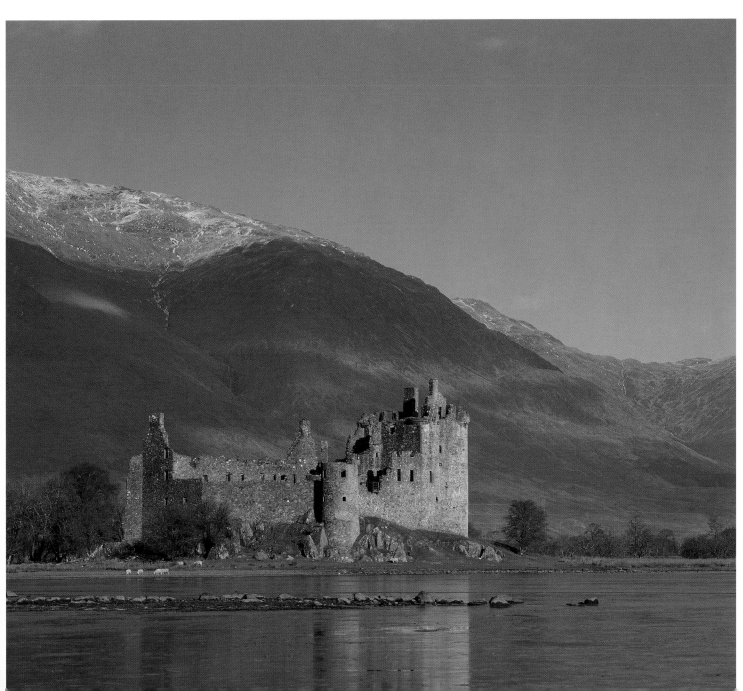

LEFT: Kilchurn Castle sits on a small peninsula on Loch Awe. It was originally built around 1420 as a five-story tower house by Sir Colin Campbell of Glenorchy: it has been much altered through the centuries. It was abandoned in 1740 and fell into terminal decay when it lost its roof in 1770.

FAR LEFT: Kilchoan Bay on the Ardnamurchan peninsula is overlooked by the mass of Ben Hiant. A ferry runs from Kilchoan to Tobermory on the island of Mull.

RIGHT: The fishing harbor at Carradale on the east coast of Kintyre has views across the Kilbrennan Sound toward the hills of Arran in the distance.

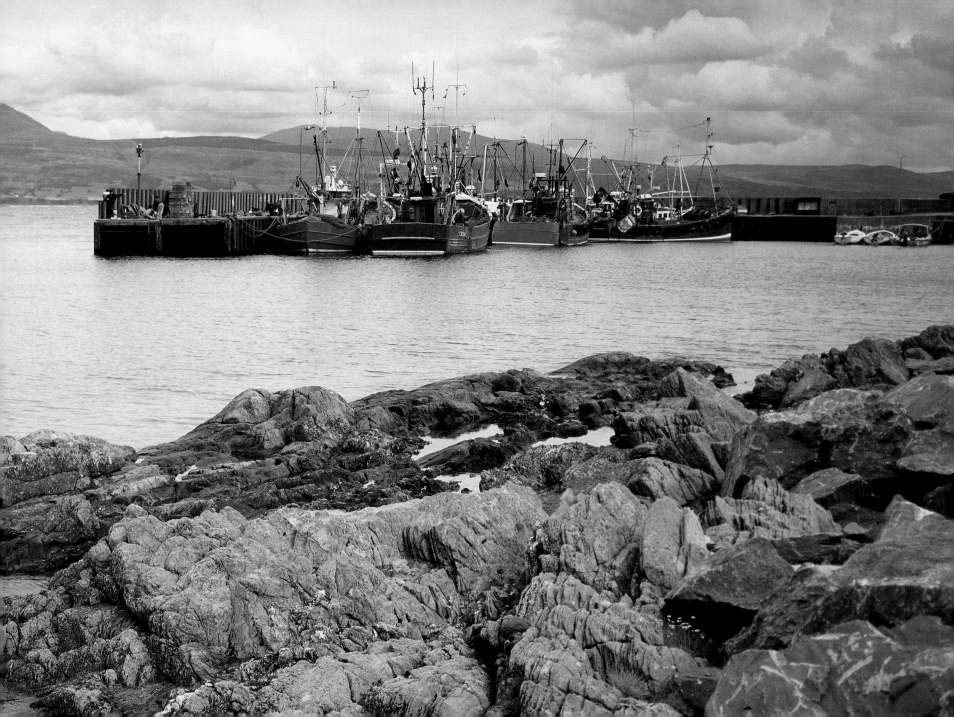

ABOVE: Prehistoric rock carvings at Cairnbaan in Kilmartin Glen. Within six miles of Cairnbaan there are around 150 prehistoric remains as well as many other fascinating historic monuments.

RIGHT: A pair of medieval grave slabs in Kilmartin churchyard. The graveyard also contains many other medieval grave slabs including a number moved from St Columba's Chapel in Poltalloch.

FAR LEFT: At the entrance to Loch Sween lies the thirteenth century Keills Chapel dedicated to St Charmaig. Nearby stands an ancient eighth century blue slate cross known as the High Cross of Keills—the pride of a magnificent collection of Celtic carved crosses at the chapel.

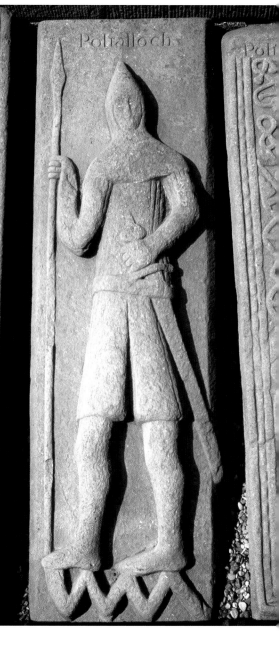

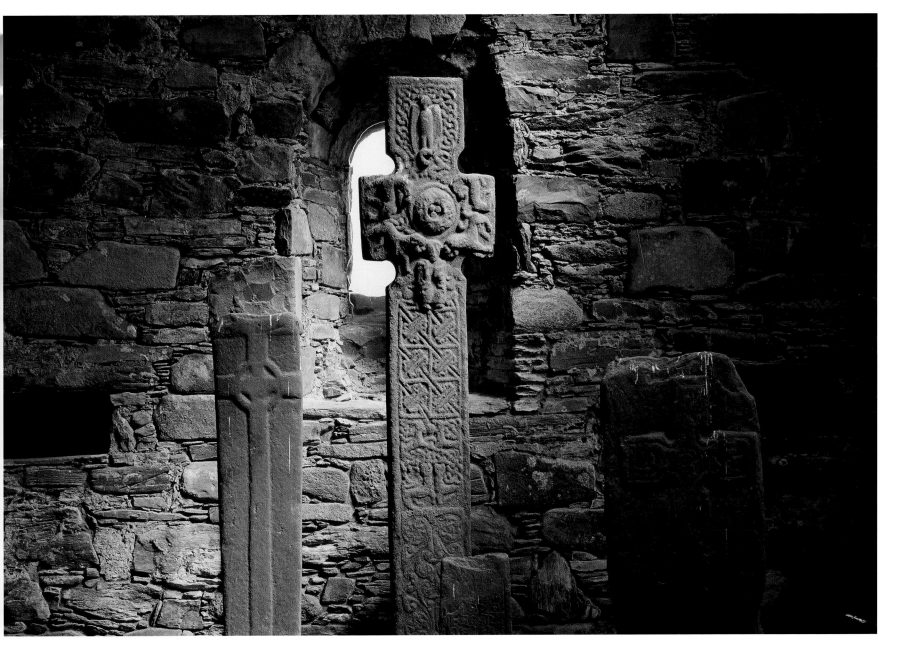

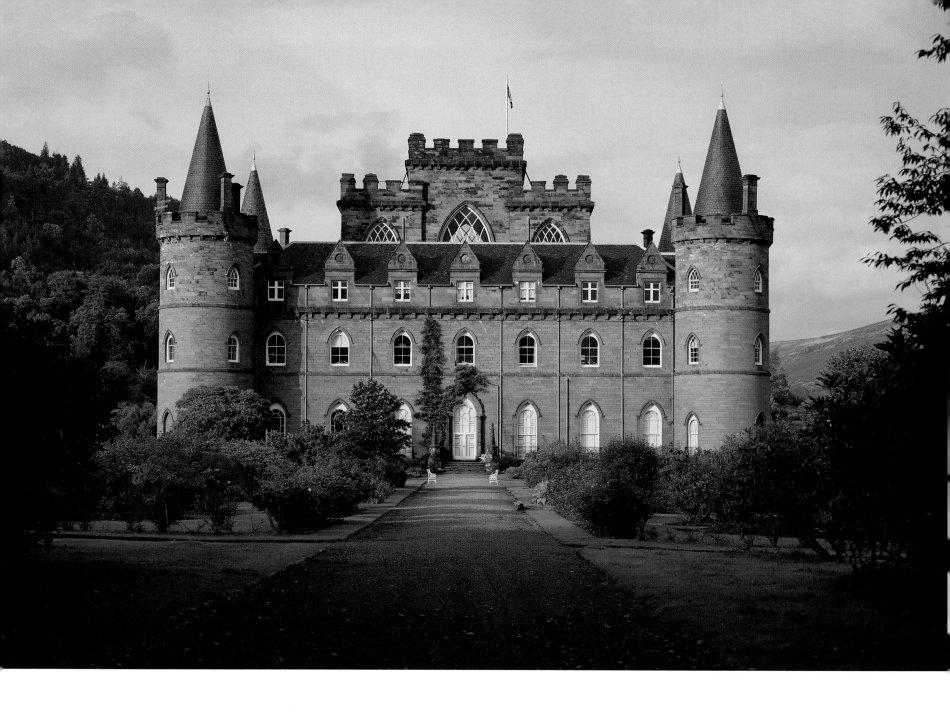

LEFT: Neo-Gothic Inverary Castle is the seat of the dukes of Argyll. Building started on the "new castle" in 1520 and was not fully completed until 1770. Only then were the remains of the old castle (a few yards away) finally demolished in 1773.

RIGHT: Innischonnel castle was the original stronghold of the Campbells of Loch Awe. It began as a stone enclosure in the early thirteenth century then was turned into a much stronger castle in the fifteenth century.

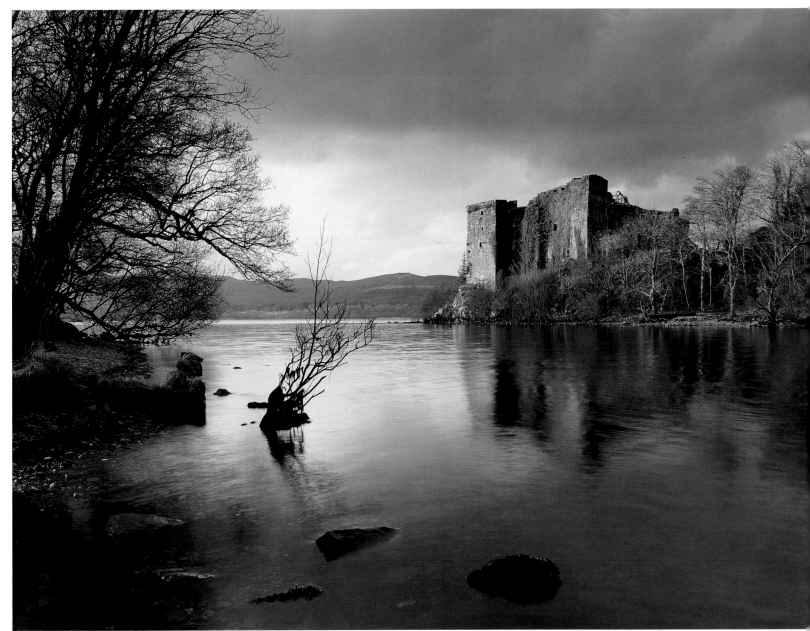

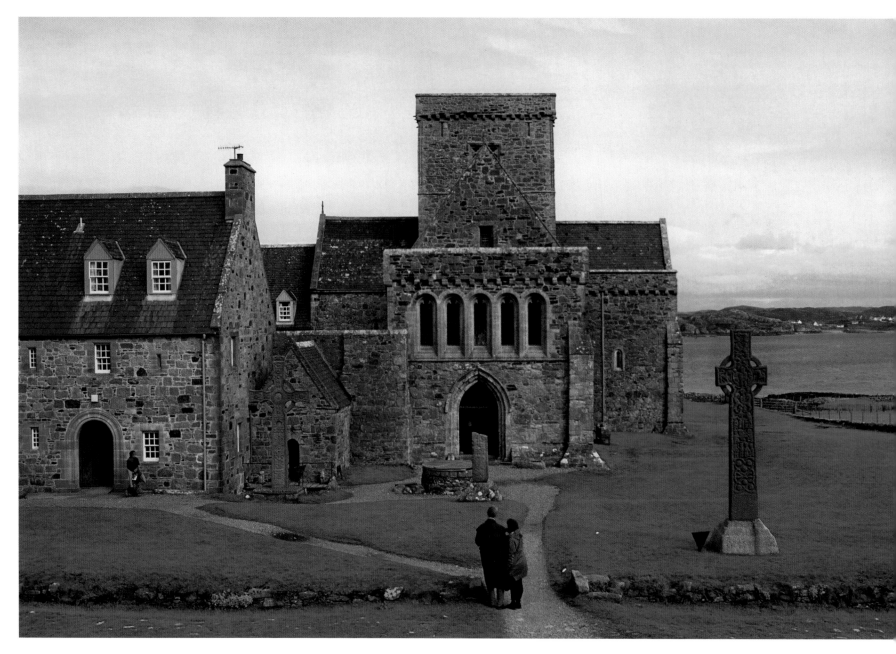

69

LEFT: Chapel detail, Iona Abbey.

LEFT: Saint Columba landed on the island of Iona from Ireland in 563 AD and founded a Christian settlement. It soon became one of the holiest sites in Britain and survived despite successive attacks by Viking raiders in 795, 802, 806, and 825. However, it wasn't until 1200 that Iona really became a center for Christianity when a Benedictine monastery and then an Augustinian nunnery were built on the island. The communities were abolished in the 1560s when the Reformation swept Scotland, and for 200 years the buildings were abandoned. In the late nineteenth century the Duke of Argyll decided to restore the foundation. Work was completed by 1910.

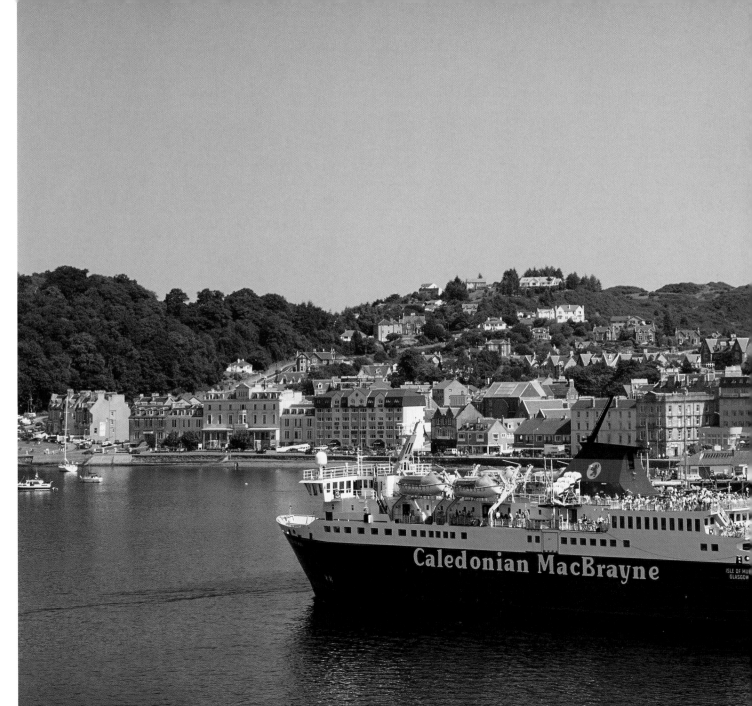

RIGHT: Oban was a small fishing village until the early Victorian steamers used the town as the departure port for the Western Isles. Since then it has become a popular holiday destination situated on the spectacular Firth of Lorne on the coast of west Scotland.

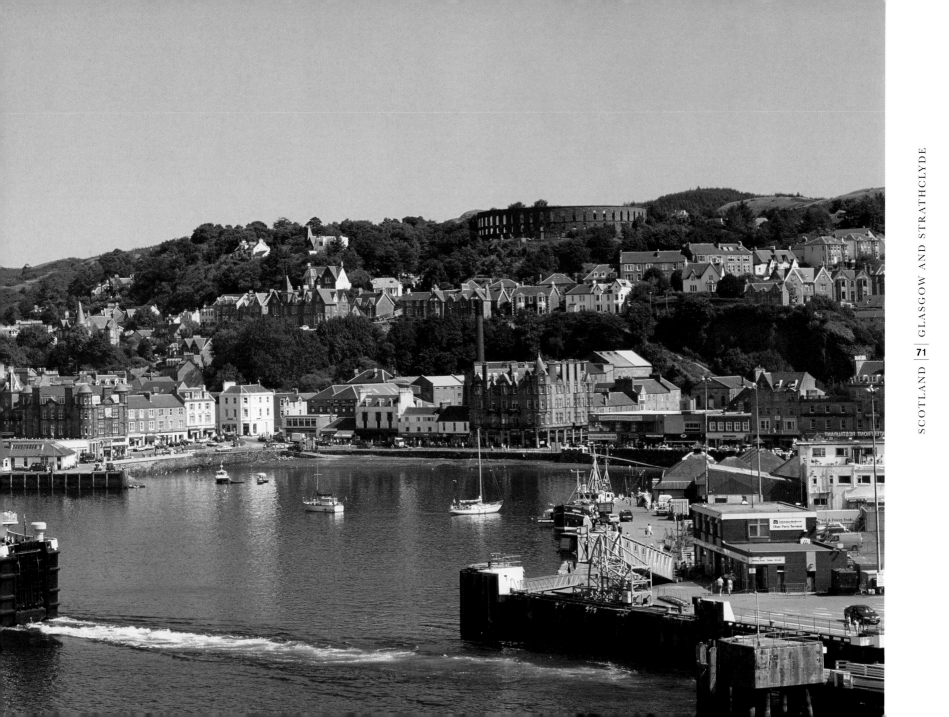

RIGHT AND FAR RIGHT: The tiny island of Staffa in the Inner Hebrides is world-famous for the remarkable hexagonally jointed basalt volcanic rock formations in Fingal's Cave. The cave is also known as *Uamh-Binn*—The Cave of Melody. The island is uninhabited except for thousands of seabirds, especially puffins.

OVERLEAF
LEFT: Glengarrisdale Bay on the island of Jura. As well as various smaller birds sometimes golden eagles can be seen here, also the area is home to otters and seals.

RIGHT: The view from south of Oban out across the Sound of Jura to the island of Jura in the Inner Hebrides.

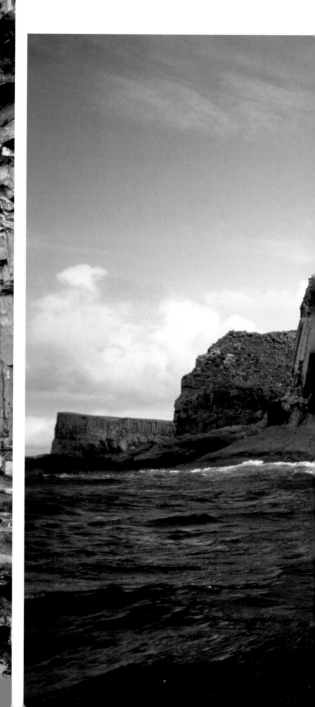

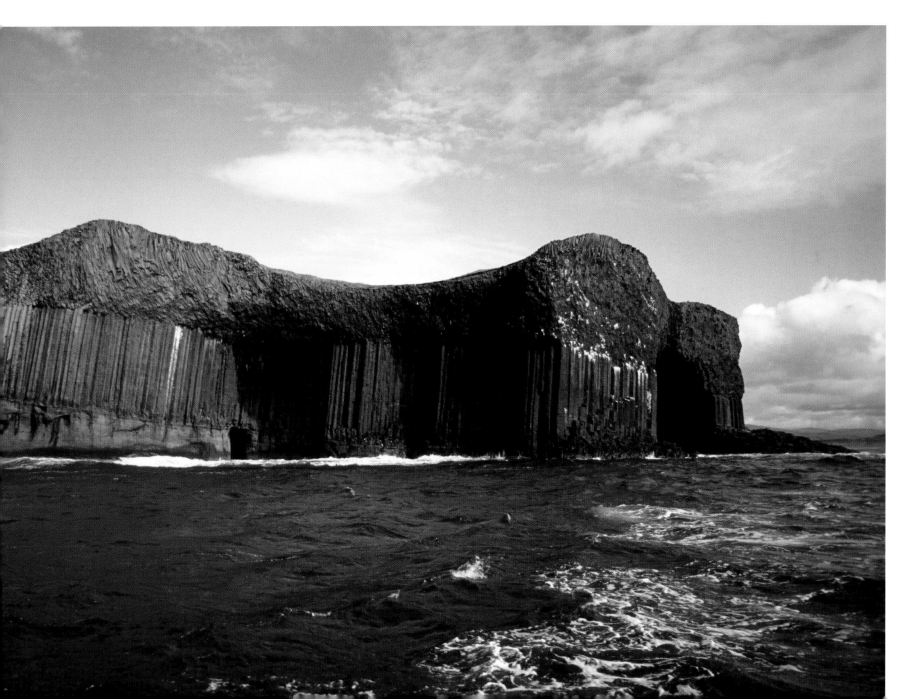

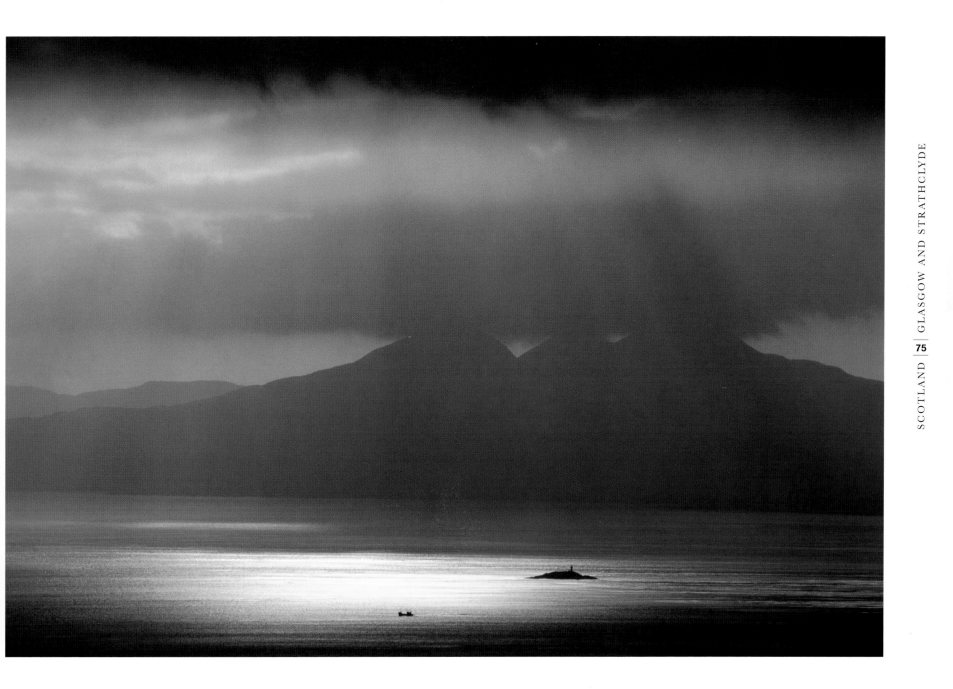

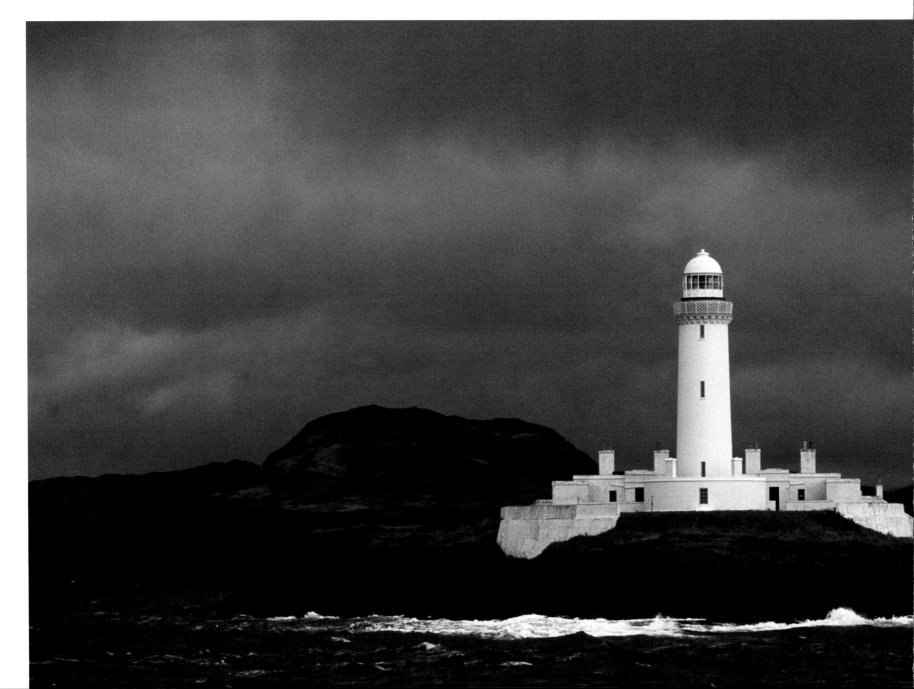

LEFT: The Eilean Musdile Lighthouse sits on its tiny island at the southern tip of the island of Lismore, in the Firth of Lorn at the entrance to Loch Linnhe. Built by Robert Stevenson in 1833 it was manned until 1965 when it was automated. Its beacon sends out a white flash every ten seconds and has a range of almost 20 miles.

RIGHT: South of Oban lies Kilmartin Valley which contains over 150 ancient sites including a rich assembly of standing stones, burial cairns, carved stones, and other prehistoric monuments.

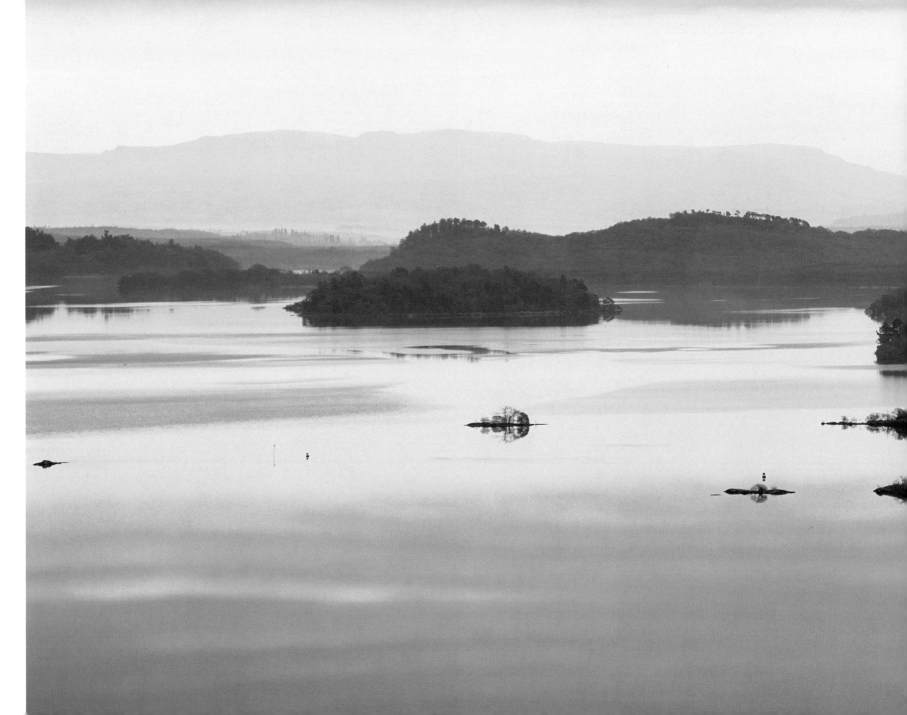

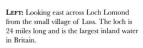

SCOTLAND | GLASGOW AND STRATHCLYDE

79

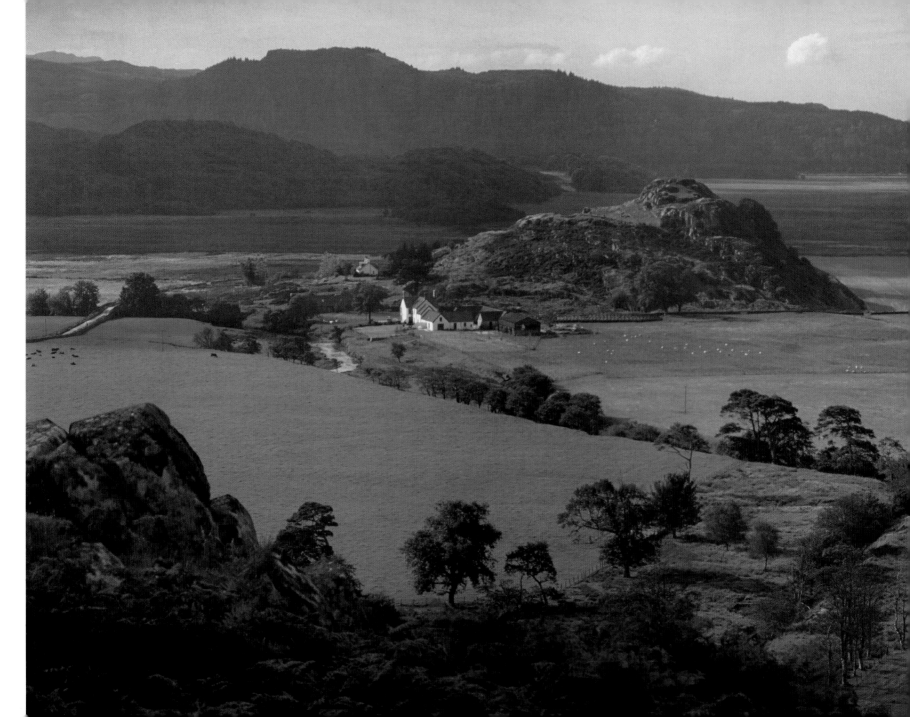

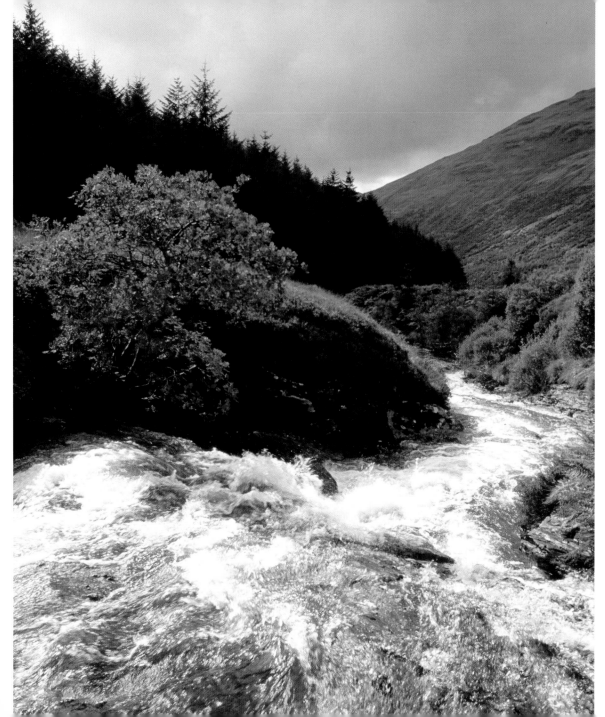

LEFT: The rushing waters of a stream near the head of Loch Goil. The area is popular with both walkers and mountain bikers.

FAR LEFT: Dunadd Iron Age Hill Fort dominates Kilmartin Valley and the nearby River Add. Dunadd was the capital of the ancient Celtic kingdom of Dalraida, in around 500 AD. It rises out of the Great Moss, now a nature reserve which contains one of Scotland's few remaining peat bogs.

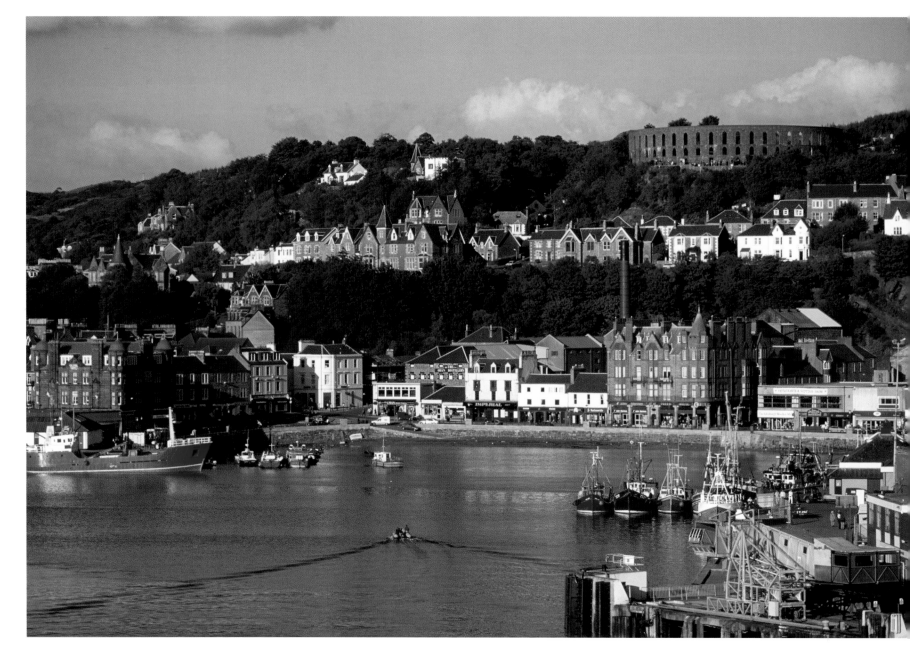

LEFT: A view of Oban looking over the harbour towards the town center and the amphitheater of MacCaig's Tower. The building was started in 1897 to give work to the unemployed. MacCaig, however, died before work was completed and the building was abandoned.

RIGHT: Near Lochgilphead in Knapdale Forest lies the deserted township of Arichonan. The first time it appears in the records was in 1654 but the town was abandoned around the middle of the nineteenth century during the Highland Clearances when large tracts of Scotland were cleared, often violently, and the people forced from their homes to live a subsistence life on the coast—all to provide unhindered grazing for sheep. Arichonan was one of the last places to be cleared.

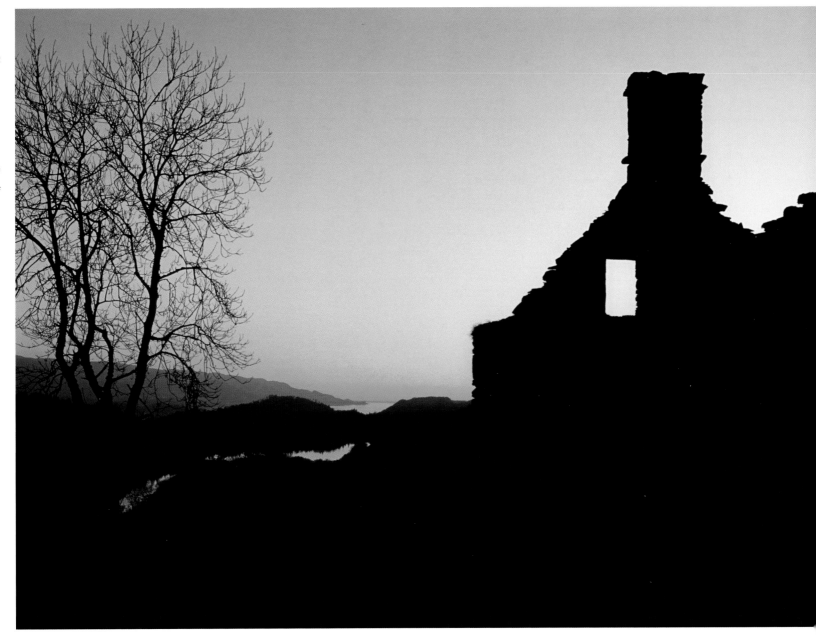

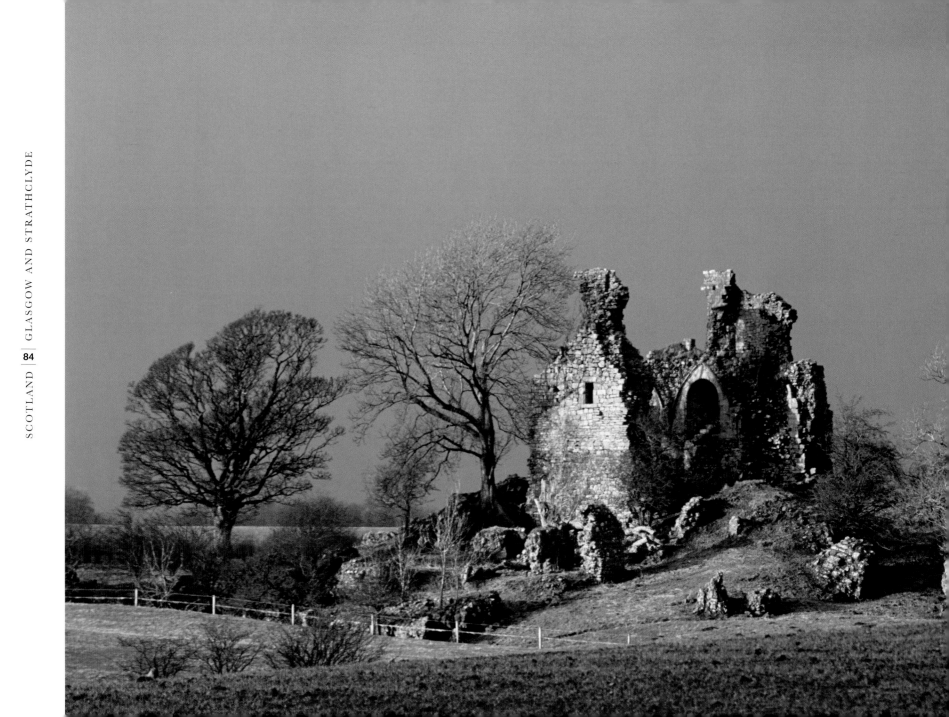

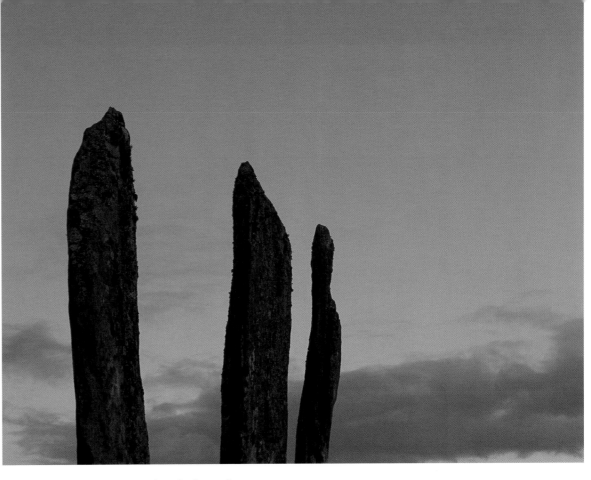

LEFT: The ruins of Craigie Castle an early Scottish tower house. The castle was probably built in the early 1200s and then the tower house was added in the fifteenth century. Still visible are the remains of the mound and surrounding moat.

ABOVE: Standing stone alignments at Ballymeanoch in Kilmartin Valley. They are the remnants of a large megalithic avenue. Nearby is a burial cairn and the flattened (thanks to ploughing) remains of a henge monument.

Edinburgh and Lothian

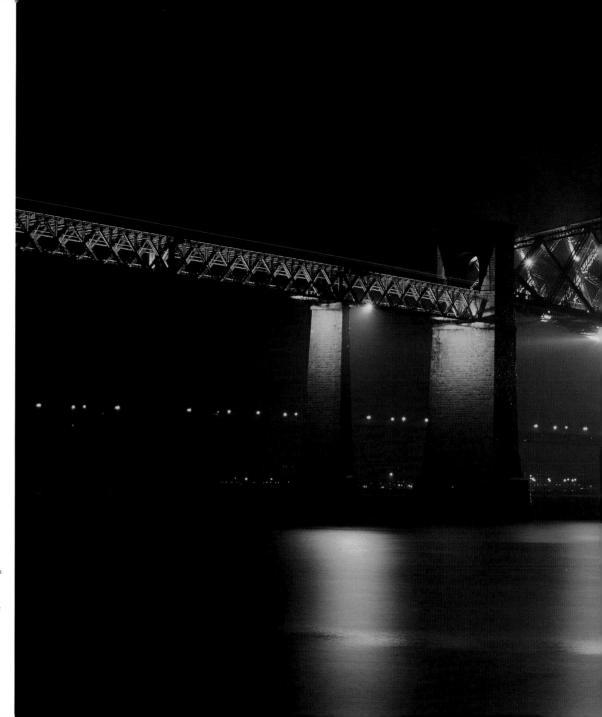

Edinburgh lies in Lothian on the eastern side of Scotland near the Firth of Forth; it is the capital of Scotland. This is a rich area full of history—magnificent castles, stunning churches, enormous private houses, fantastic gardens—plus miles of glorious coastline. There is so much to see and enjoy in Edinburgh, it is hard to know where to start. Many people first come to the city for the annual Edinburgh and Fringe Festivals only to fall in love with the place. It is the royal and administrative center of Scotland, and consequently has all the pagentry and pomp associated with politicians and majesty.

The National Trust for Scotland is the guardian of many important heritage sites and provides a good starting point for visitors who want to see some of the highlights of the region. In Lothian alone they look after Newhailes and Inveresk Lodge Garden, both near Musselburgh, the House of the Binns at Linlithgow, Malleny Garden in Balerno, and Preston Mill and Phantassie Doocot in East Linton.

The countryside of Lothian offers rich farmlands and is an important contributor to the Scottish economy. But for visitors many of the principal attractions of Lothian are the magnificent golf courses. Scotland is, of course, the home of the game, which was first recorded at Musselburgh, just outside Edinburgh. On Leith Links the gentlemen of the Edinburgh Golf Club drew up the first rules of the game and there are plenty of challenging courses to prove it—Muirfield and Dalmaho are just two. In fact there are links courses all the way east down the coastline, while inland to the south and west there are plenty of fine parkland courses.

RIGHT: One of the most famous bridges in the world—the Forth Rail Bridge was designed by Sir William Arrol and opened in 1890 by the Prince of Wales. This spectacular cantilever bridge crosses the River Forth and joins North Queensferry to South Queensferry. The one and a half mile bridge carried 50,000 trains in its first year alone and has never looked back . This remarkable landmark is still in continuous daily use carrying the main line railway north from Edinburgh to Perth, Aberdeen, and Dundee.

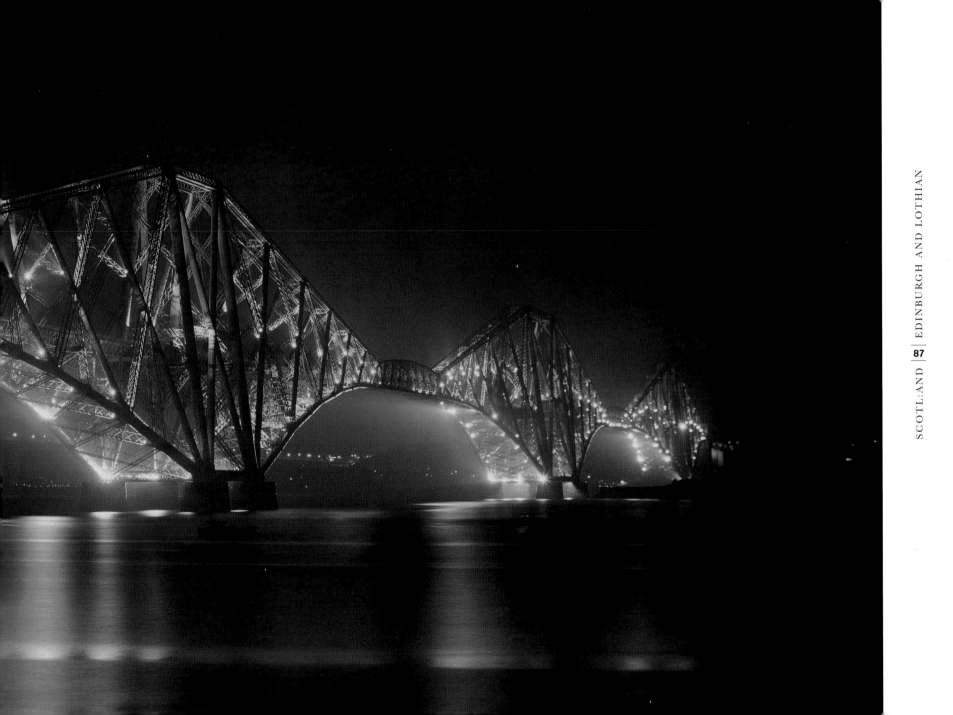

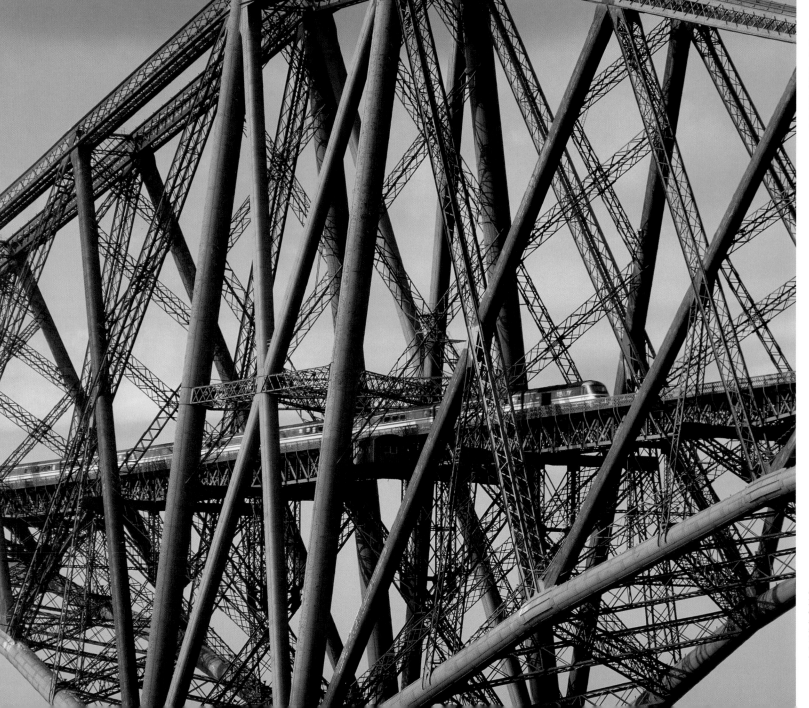

LEFT: Detail of the Forth Rail Bridge showing its tubular construction..

RIGHT: View of the city center from Calton Hill, one of the seven hills of Edinburgh. The acropolis was started in 1822 as a replica of the Parthenon in Athens for the fallen in the Napoleonic Wars. However, as the façade was finished, the money ran out and it has never been completed.

OVERLEAF
LEFT AND RIGHT: Two views of Edinburgh castle which has sat for 1,000 years high above the city on top of "the Rock"— actually an extinct volcano. At seen from Princes Street Gardens. The oldest part of the castle is the tiny St Margaret's Chapel which dates from the 1100s.

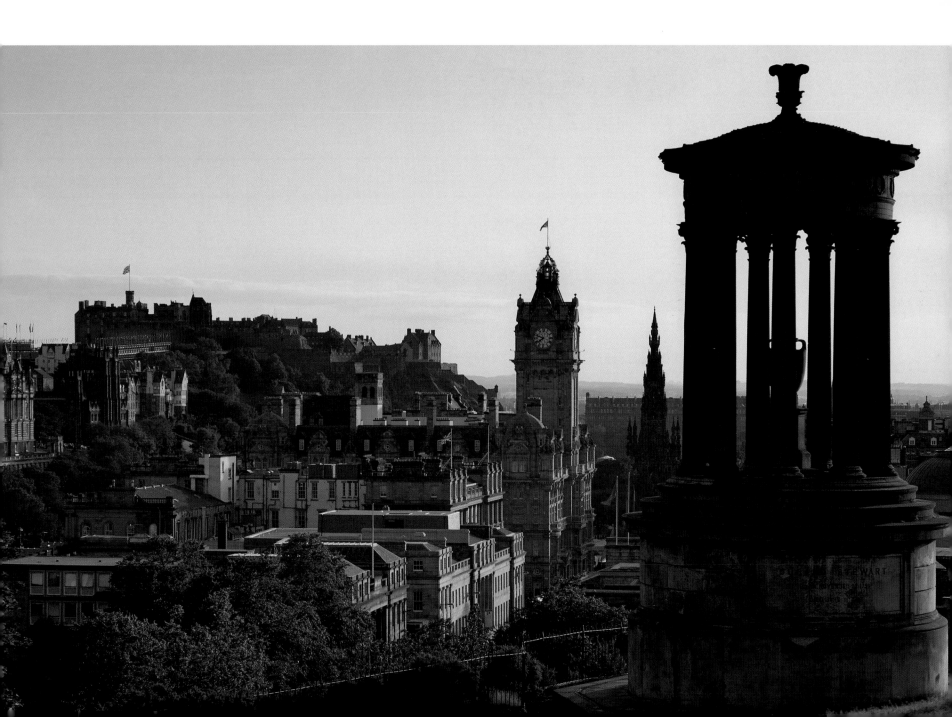

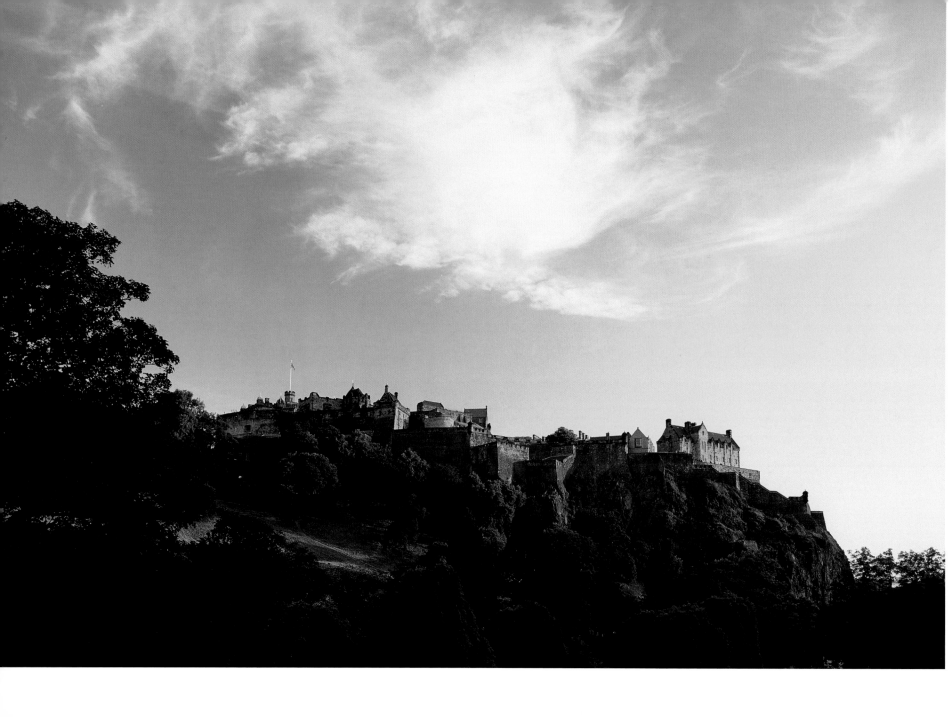

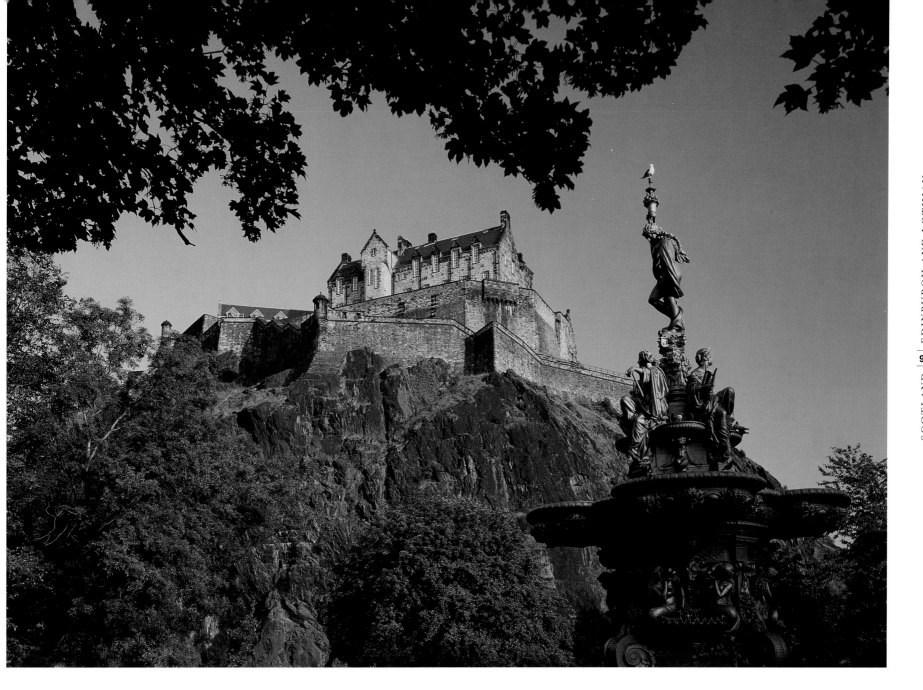

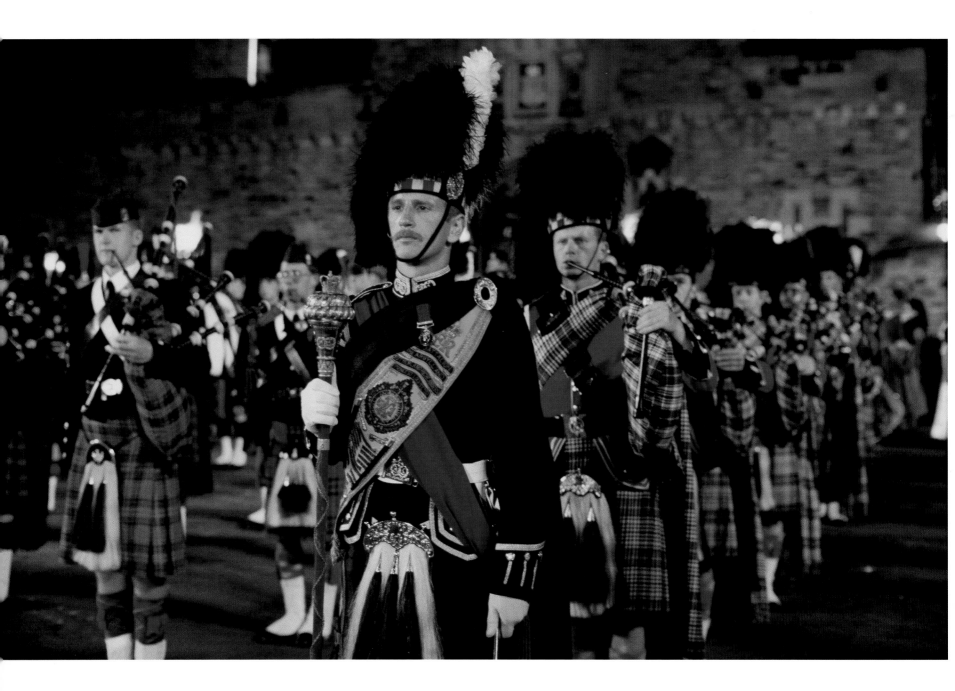

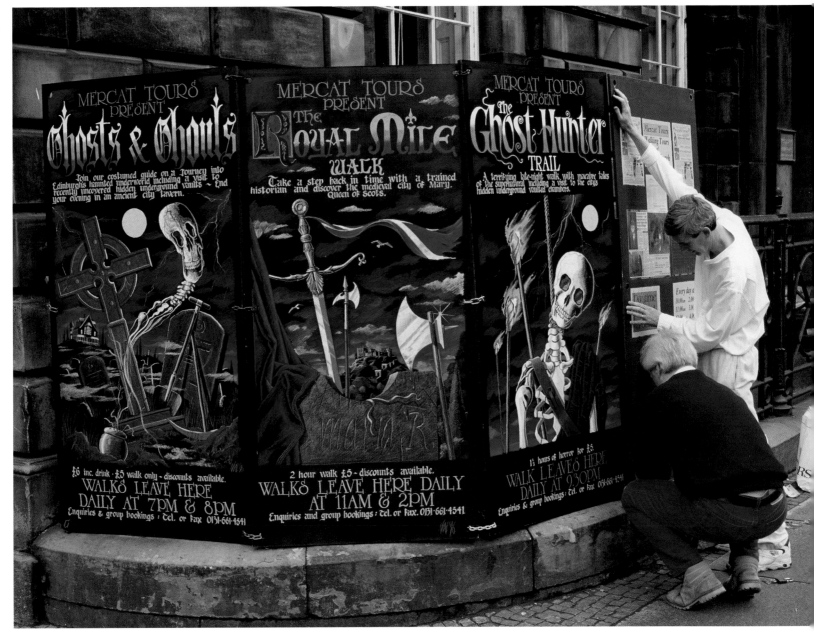

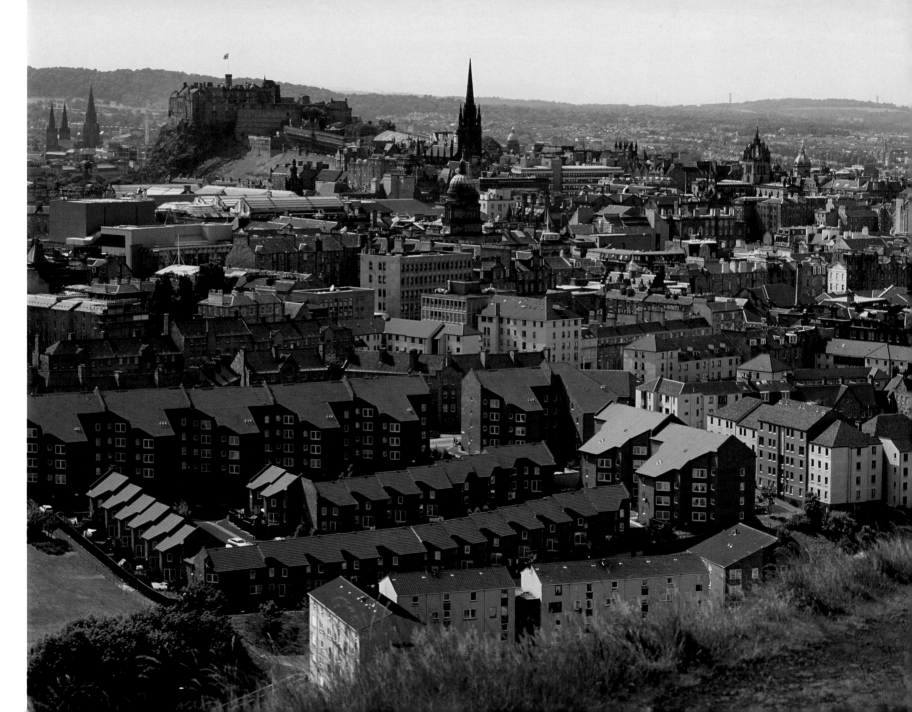

LEFT: A view over Edinburgh from Salisbury
Crags. The Crags sit in the shadow of
Arthur's Seat on the west side of Holyrood
Park and are the remains of glaciated rocks.

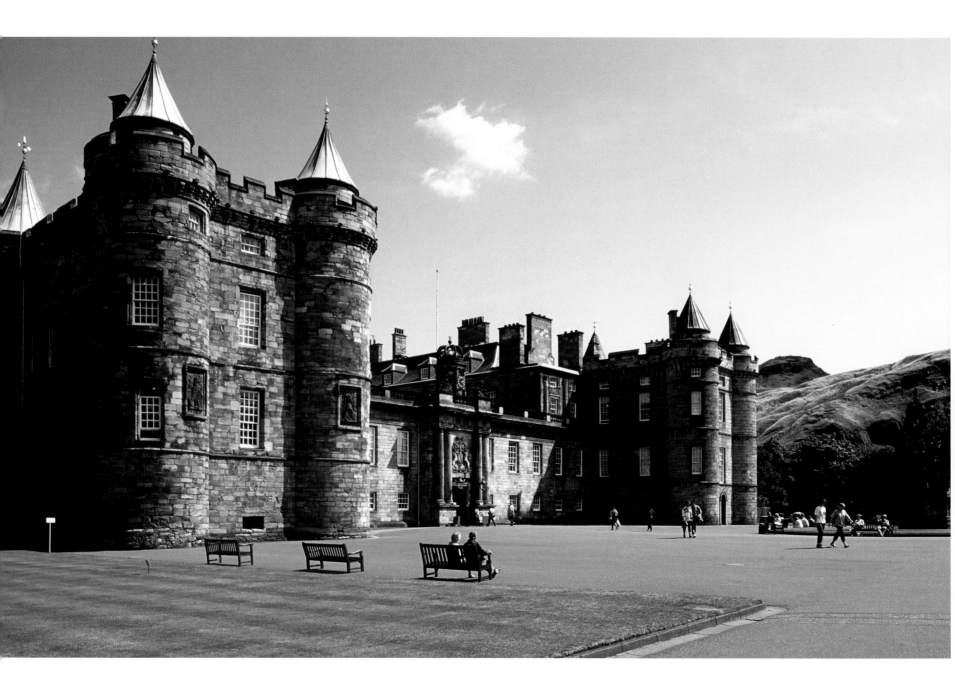

LEFT AND ABOVE: The Palace of Holyroodhouse and detail of some of the elaborate statuary. At the end of Edinburgh's Royal Mile lies the royal Palace of Holyroodhouse, in the shadow of Arthur's Seat. This baroque residence is steeped in Scottish history, especially that of Mary Queen of Scots who lived here between 1561 and 1567. She married two of her husbands in the Abbey and witnessed the murder of her private secretary, David Rizzio, in her Outer Chamber. Holyrood is still regularly used as the official Scottish royal residence.

RIGHT: Linlithgow Palace is now in ruins but remains one of Scotland's four royal palaces. Most of the building dates from the time of James I, the apartments and rooms are all based around a central courtyard in which this fountain sits.

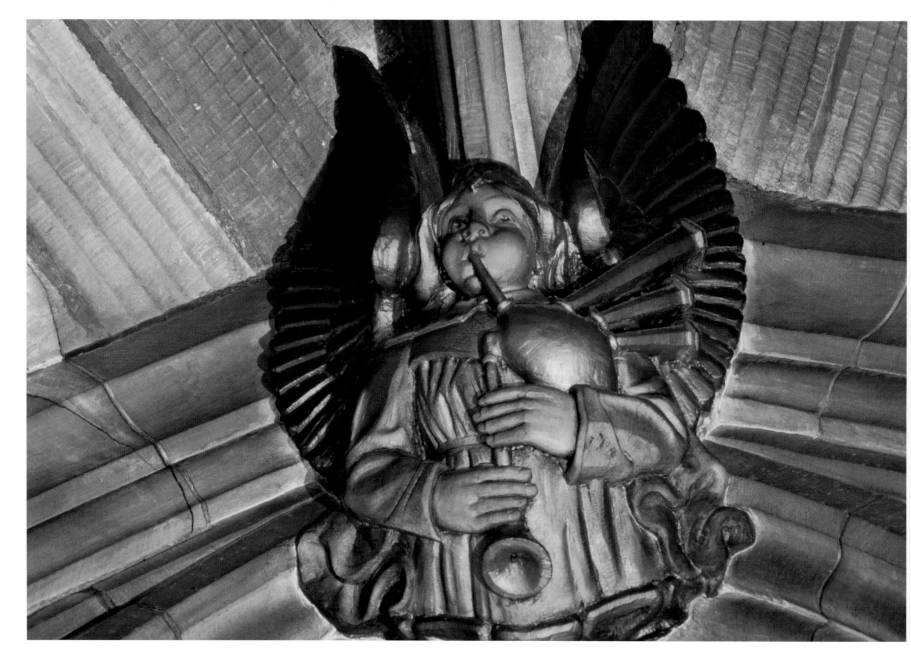

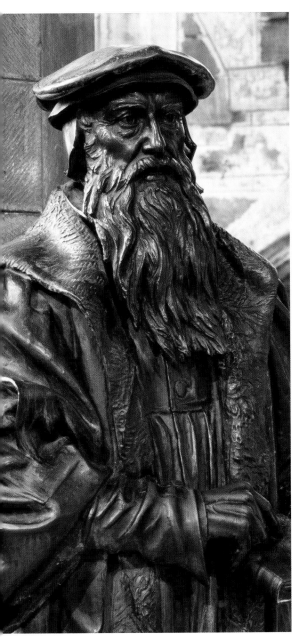

LEFT: The statue of John Knox in St Giles Cathedral, Edinburgh, where he used to preach. Knox (c.1515–72) was ordained as a Catholic priest but soon became enthused by the Reformation. He traveled to Geneva three times to learn from the extremist Reformer John Calvin. Knox attempted to convert Mary Queen of Scots to his way of thinking: to his mind she was one of the "Monstrous Regiment of Women" and not worthy to be his monarch.

FAR LEFT: Halfway down the Royal Mile sits St Giles' Cathedral one of the highlights of which is the Thistle Chapel, built between 1909 and 1911. The chapel is dedicated to the Most Noble Order of the Thistle, the greatest order of Scottish chivalry. Inside this small chapel are many elaborate carvings including this corbel of an angel playing the bagpipes.

RIGHT: Outside St Giles cathedral in Edinburgh High Street. The annual Fringe Festival attracts street performers and entertainers making the streets alive with music and comedy.

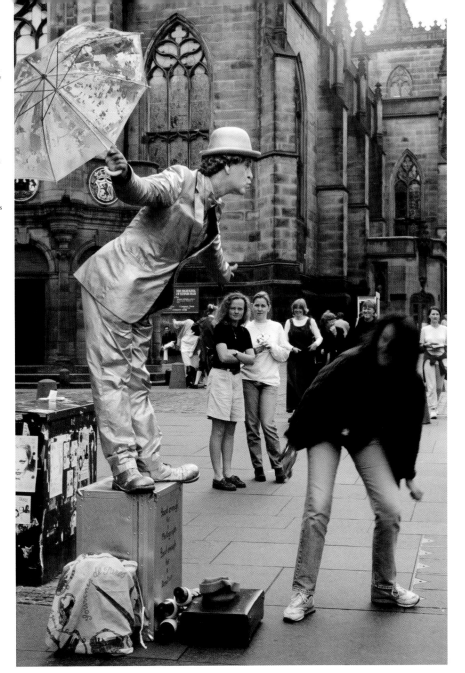

ABOVE AND RIGHT: Gravestone details. Waterloo Place cemetery was built on the Old Carlton burial ground. As well as the graves it contains a statue created in memorial to Abraham Lincoln and unveiled on August 21, 1893. The cemetery also contains memorials to Scotsmen who died during the American Civil War.

FAR RIGHT: Busking musicians in front of the Royal Scottish Academy, Edinburgh during the annual Festival.

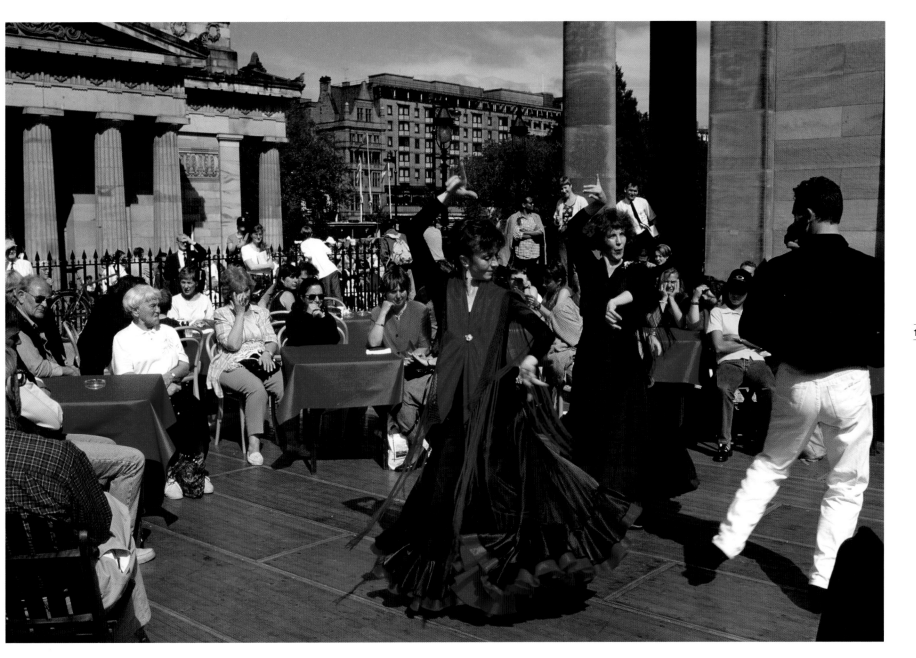

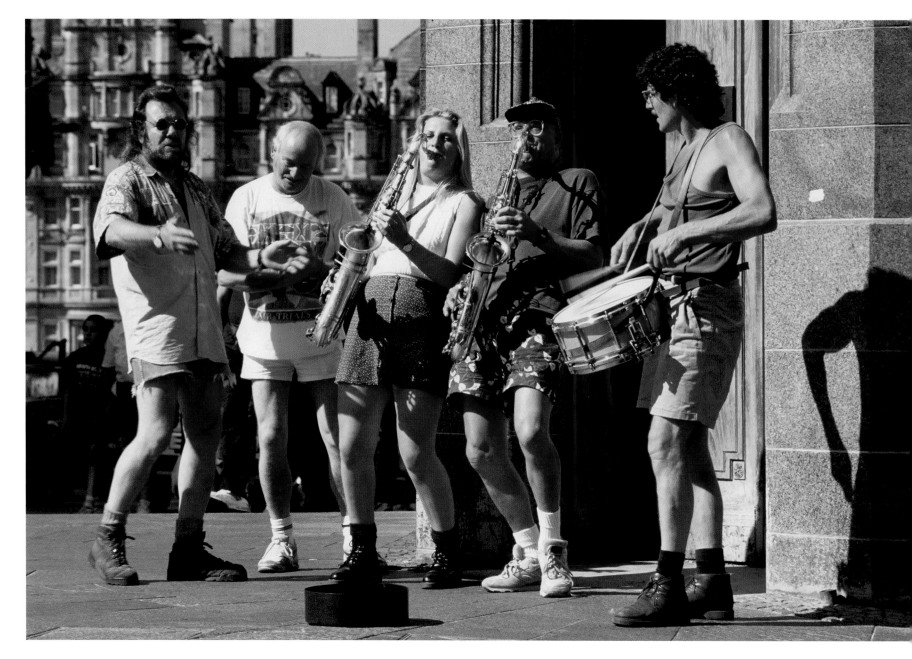

LEFT: The story of the Prentice Pillar in Rosslyn Chapel is that it was carved by an apprentice mason while his master was inspecting carved pillars in Italy. On his return the mason was so jealous of the pillar's beauty that he struck the apprentice dead.

FAR LEFT: Musicians on the corner of High Street and North Bridge.

ABOVE: Rosslyn Chapel detail. Since its construction began in 1446 Rosslyn Chapel has evoked wonder and surprise with the beauty and intricacy of its stonework. During their attack on nearby Rosslyn Castle in 1650, Cromwell's troops used the chapel as stables, but left it otherwise unharmed. And in 1688 locals damaged the "popish" chapel following the accession of William and Mary but it is otherwise practically undamaged.

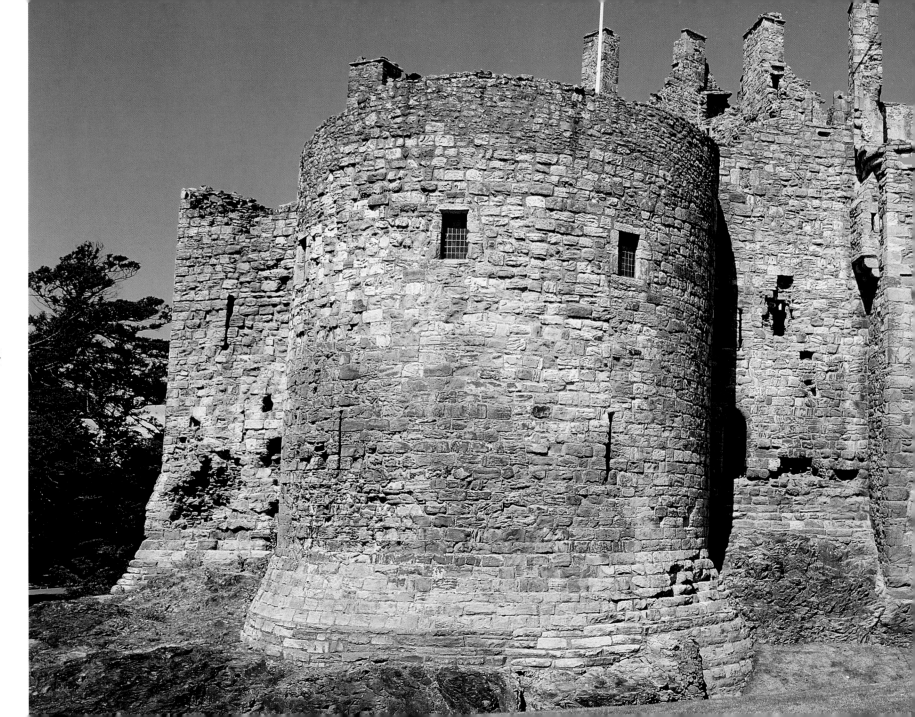

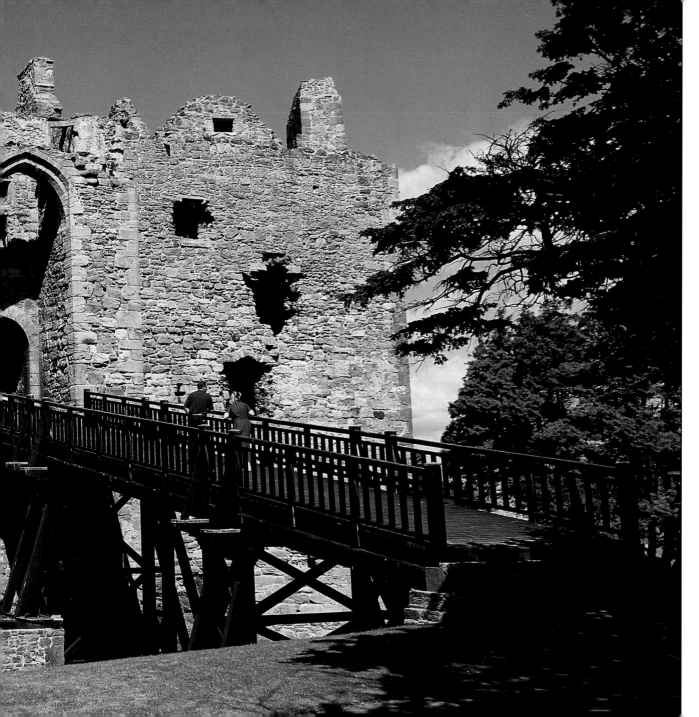

LEFT: The earliest parts of Dirleton Castle date from the 13th century, although the earliset castle was made from stone and timber in the 12th century. Dirleton Castle's defences were continually tested from the first siege in 1298 when the Bishop of Durham eventually forced a surrender. The castle changed hands many times, until it was partially demolished in 1314 on the orders of Robert Bruce. Serious rebuilding was undertaken in the fourteenth and fifteenth centuries. The three-story portions were mostly built during the Renaissance.

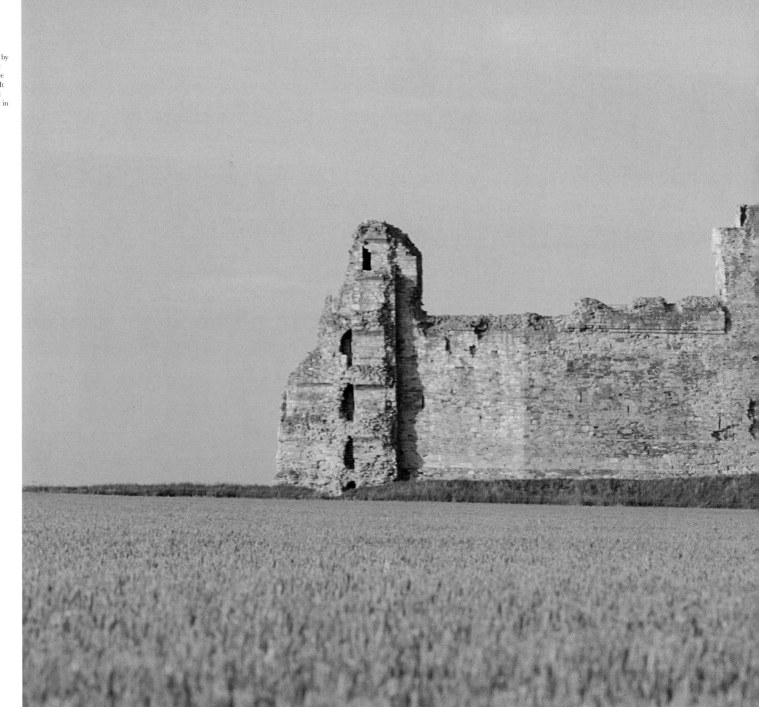

RIGHT: Tantallon Castle was probably turned into a coastal fortress around 1350 by William, first Earl of Douglas. Formidably sited, Tantallon sits on a promontory above the sheer rock cliffs of the Firth of Forth. It was beseiged by both James IV (1491) and James V (1526) though neither took it, but in 1651 General Monck forced its surrender after a 12-day bombardment.

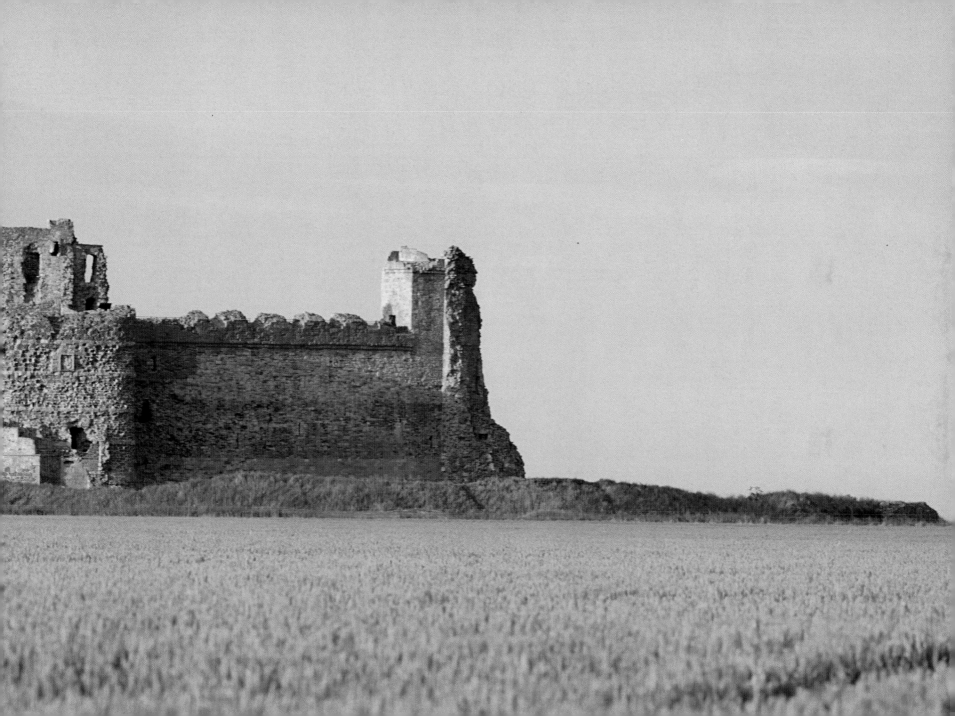

Central Scotland, Fife, and Tayside

The ancient Kingdom of Fife is Scotland's smallest region yet it contains a number of Scotland's greatest buildings and treasures. One of these is Dumfermline, the one-time capital of Scotland. King Robert I—the Bruce—is buried here in the parish church. It was a Benedictine Abbey in his time. His skeleton was discovered in 1818. His heart had been removed on his instructions and was on its way to the Holy Land when its carrier, Lord Douglas, fell in battle. The heart was retrieved and taken to Melrose in Roxburghshire where it was said to be buried.

One of the highlights of Fife is the Palace of Falkland in the small royal burgh of Falkland. This is where the Stuart kings came for one of their favorite pasttimes—hunting. The palace is now looked after by the National Trust for Scotland; however, it is visited as much for its fabulous garden as for the palace itself.

St Andrews in Fife claims to be the world home of golf in the form of the Royal and Ancient Golf Club; the town is also the site of the oldest Scottish university, St Andrews, which was founded in 1412.

Tayside on the east coast of Scotland is bigger, some 3,000 square miles in total, and contains Perth, Kinross, Dundee, and Angus. With a long coastline it has a considerable maritime heritage. Ships from the region have traded with the Baltic for over five centuries. Dundee on the Firth of Tay provided an excellent anchorage away from the vigor of the North Sea and became an important trading port. Even the Romans used Dundee as a safe harbor and trading post. Furthermore, Kenneth MacAlpine, the first King of the Scots was based in Dundee.

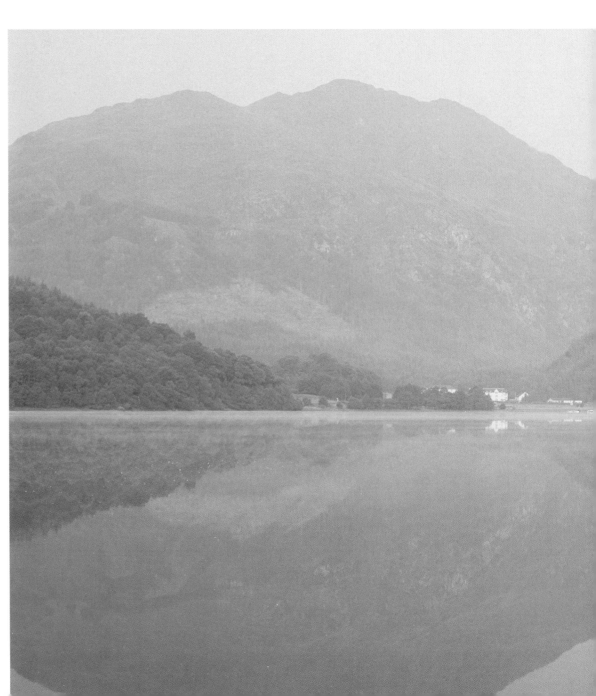

RIGHT: The Trossachs and Loch Achray, Perthshire. This beautiful spot has been immortalized by the Romantic poets—Dorothy Wordsworth and, of course, Sir Walter Scott in *The Lady of the Lake*. The poem is about King James V hunting a stag. The chase passes Loch Venachar and Loch Achray and enters the Trossachs Glen. It put the area on the cultural map and it has proved of lasting interest to tourists ever since.

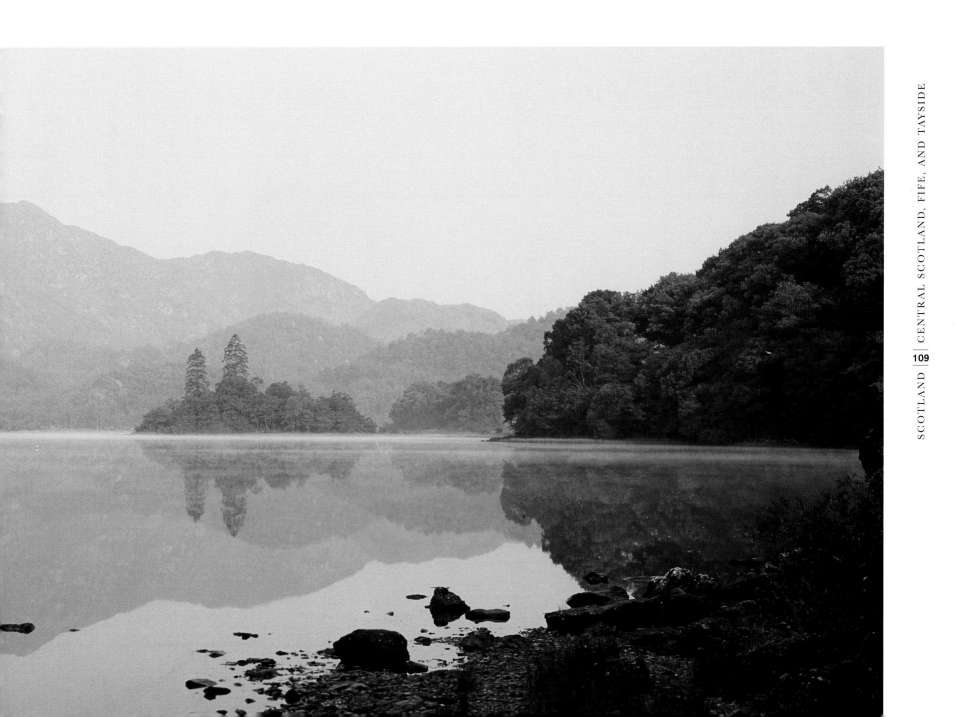

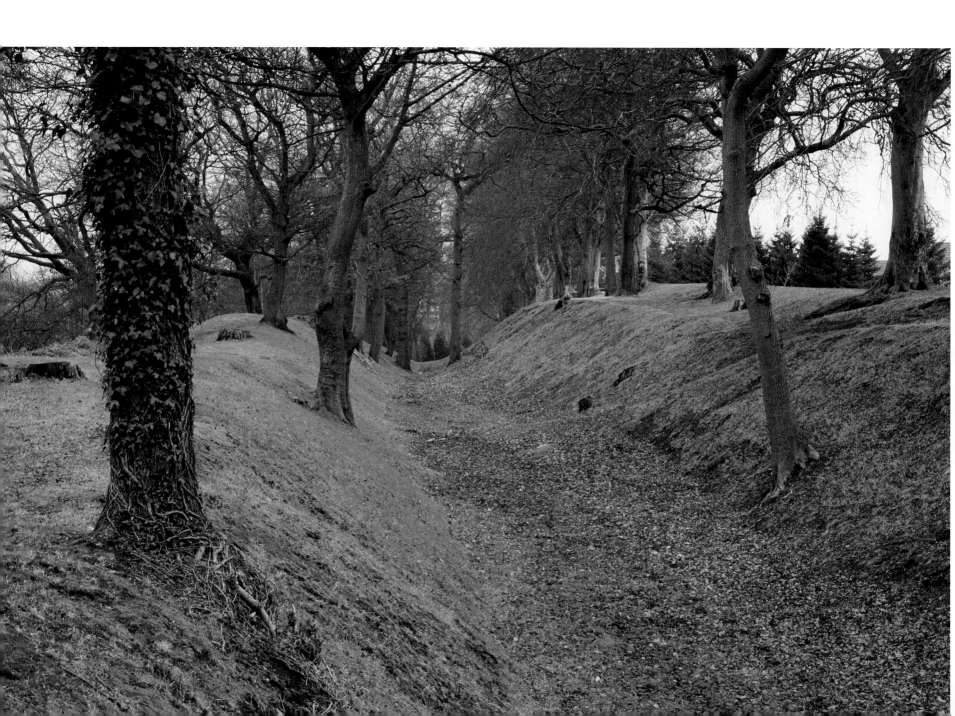

Left: The Antonine Wall and ditch at Watling Lodge, near Falkirk, where there was a fort and a gateway, protected by a guardhouse.

Right: Rough Castle, a Roman Fort on the Antonine Wall, is remarkable for the survival of its "lilia"—defensive pits that were filled with sharpened spikes. The Antonine Wall was the northernmost extent of Roman territory in Britain, built on the orders of Emperor Antonius Pius (86–161 AD) who succeeded Hadrian. It is 37 miles long, spans Scotland between the Firth of Forth and the Firth of Clyde and was built around 140 AD. It wasn't particularly effective: the northern tribes pushed the Romans back to Hadrian's Wall only 40 years later.

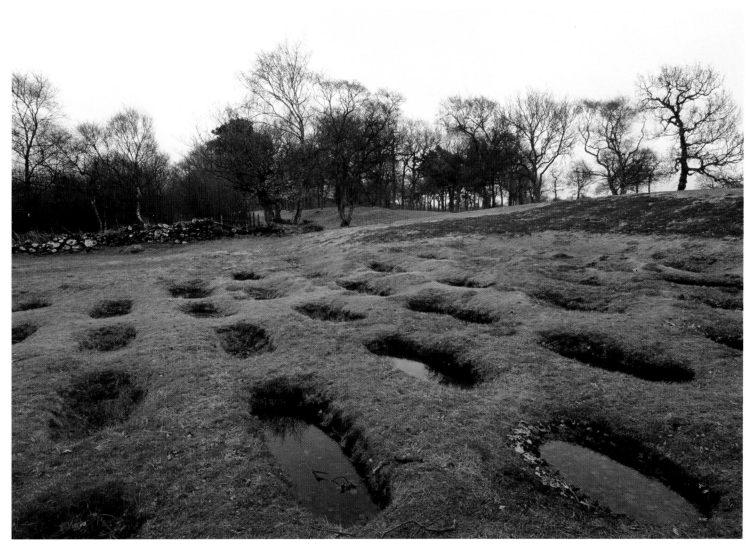

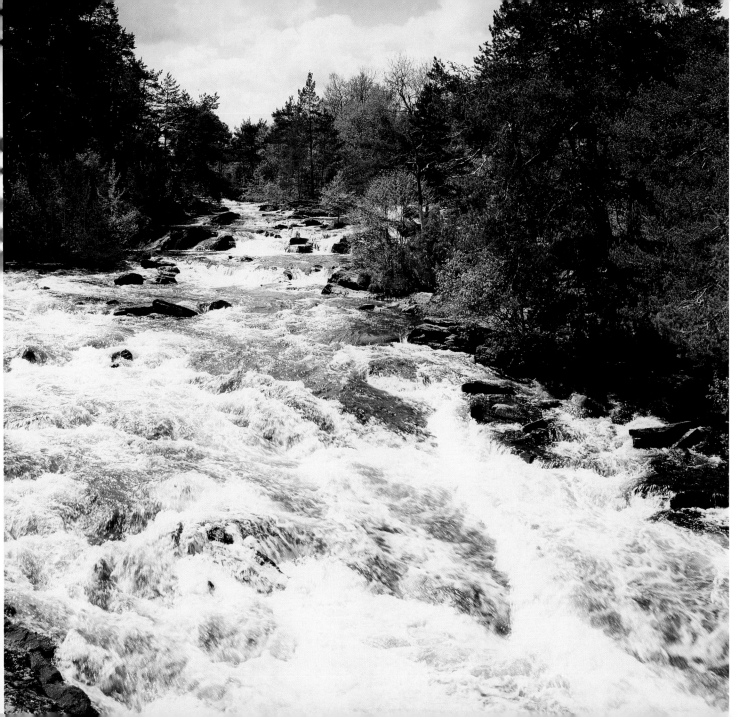

LEFT AND FAR LEFT: The River Dochart at Killin and the Falls of Dochart near Loch Tay. With Ben More towering above, the river flows past Crianlarich toward Loch Tay, entering the loch at one of the area's beauty spots: the Falls of Dochart. Near the Falls stand the eight healing stones of eighth century St Fillan. Each stone represents a part of the body which it is supposed to heal. Ben More is the highest mountain south of Strath Tay and one of the most imposing in the southern highlands, standing 3,851ft tall.

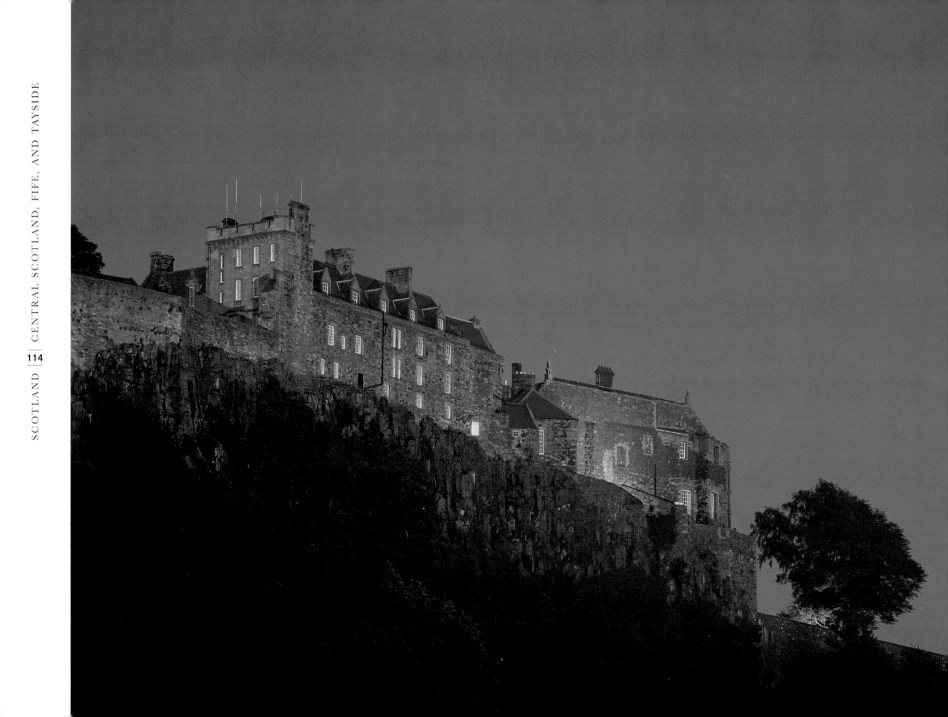

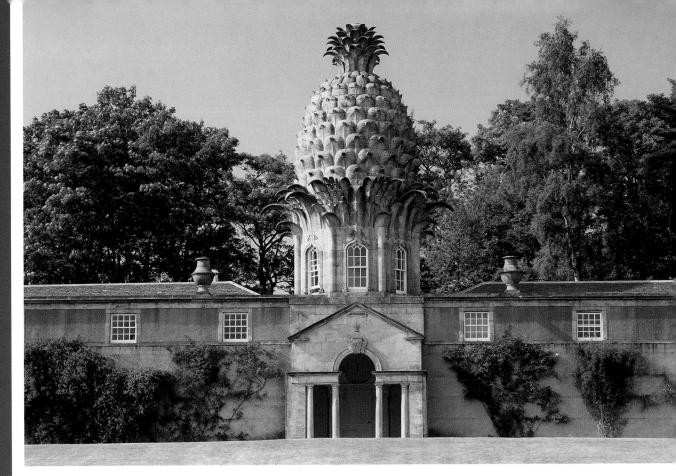

LEFT: Stirling Castle is one of the most imposing sights in Scotland, commanding the route to the Highlands, and stands as proudly now as when it was the main bulwark against English attacks in the thirteenth and fourteenth centuries. Seized by Edward I in 1296, "Braveheart" William Wallace took it in 1297 only to lose it again in 1298. The Scots held it again in 1299 until Edward I took it after a tough three-month siege in 1304. It remained in English hands until Bannockburn. By the fifteenth century it had been rebuilt as one of the finest Renaissance buildings in Britain.

ABOVE: The Pineapple is a folly found in Dunmore Park. It was built four John Murray, the fourth Earl of Dunmore, in 1761. It is 53ft high and carved from stone. Why? There are many stories: that it was a belated wedding present based on a building seen while on honeymoon in Italy; the result of a wager; or possibly the commemoration of growing the first pineapple in the area. Whatever the reason it is a wonderful building.

RIGHT: The steamboat *Sir Walter Scott* seen on Loch Katrine. Both go together, for Scott's masterpiece *The Lady of the Lake* includes these lines:

> "... *gleaming with the setting sun,*
> *One burnish'd sheet of living gold,*
> *Loch Katrine lay beneath him roll'd,*
> *In all her length far winding lay,*
> *With promontory, creek, and bay,*
> *And islands that, empurpled bright,*
> *Floated amid a livelier light,*
> *And mountains, that like giants stand,*
> *To sentinel enchanted land."*

Built in 1901 by William Denny & Bros Ltd, Dumbarton, SS *Sir Walter Scott* is the only surviving screw steamer in regular passenger service in Scotland. She was transported by barge up Loch Lomond and overland by horse-drawn cart to Stronachlachar pier on the loch where she was rebuilt and launched.

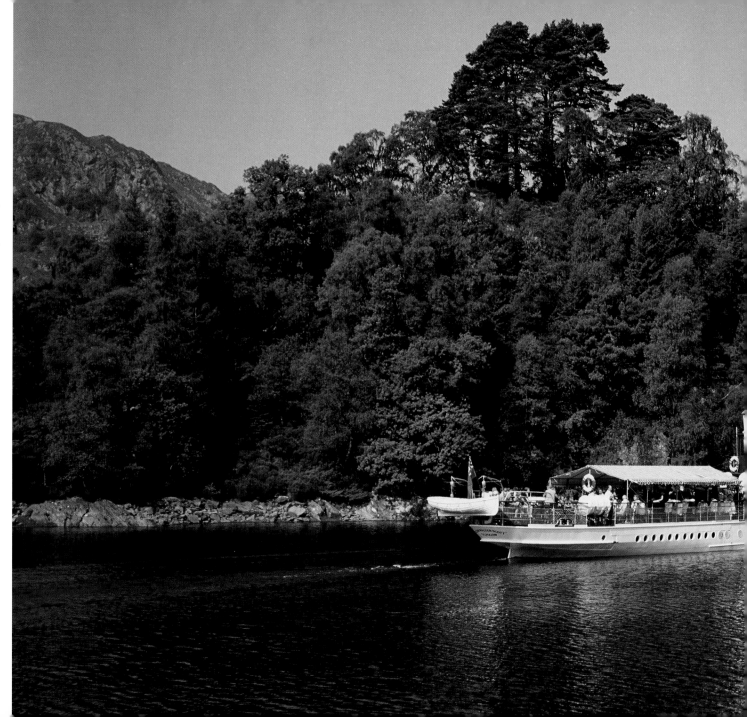

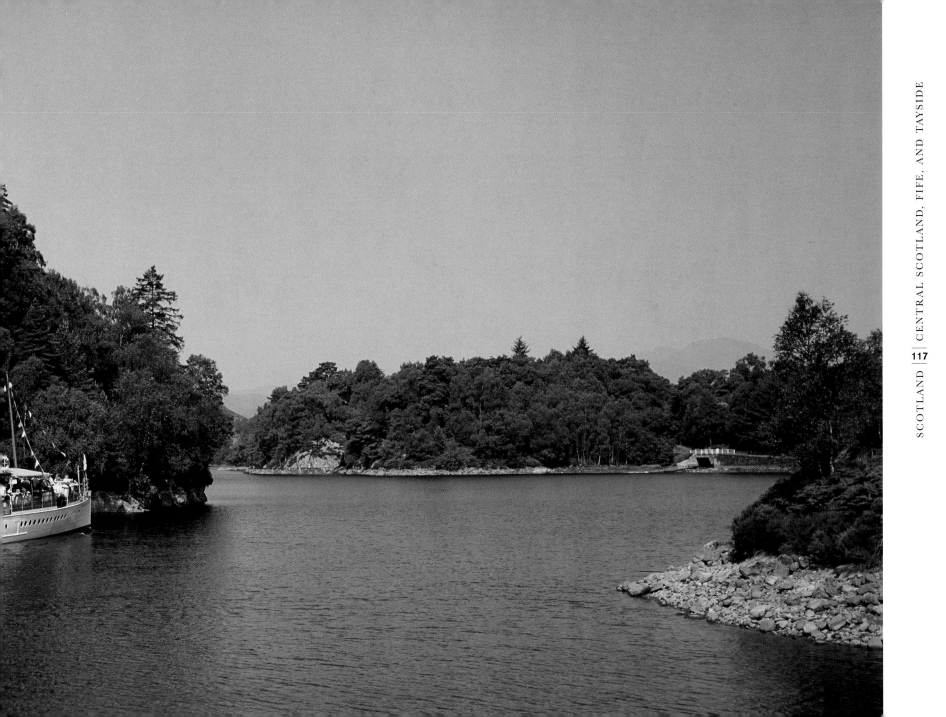

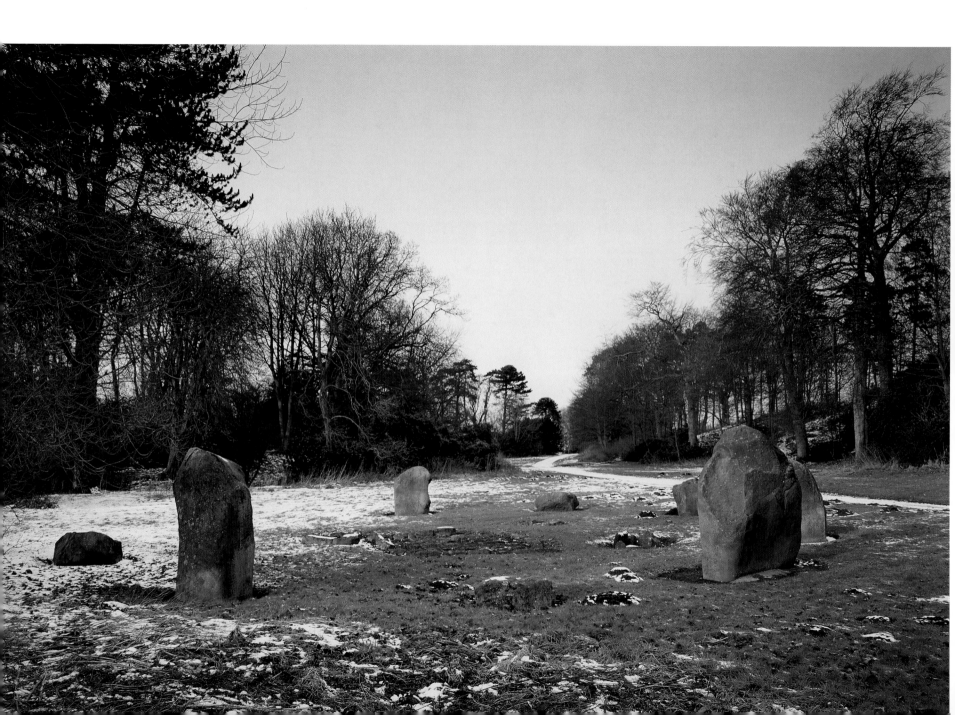

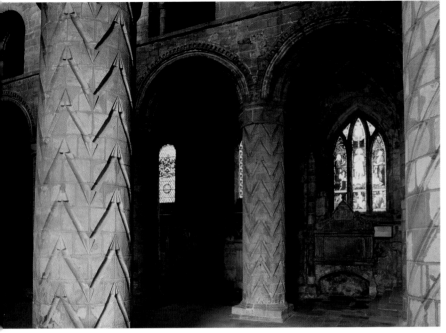

LEFT: The stone circle at Balbirnie is nearly 5,000 years old. It isn't in its original position: it was re-erected some 350ft away when the nearby A92 was widened. It would have had 10 stones in an elliptical shape with a slab-lined rectangle in the middle and four cists. Five of the stones still stand, three are stumps and two are missing.

ABOVE: The Benedictine Dunfermline Abbey was founded by an Anglo-Saxon princess, who fled north after defeat by the Normans at Hastings. She married King Malcolm III and became Queen Margaret, and she was instrumental in reforming the Celtic Church. The royal connection was continued and one of the greatest of all Scottish kings, Robert I (Robert Bruce), was buried here. These are piers at the eastern end of the nave.

RIGHT: The "Mercat" (market) cross at Culross. As the picture shows, while it is called a cross it is actually a stone shaft crowned with a unicorn. These "crosses" are well distributed through the older parts of Scotland (around 126 are extant) many of them carrying heraldic beasts, armorial bearings or sundials.

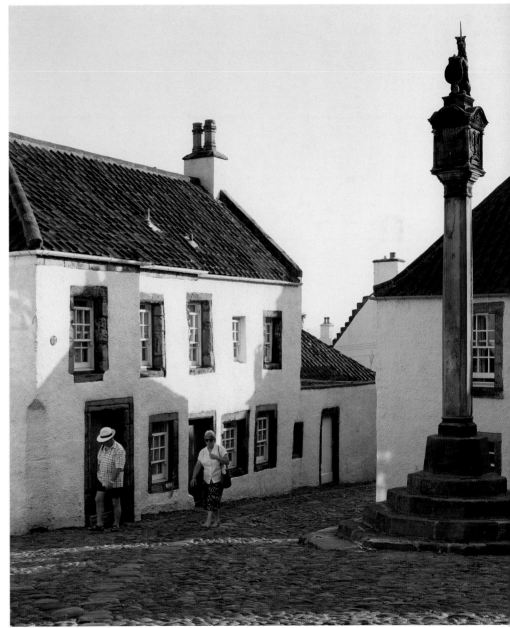

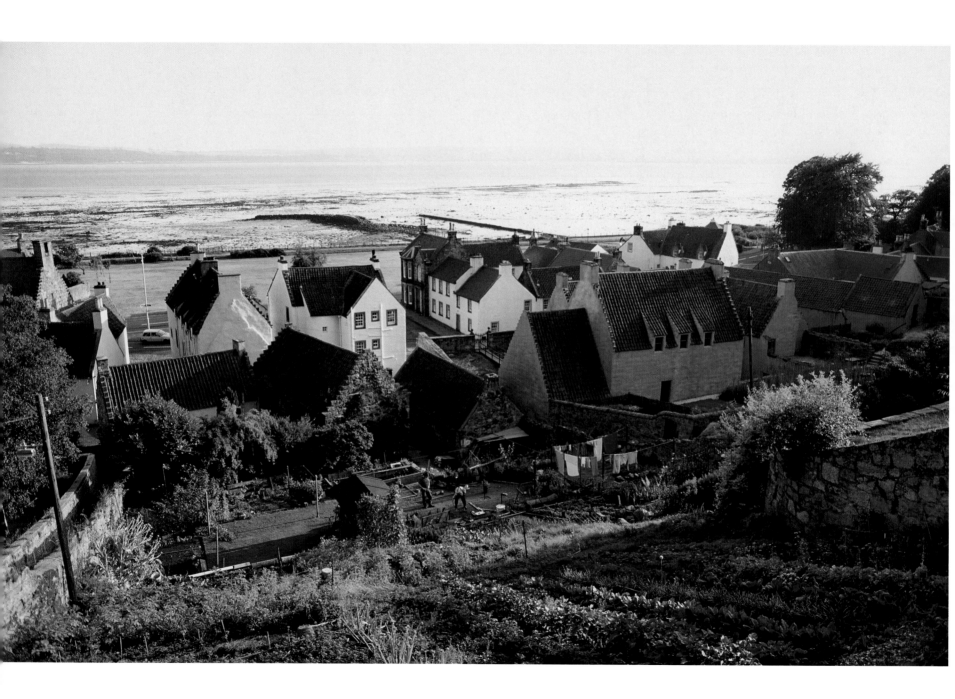

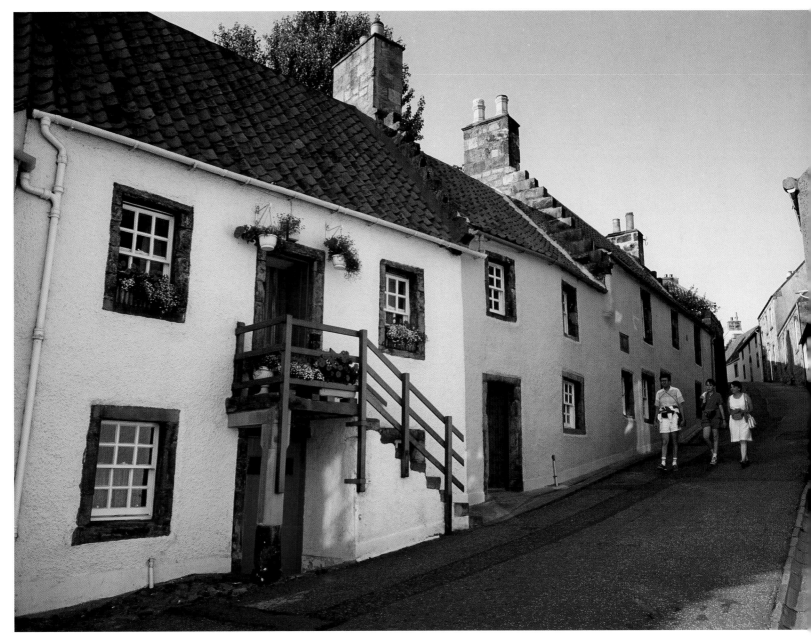

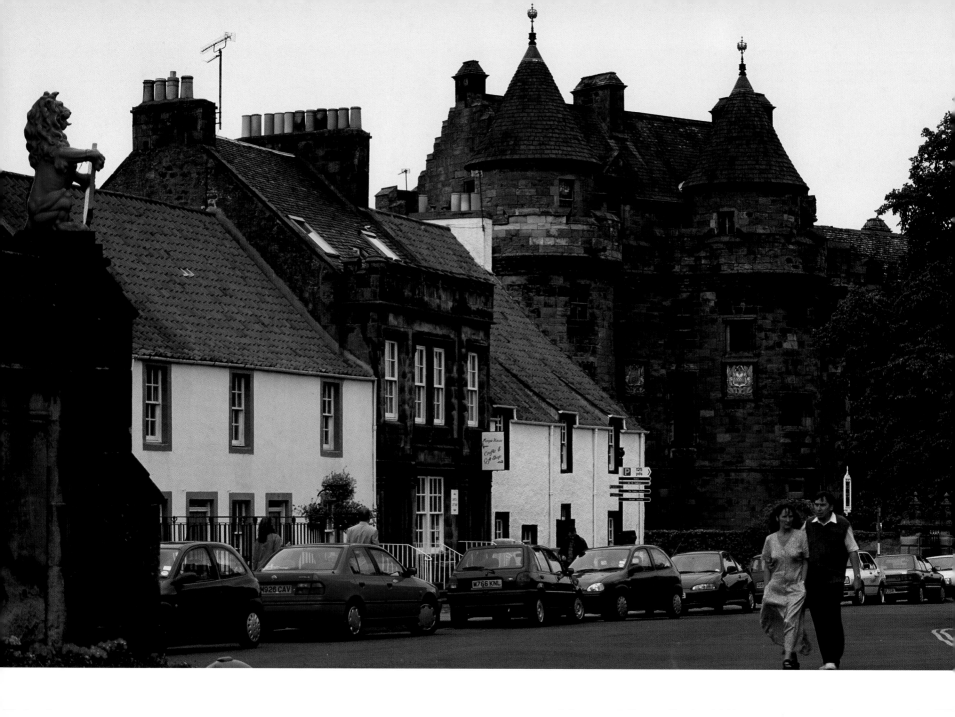

RIGHT AND FAR RIGHT: Falkland Palace, started by James III and enlarged by James IV and V, dominates Falkland High Street. James V is said to have died of melancholy there, in spite of the sentiments expressed in the plaque beside the palace. His daughter—Mary, Queen of Scots—would have a wild reign that would end under the executioner's axe.

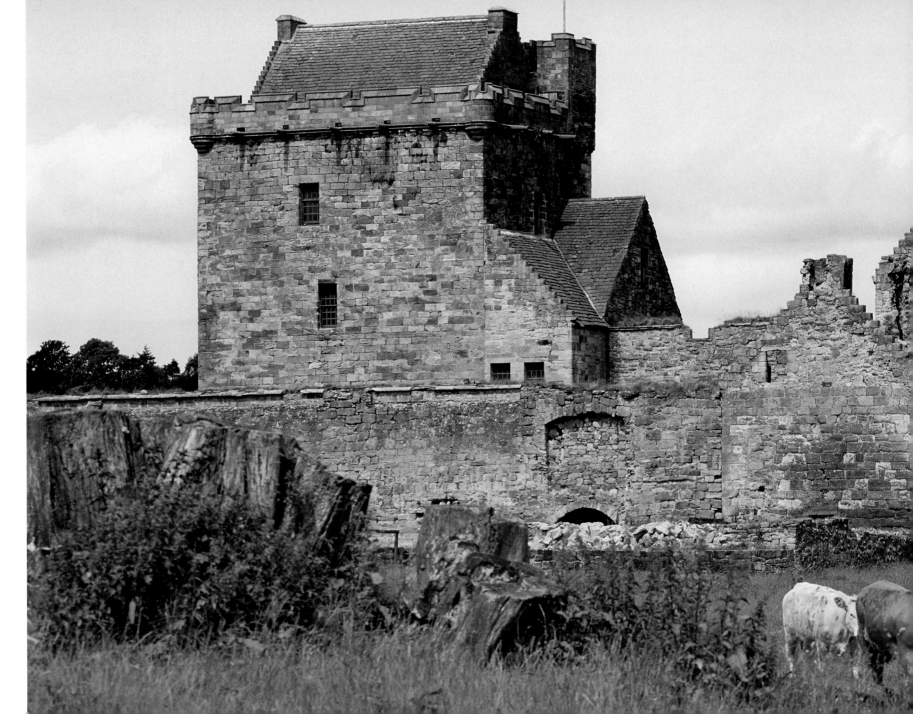

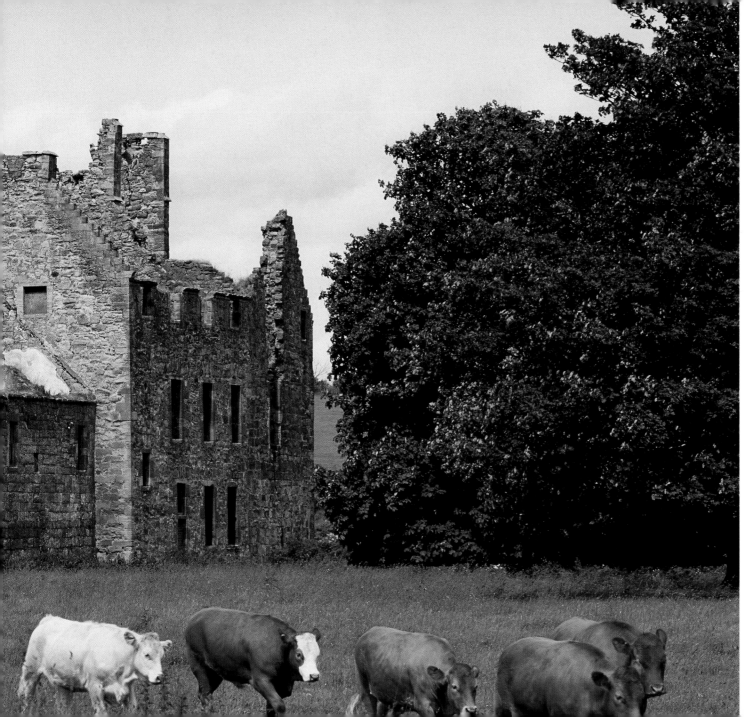

LEFT: Recent renovation has seen Balgonie Castle take on a much less delapidated air. Standing on the banks of Loch Leven, it is a sizable castle with a four-story great tower.

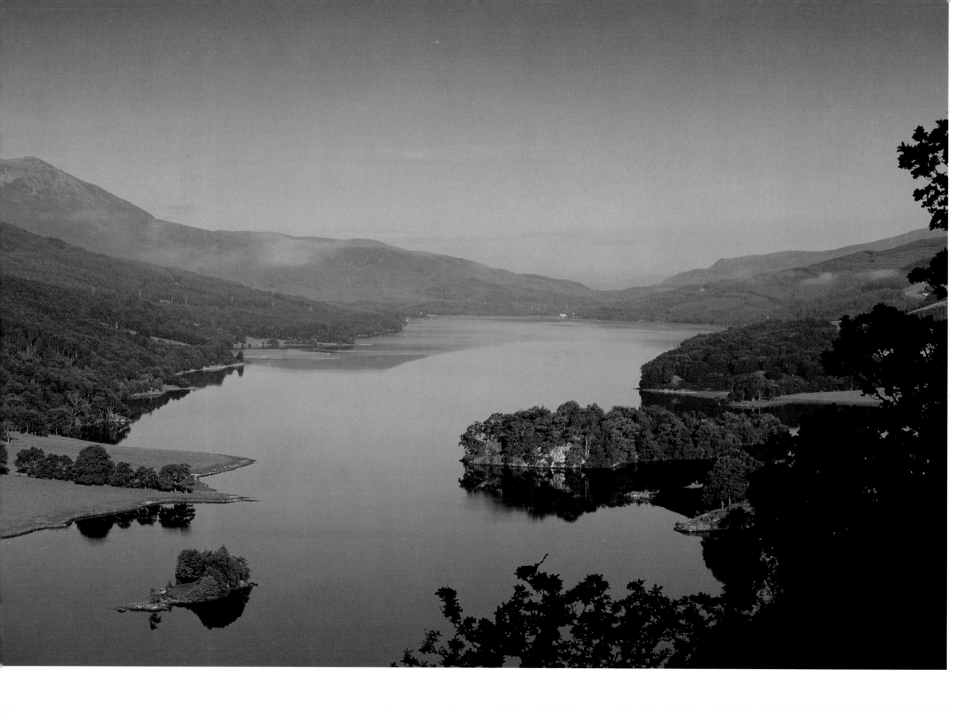

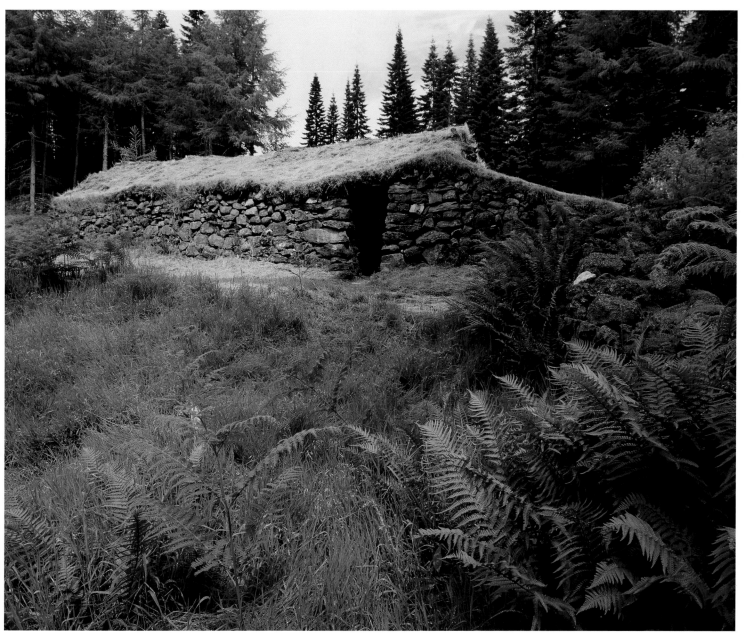

LEFT: A ruined "clachan"—a farm settlement dating from around 1750—above the east end of Loch Tummel. In the hills behind the Queen's View, many of the forest walks are punctuated by clearings such as this. The main building has been reconstructed and the rest of the area has been excavated to expose the remaining buildings.

FAR LEFT: The Queen's View of Loch Tummel, Tayside. Which queen? There is a debate on this: many point to Queen Victoria's visit on October 3, 1866, well recorded in her journal. Others, however, suggest the view had been admired by Mary Queen of Scots.

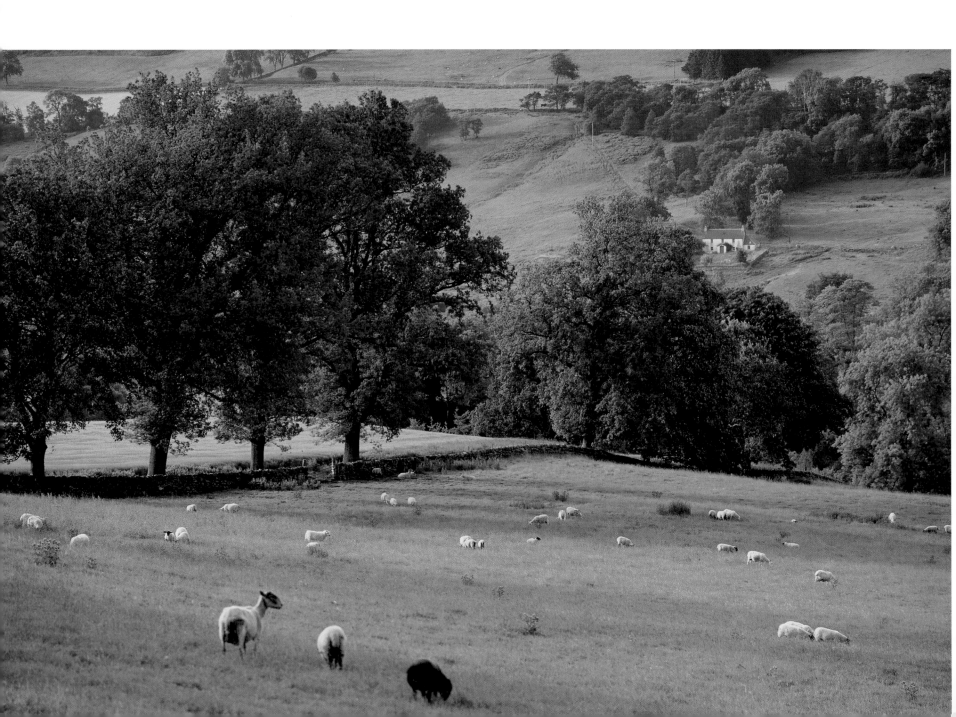

LEFT: Farmland north of Blairgowrie, Perthshire. A notable fruit-producing area—half of Scotland's raspberries are produced around here— Blairgowrie sits opposite Rattray on the River Ericht where it emerges from spectacular gorges in Strathmore.

RIGHT: Loch Leven Castle is one of the oldest tower houses in Scotland, having been started in the fourteenth century. Mary, Queen of Scots, was imprisoned here between June 1567 and May 1568. While there, on July 24, 1567, she was forced to abdicate in favor of her infant son James VI. She escaped—but it was a case of "out of the frying pan into the fire" for her supporters were decisively defeated in battle and she ended up in England under the "protection" of Elizabeth I. She was beheaded at Fotheringay in 1587. Yet, she had the last laugh: her son became James I of England on Elizabeth's death in 1603.

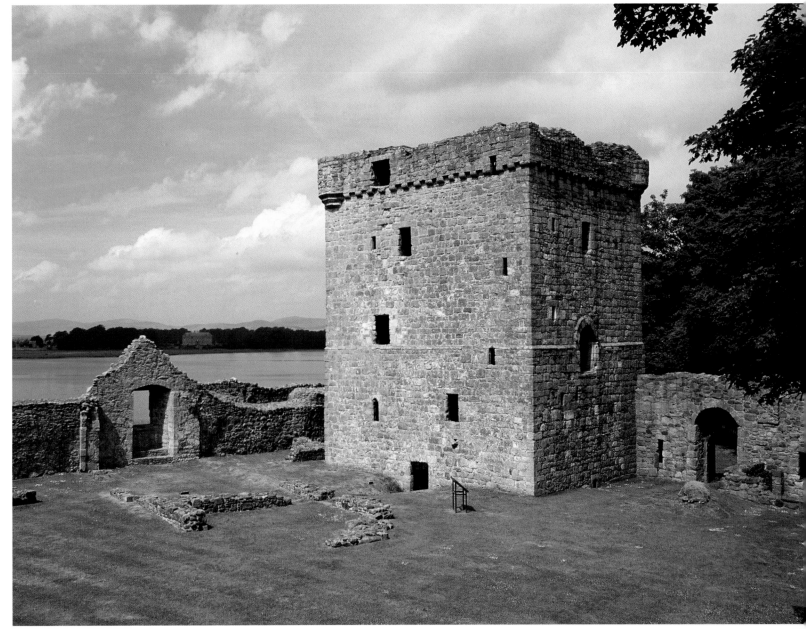

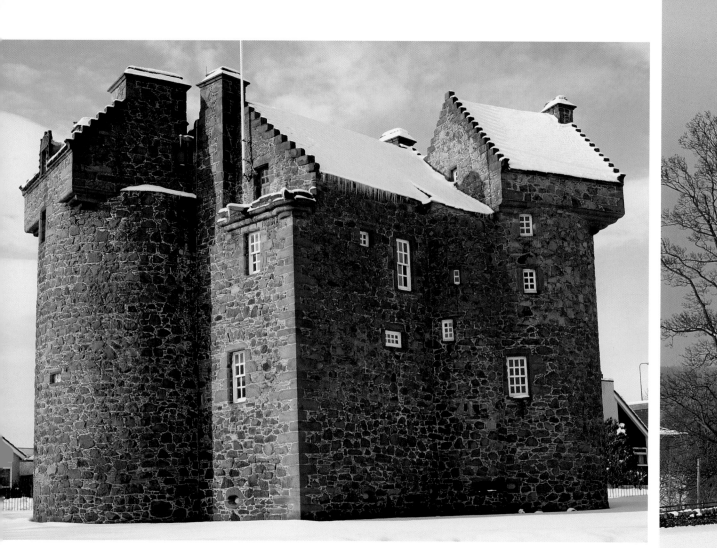

ABOVE: Claypotts Castle is a Z-plan castle, with circular towers at diagonally opposite corners, corbelled out to form overhanging cap houses. Claypotts was built in the late sixteenth century for the Strachan family. It passed into the hands of a family who supported James II—the Grahams of Claverhouse—and consequently it was given to one of William III's supporters after the Glorious Revolution.

RIGHT: Huntingtower Castle, Tayside, dates from the fifteenth century—with two complete towers, one from the fifteenth–sixteenth century, the other from the sixteenth century and joined by a spiral staircase to the Great Hall. Between the two towers, the range is seventeenth century. The castle has fine painted ceilings. Once owned by the Ruthven family, it is famous for having been the location to which King James VI was abducted by William Ruthven, Earl of Gowrie and the Earl of Mar in 1582. They did so in order to ensure that James's catholic advisor, Lennox, lost his influence. Gowrie led a new government which gave the Presbyterians ruling powers, all the while keeping James captive. Lennox died in 1583 and in June that year James escaped. William Ruthven was charged with treason and had his head cut off. Huntingtower is also notorious for the famous leap between two towers by a daughter of the house who was nearly caught in her lover's room.

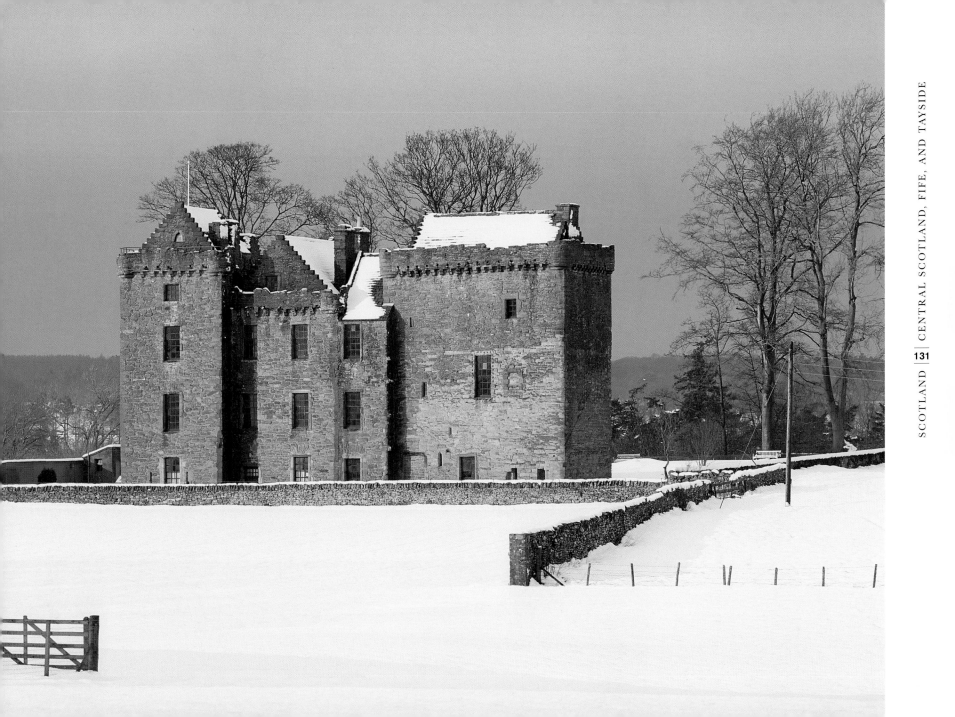

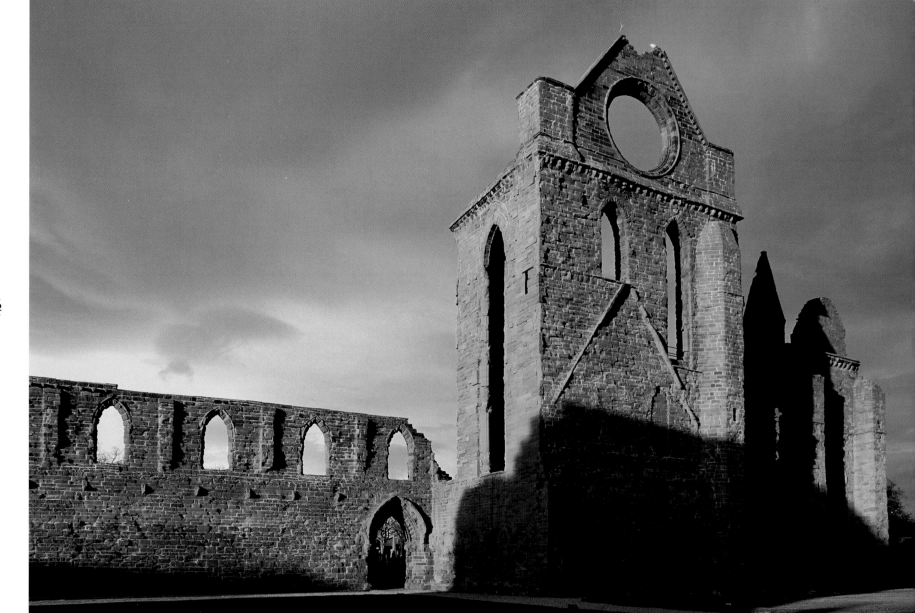

LEFT: Arbroath bears one of the proudest names in Scottish history for it was there on April 6, 1320, that the Declaration of Arbroath was prepared. After the ravages of Edward I, Scotland inflicted a massive defeat on the English King Edward II at Bannockburn in 1314 and went on to recapture Berwick. The Declaration of Arbroath was a declaration of Scottish independence, made to Pope John and drawn up in Arbroath Abbey probably by the Abbot, Bernard de Linton, who was also the Chancellor of Scotland. It bears the seals of eight earls and forty-five barons. It was conveyed to Rome and the Pope accepted the Scottish case. Its importance continued down the years: nearly 500 years later it was used as the basis for the American Declaration of Independence.

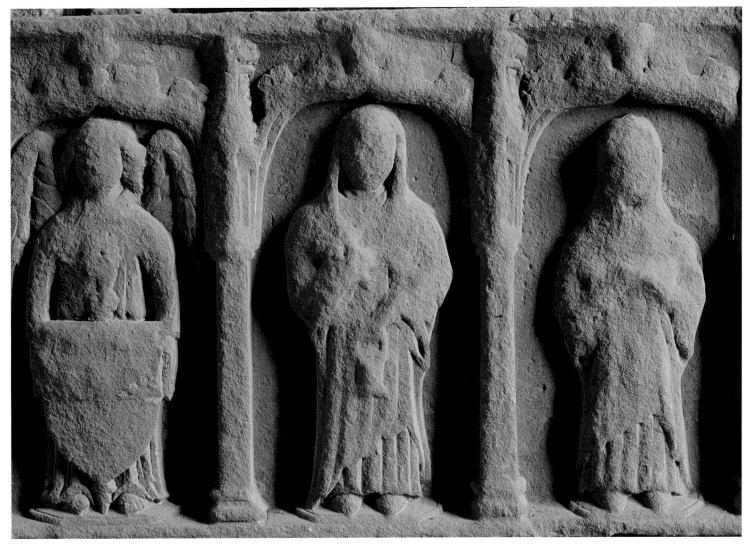

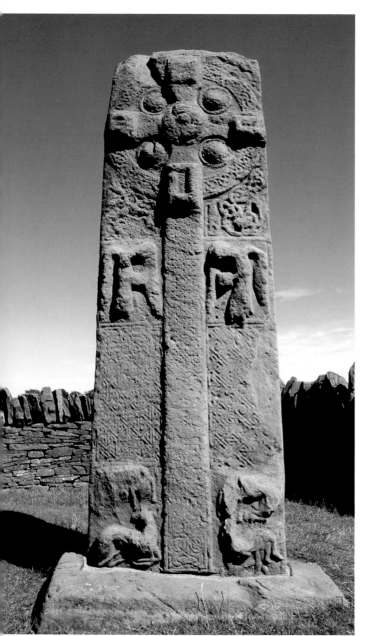

LEFT: Pictish cross slab beside the road in the village of Aberlemno on Tayside. This side shows a Celtic cross, halfway down both sides are two mourning angels carrying books, and at the base are four creatures—possibly the four Gospel writers. On the reverse side are a number of symbols, Biblical characters, and a hunting scene.

RIGHT: Pitlochry sits almost centrally in Scotland in the wooded valley of the Tummel, which flows into the River Tay south of Ballinluig. A Victorian town, Pitlochry is best known for its Festival Theater, founded by John Stewart in 1951.

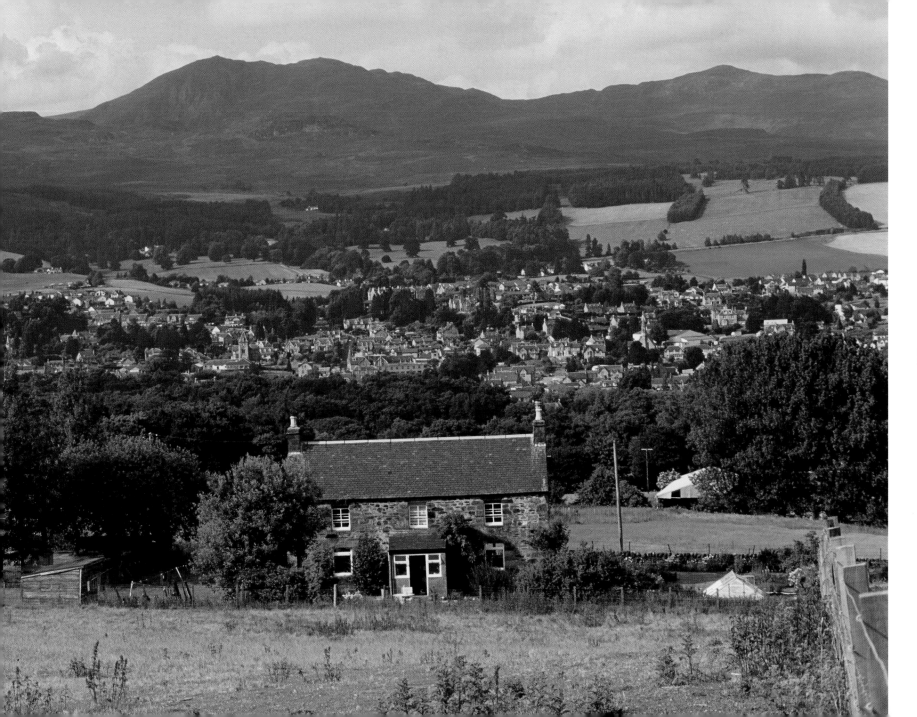

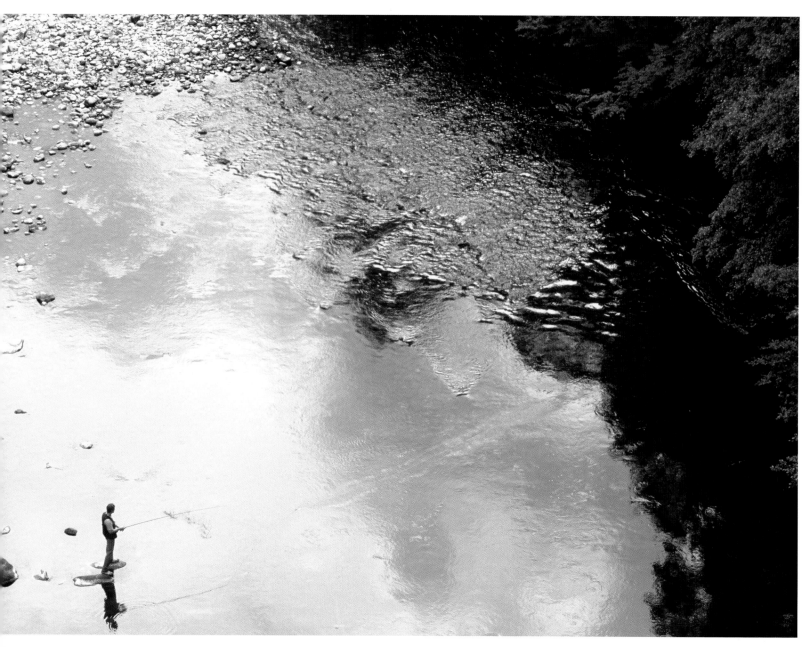

LEFT: Fishing in the River Garry at Pitlochry. The principal catches are summer salmon and grilse; the former have to ascend the Pitlochry Salmon Ladder at Pitlochry Dam to get upriver first.

RIGHT: Aberlemno in Angus is a village noted for its Pictish sculpted stones, possibly the best in Scotland. This detail shows a battle scene from the back of a six-foot tall stone that has a cross and animals on the front.

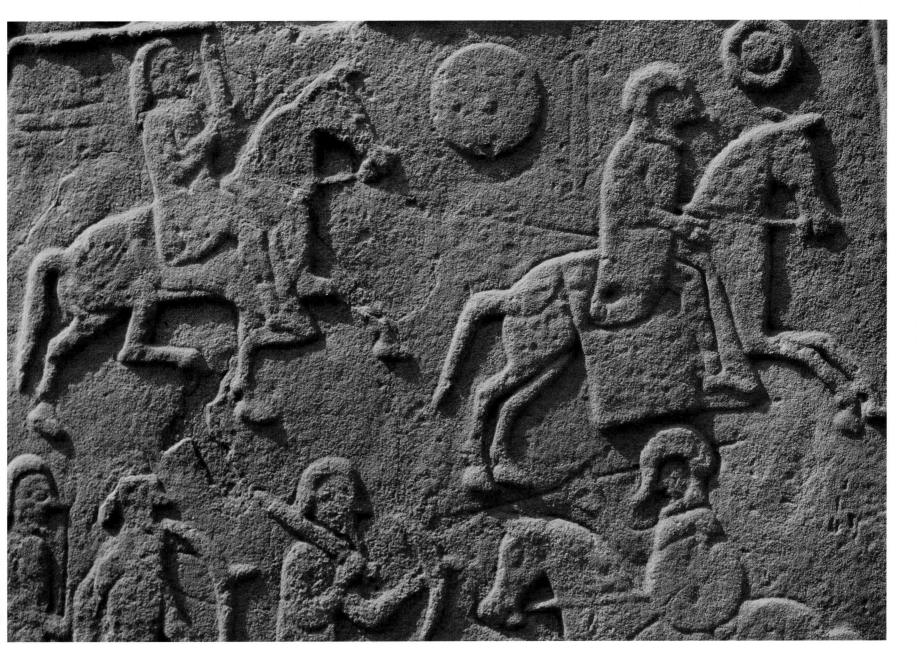

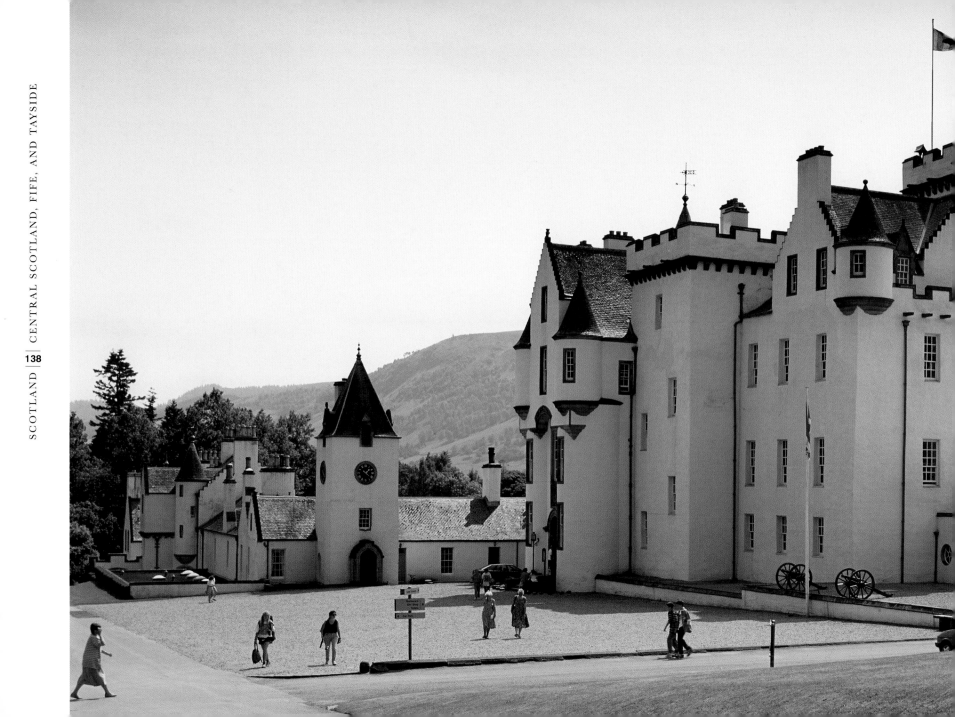

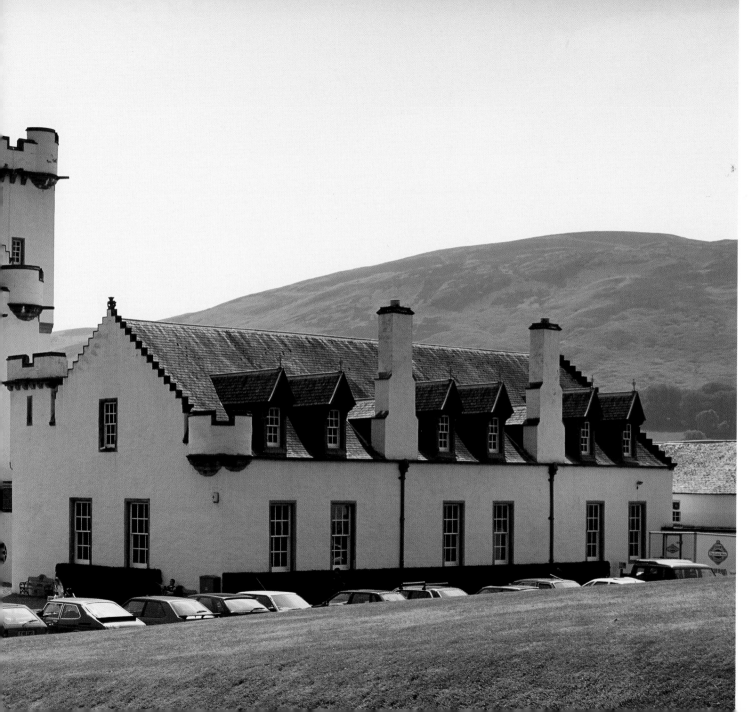

LEFT: Blair Castle is the seat of the Dukes and Earls of Atholl. An eighteenth century house built on thirteenth century foundations, Blair Castle has changed hands a number of times in his history. It was taken by the Parliamentarians in the Civil War and during the second Jacobite rising Bonnie Prince Charlie stayed there. Occupied by the English, the Jacobites under Lord George Murray besieged the castle to retake it—often said to be the last castle siege in Britain.

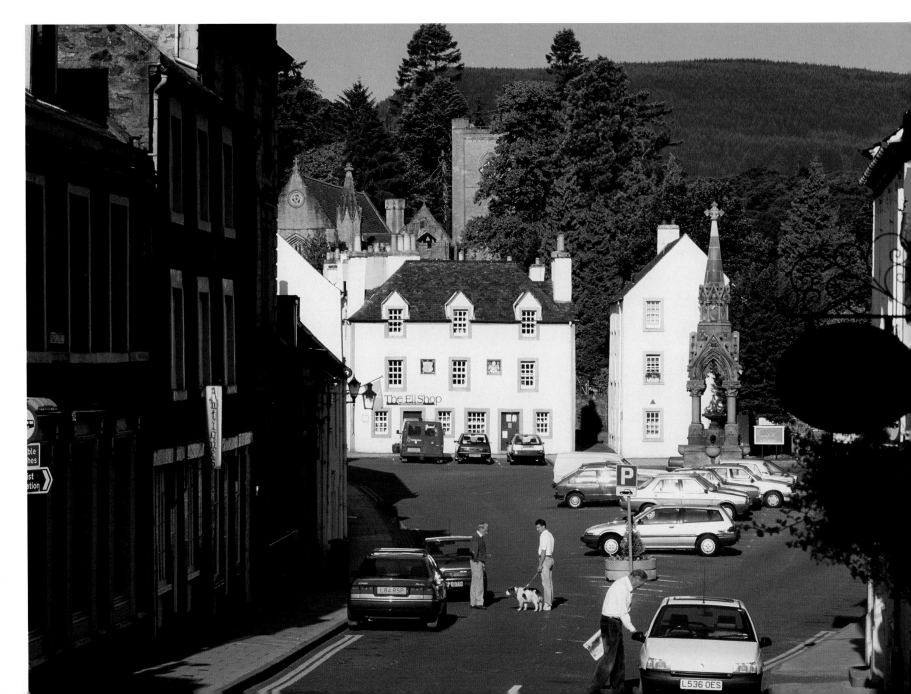

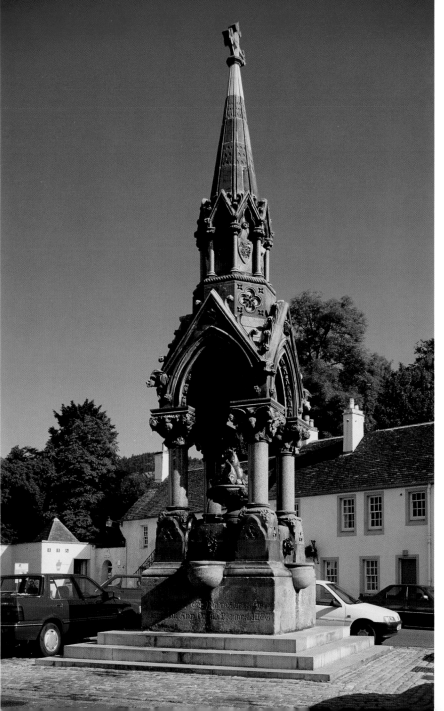

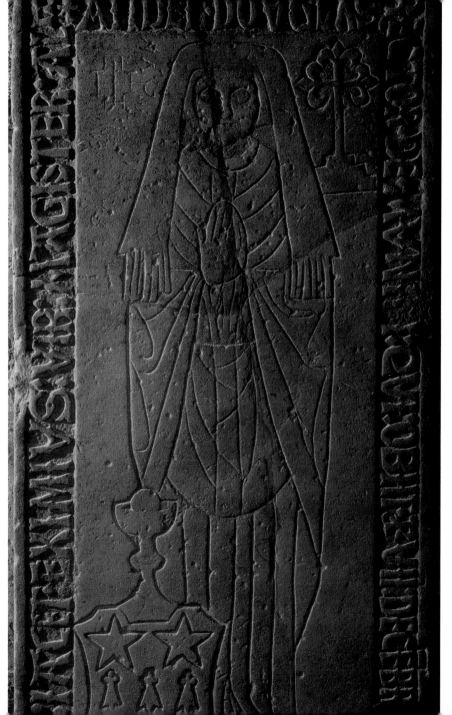

LEFT AND RIGHT: Dunkeld Cathedral sits above the town (see page 140) and was once the capital of Scotland (jointly with Scone) when Kenneth MacAlpine united the kingdoms of the Picts and Scots in 844. The cathedral started life a lot later than this: it's a medieval building that was started in 1318. It took nearly 200 years to complete: the northwest tower finally being finished in 1501. Alas, it was not to survive the Reformation and was severely reduced in the middle of the century.

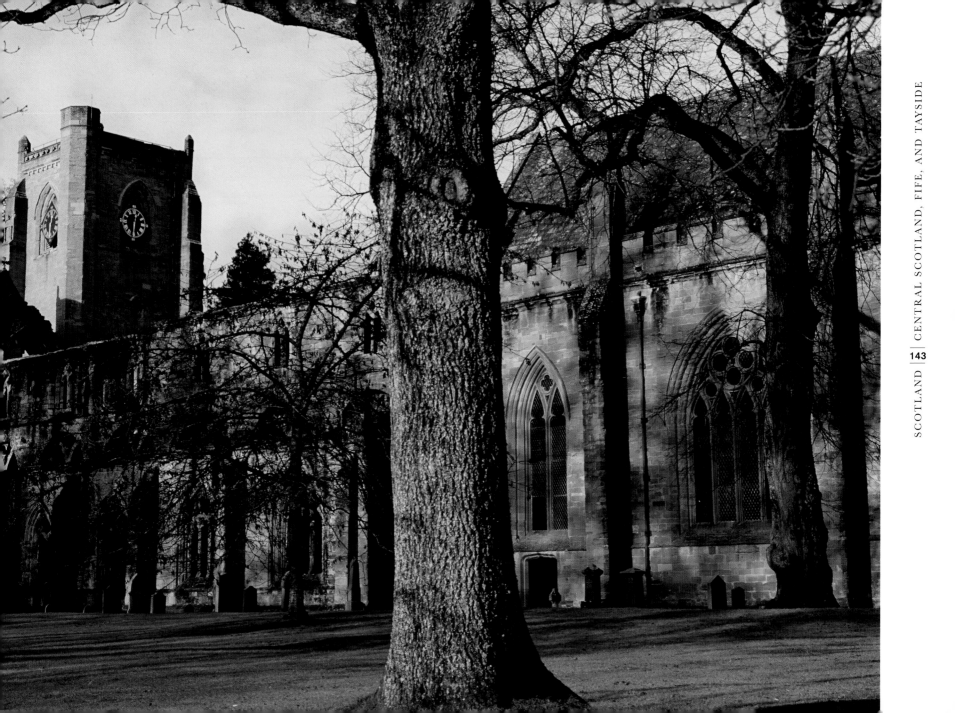

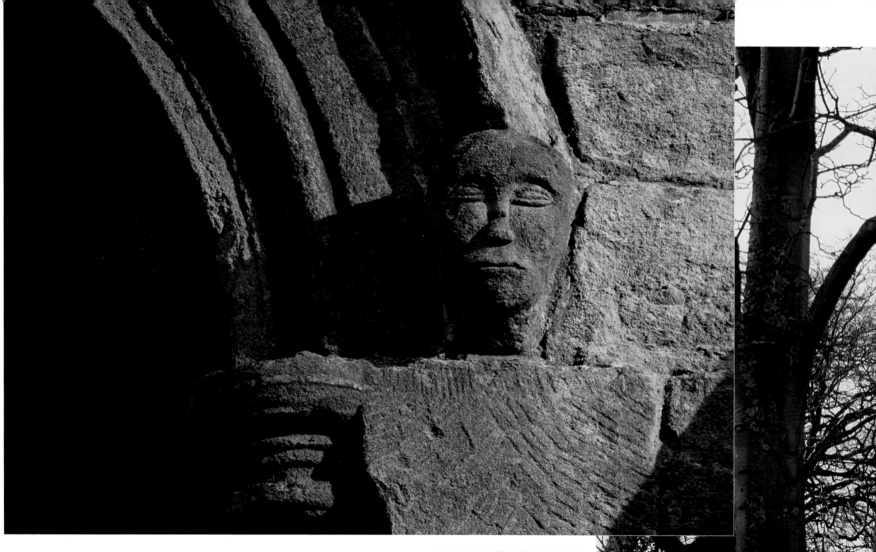

ABOVE AND RIGHT: Brechin Cathedral is largely
a thirteenth century construction that was
butchered in the early nineteenth century. Long
restoration has helped restore some semblance
of dignity to a structure whose foundations date
back to the early twelfth century. The round
tower attached to the church is probably earlier
still, possibly eleventh century. It is 87ft tall and
of a similar style to the Celtic medieval round
towers found in Ireland. Nearby Brechin Castle
held out for three weeks against the "Hammer
of the Scots"—Edward I of England—in 1303.

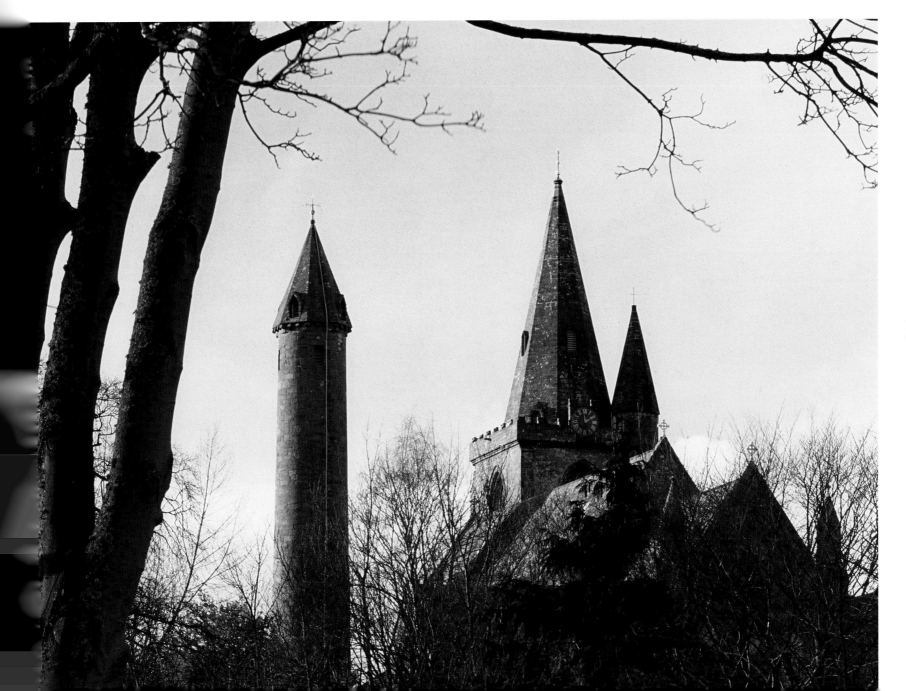

Grampian

Up on the far northeast coast of Scotland sits the huge region of Grampian with its magnificent capital city, Aberdeen. This is the area that so captured Queen Victoria's heart that she spent as much of her time here as possible at her castle at Balmoral. She wrote, "It seems like a dream to be here in our dear Highland home again. Every year my heart becomes more fixed in this dear Highland paradise." In fact the royal family still spends every Christmas holiday here.

Balmoral Castle is surrounded by a huge estate and is the private property of the royal family although parts are open to the public. The estate was bought by Prince Albert for Victoria in 1852 for £31,500, he then set about extensively extending and improving the property.

Aberdeen is known as "the Granite City" and indeed the buildings literally sparkle from the mica, quartz, and felspar embedded in the granite that so many of the city's important buildings are made from. In the last few decades Aberdeen has become enormously prosperous thanks to the proceeds of oil drilling in the North Sea.

Further south down the coast lies the fishing port of Arbroath. The town's original prosperity was built on the export of barrels of herring to Königsberg. It also gave its name to the Arbroath Smokie, a particul;ar type of smoked haddock and a great delicacy enjoyed by many gourmets.

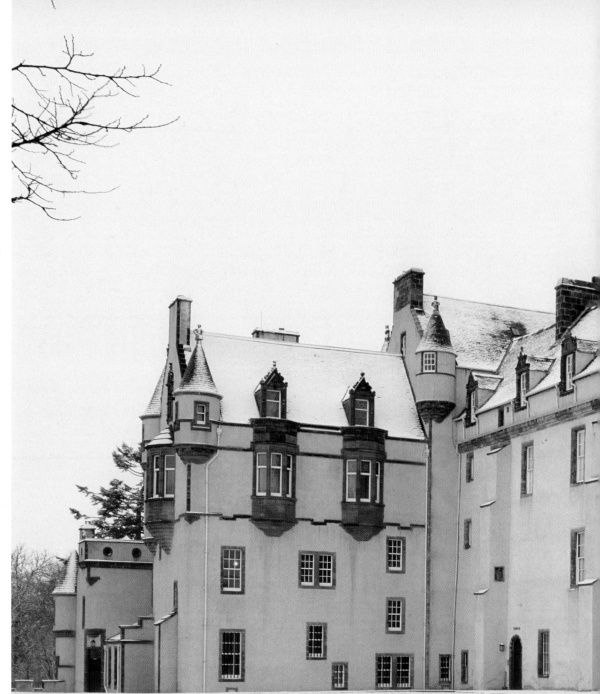

RIGHT: The great fortress-castle of Fyvie Castle. Started in the thirteenth century, the castle has been regularly and extensively improved and enlarged. Tradition claims that each of its five towers was built by the five successive families who owned the castle —the Preston, Meldrum, Seton, Gordon, and Leith families. Fyvie now belongs to the National Trust for Scotland.

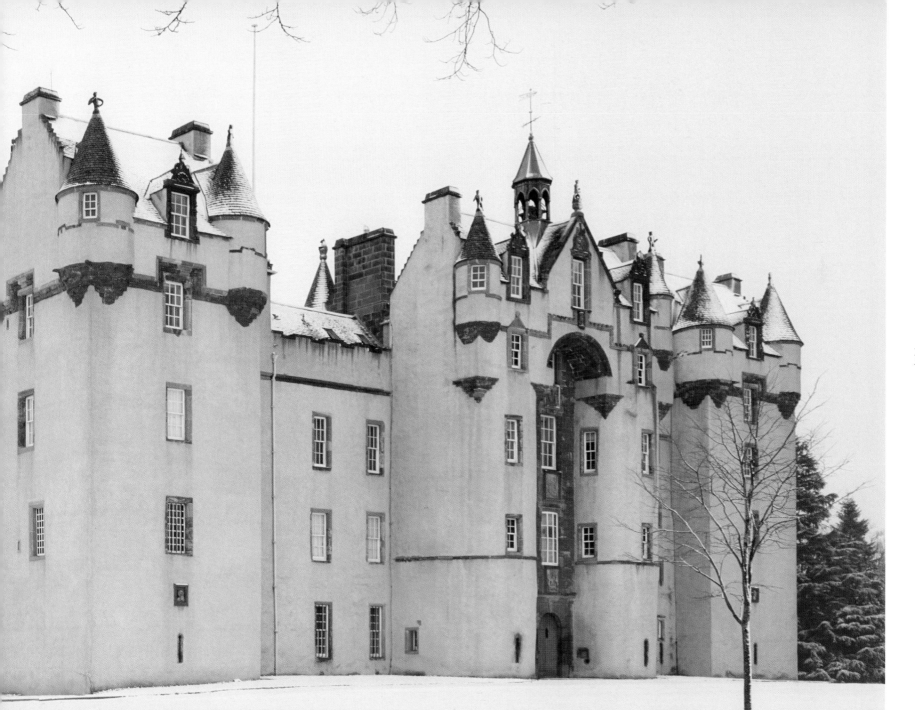

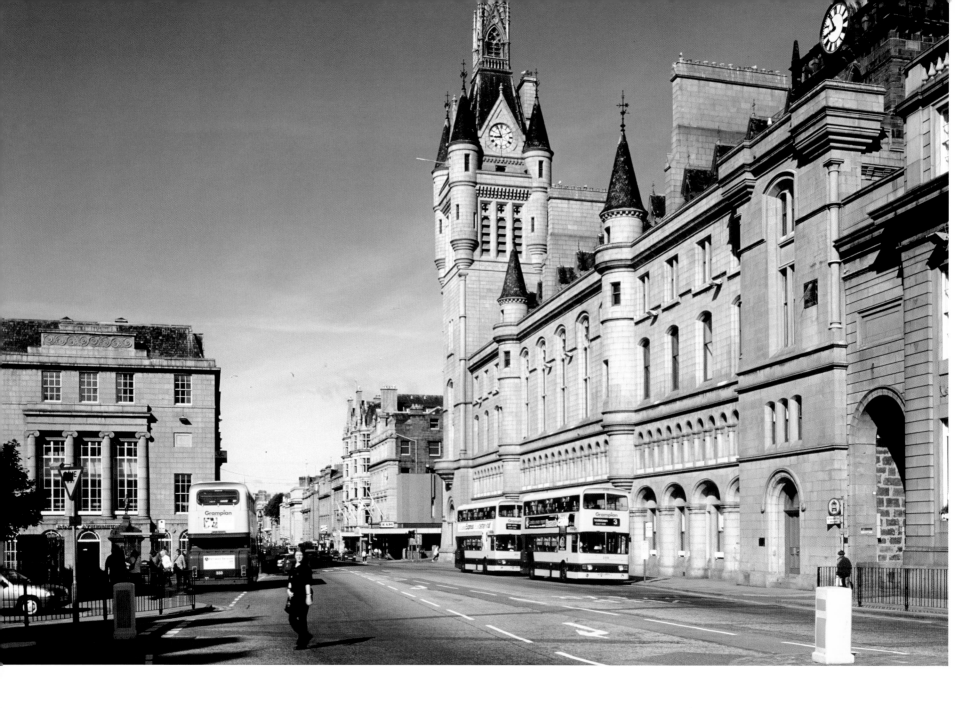

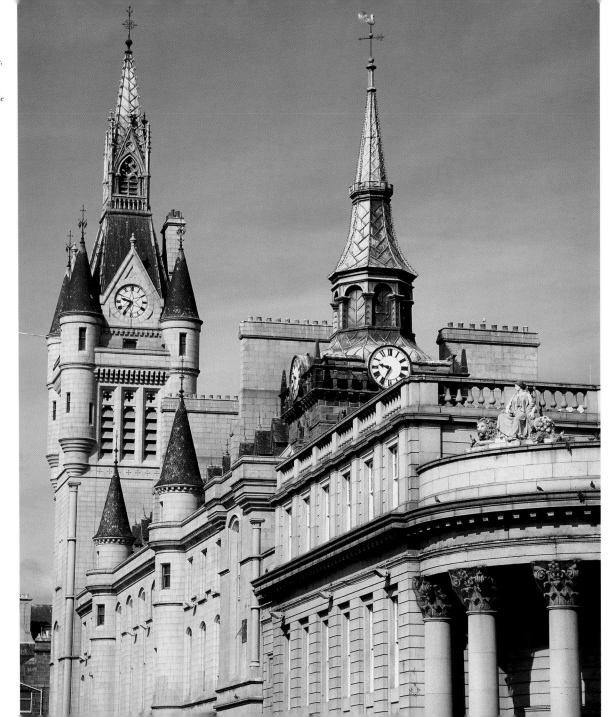

LEFT AND RIGHT: The Town House on Union Street in Aberdeen; the square tower, known as the Old Tolbooth was built 1622–29. This was the site of the dreaded "Aberdeen Maiden," the Scottish guillotine, which is claimed to be the inspiration for the French *guillotin*. Public executions were held here until 1858.

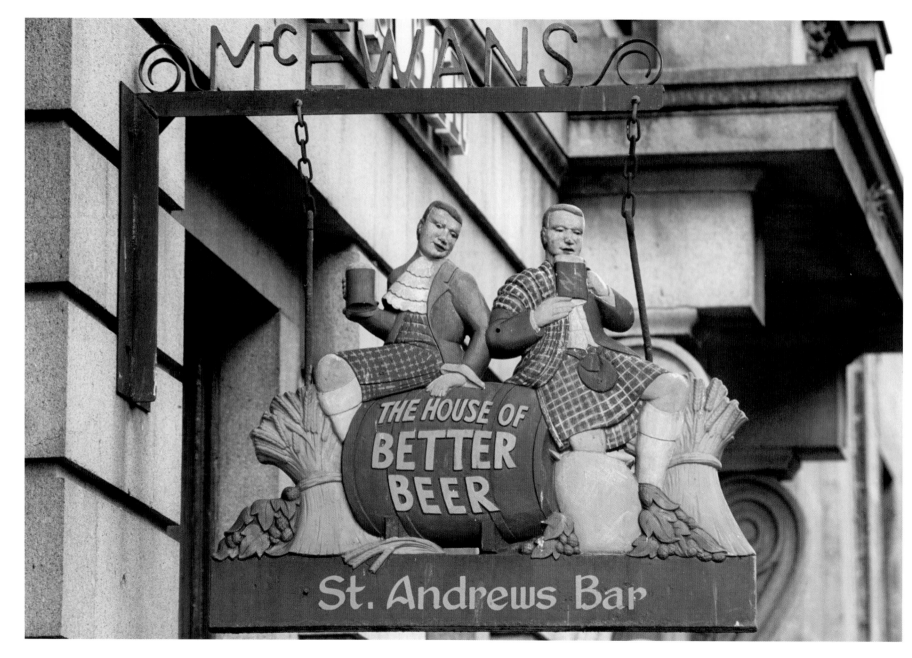

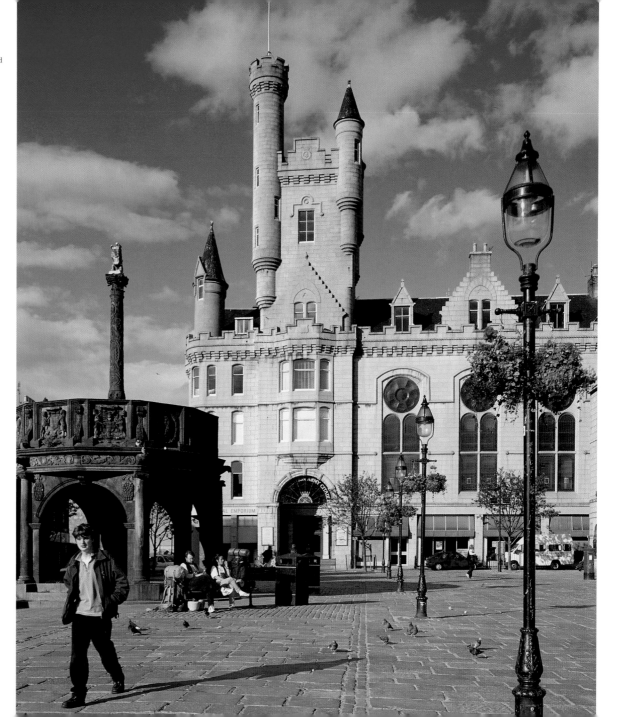

LEFT: The Granite City of Aberdeen has plenty of watering holes including St Andrew's Bar with its wonderful pub sign welcoming drinkers.

RIGHT: Castlegate lies in the oldest part of Aberdeen. The castle that the area is named for was destroyed in 1308 but remains on the city arms. The six-arched hexagonal Mercat Cross dates from 1686 and was carved by a local mason for £100.

FAR LEFT: The old fishing port of Stonehaven is sheltered by two massive headlands—Garron Point and Downie Point. Every December 31 the town holds a midwinter fire festival when the young men of Stonehaven welcome the new year by swinging burning fireballs around their heads as they march up and down the High Street.

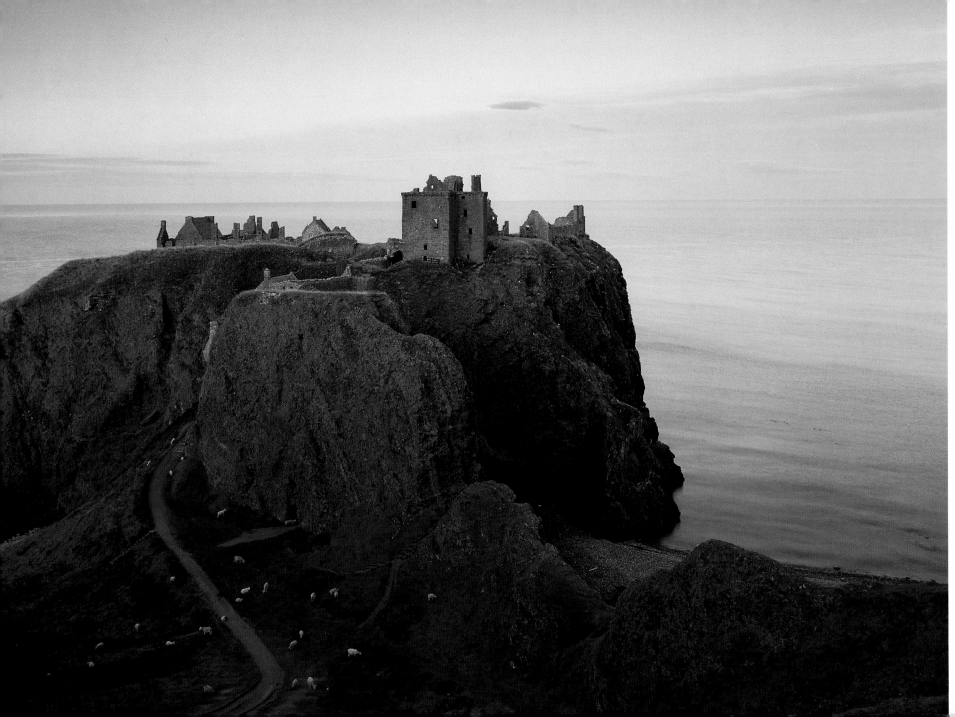

LEFT: Dramatically sited in splendid isolation on a promontory jutting out into the North Sea, Dunnottar Castle has been at the heart of much Scottish history. It is now a collection of disjointed ruins, the oldest of which belong to the fourteenth century keep whose 5ft thick walls rose to a 50ft high square tower.

RIGHT: The first fortified position at Dunnottar was built in the eleventh century. In 1297 while under English occupation, was stormed by William Wallace. It was destroyed in the first half of the fourteenth century but rebuilt as a castle by Sir William Keith, Great Marischal of Scotland at the end of the fourteenth century. Some of the ruins have been restored, most notably in the early twentieth century by Viscountess Cowdray.

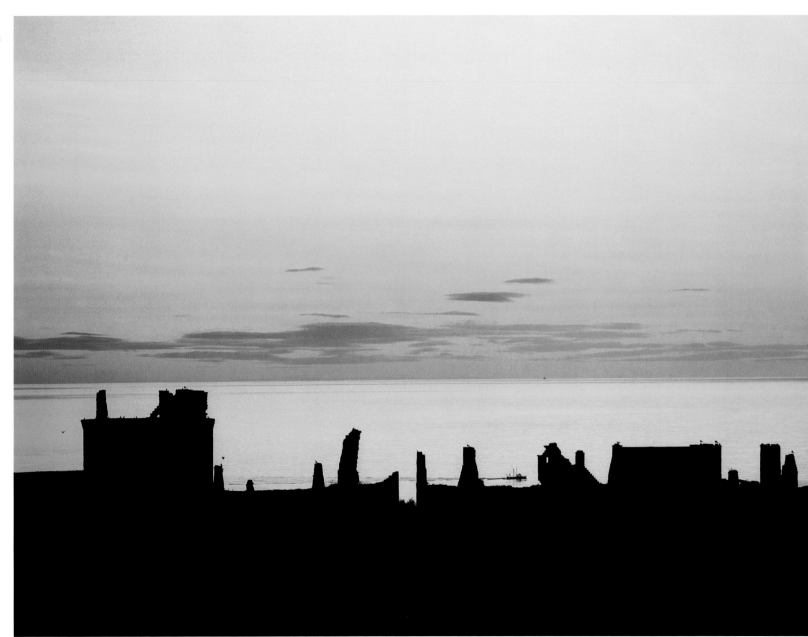

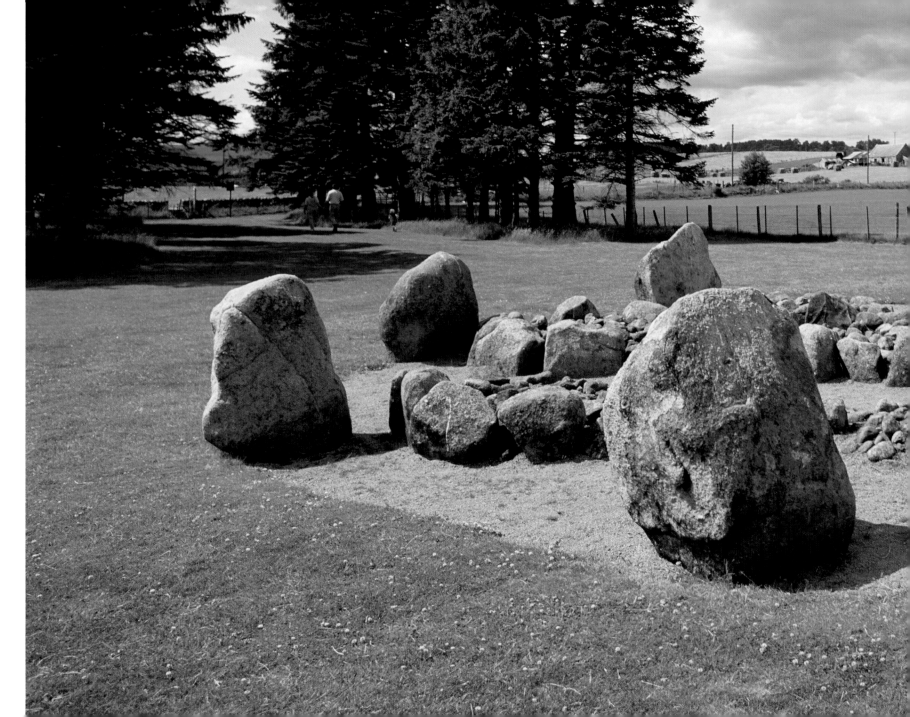

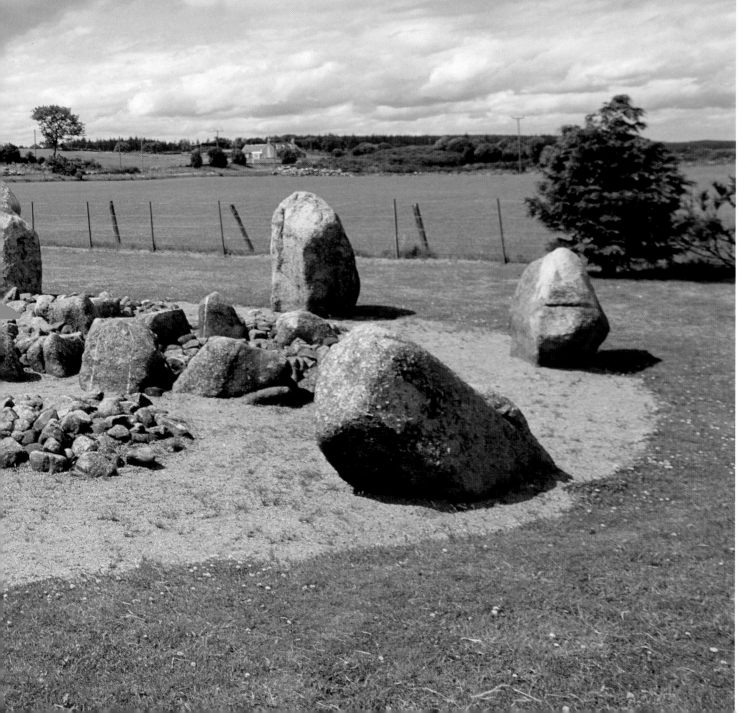

LEFT: Near the village of Echt a Bronze Age stone circle, 33ft in diameter and made up of eight red granite stones, encloses the eight Cullerlie Cairns. The cairns are built over burial pits where corpses were burned. The central cairn is the largest.

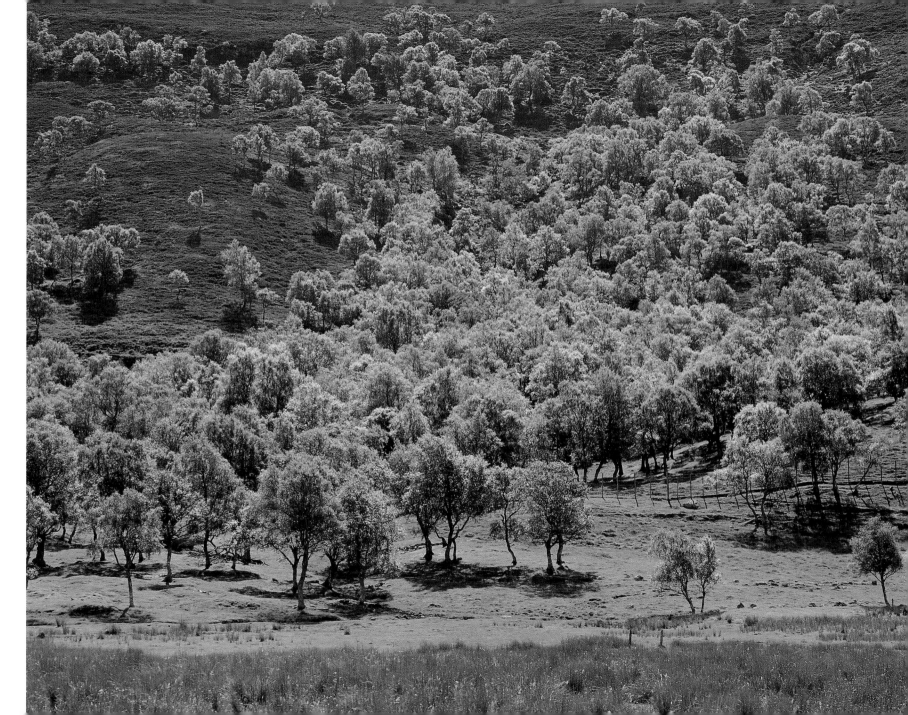

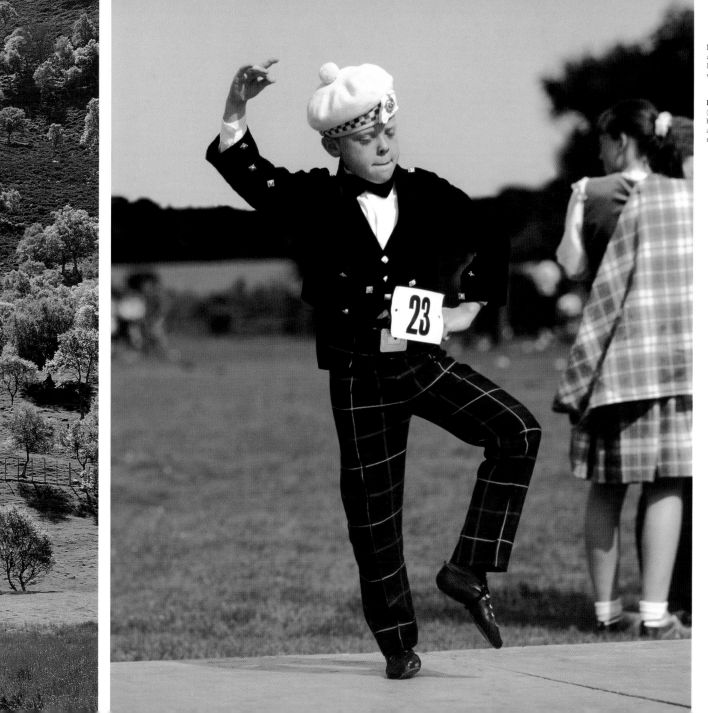

LEFT: Highland dancing is a popular attraction at many Scottish events. At the Echt Games even the youngest dancers arer very welcome.

FAR LEFT: Famous for its annual Gathering (started in 1832), Braemar has historically been a popular spot for the Scottish royalty and the nobility. Braemar is also the gateway to the Eastern Cairngorms.

LEFT: Craigievar Castle has seven stories above a stepped L-plan design and has survived with little alteration since it was constructed. The sole way into this ultimate example of a Scottish castle with its fantastic turrets, balustrades and cupolas is through a heavy, iron-studded outer door.

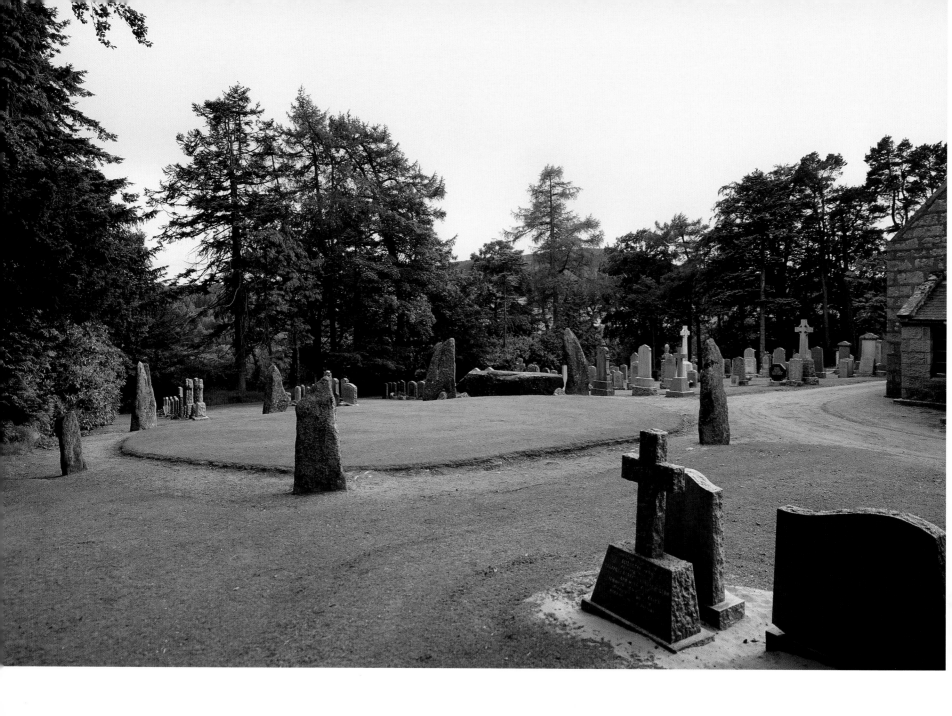

LEFT: The River Don rises at 2,000ft up in Coire Domhain on the Aberdeenshire–Banffshire border; then for about 80 miles it descends eastward to meet the sea at Aberdeen. The Don is renowned for its fine trout fishing.

FAR LEFT: Midmar Kirk recumbent stone circle.

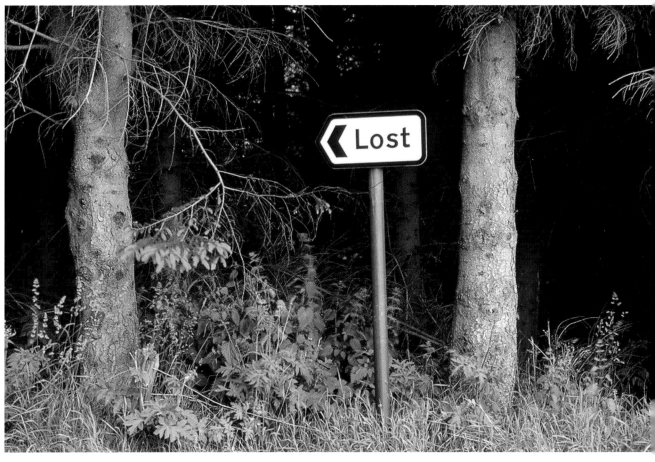

LEFT: Small cottages such as this one near Colgarth offer a real retreat from the pressures of modern life.

ABOVE: Lost in Grampian! The village of Lost is actually to be found in the Don Valley near Alford.

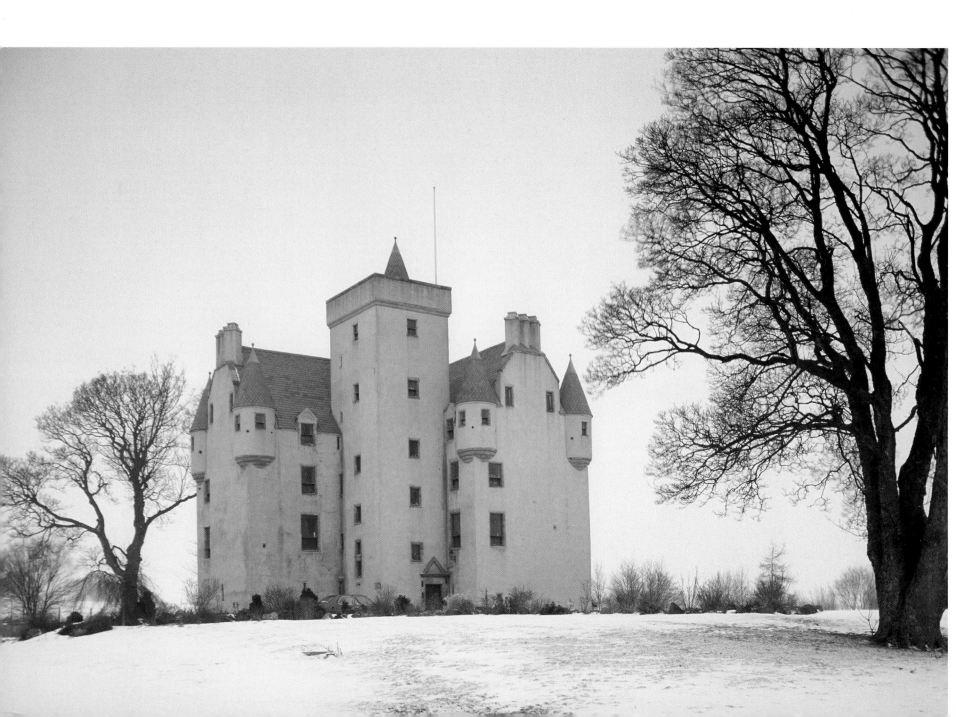

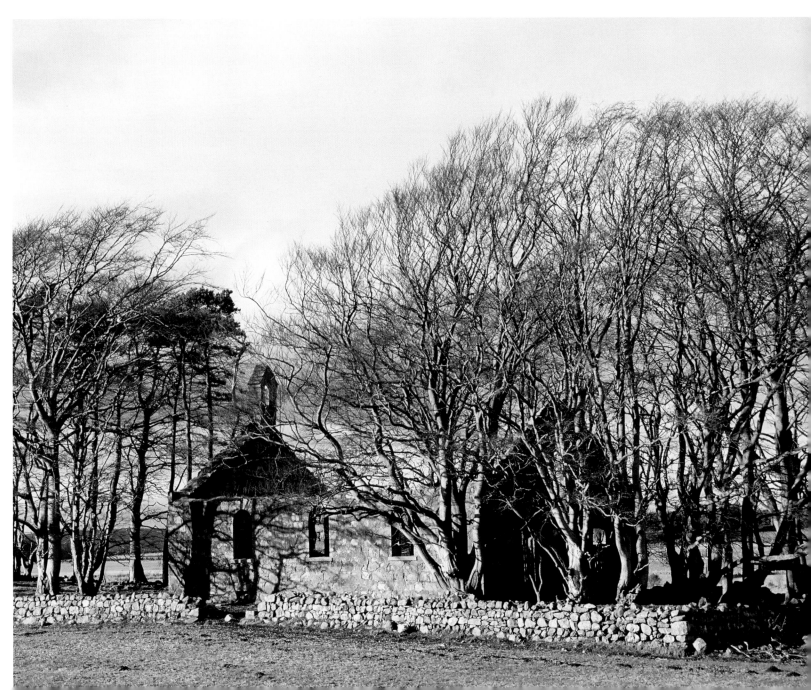

LEFT: Built in 1661 in typical Scottish style, Leslie Castle was one of the last fortified tower houses to be built in Scotland: gun ports guard the entrance to the tower.

RIGHT: The old church of St Mary at Maryculter was in use until 1782. It was built on lands belonging in medieval times to the Knights of the Hospital of St John of Jerusalem. After the Reformation their lands passed to the Crown but they were able to cede their former property to "men of substance," in this instance, to the Menzies family.

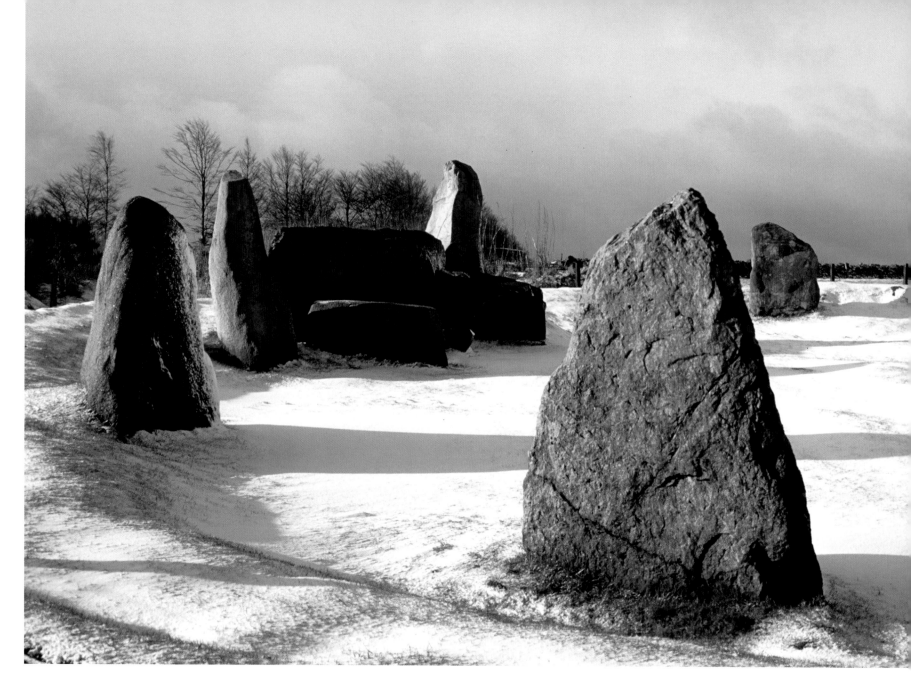

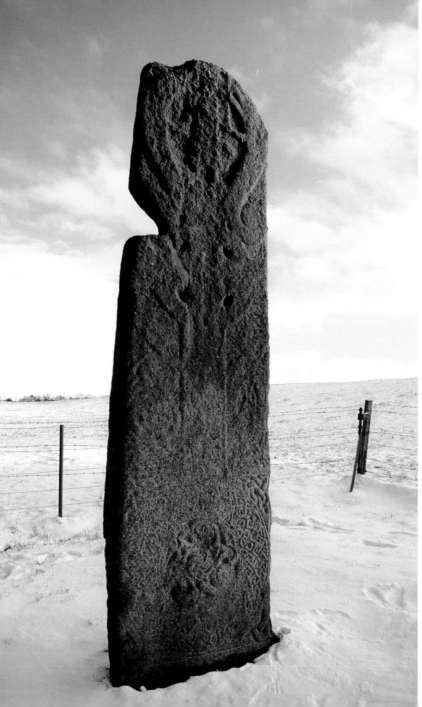

LEFT: Near the Chapel of Garioch lies the Maiden Stone, a ninth century cross-slab. Still visible are the Pictish carvings showing fish, monsters and other symbols on one side while on the other shows a Celtic cross.

FAR LEFT: Found at Inverurie are the mysterious Easter Aquhorthies, a recumbent stone circle dating from the third millennium BC. There are nine stones set in a low bank, plus a huge recumbent stone with two flankers. All but one of the stones are pink porphyry, the exception is red jasper.

RIGHT: Since 1852 Balmoral Castle has been the personal property of the monarch. Queen Victoria and Prince Albert initially leased the estate for four years before the Prince bought it for £31,500. The Prince then set about rebuilding the castle in Scottish baronial style with Balmoral quarried pale grey Invergelder granite. Queen Victoria adored her castle and 24,000 acre estate which she called "this dear paradise."

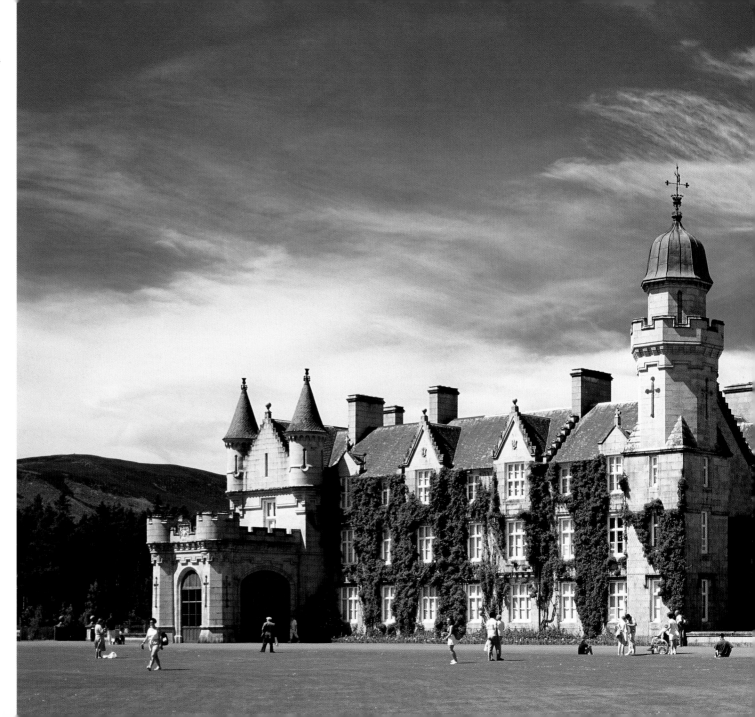

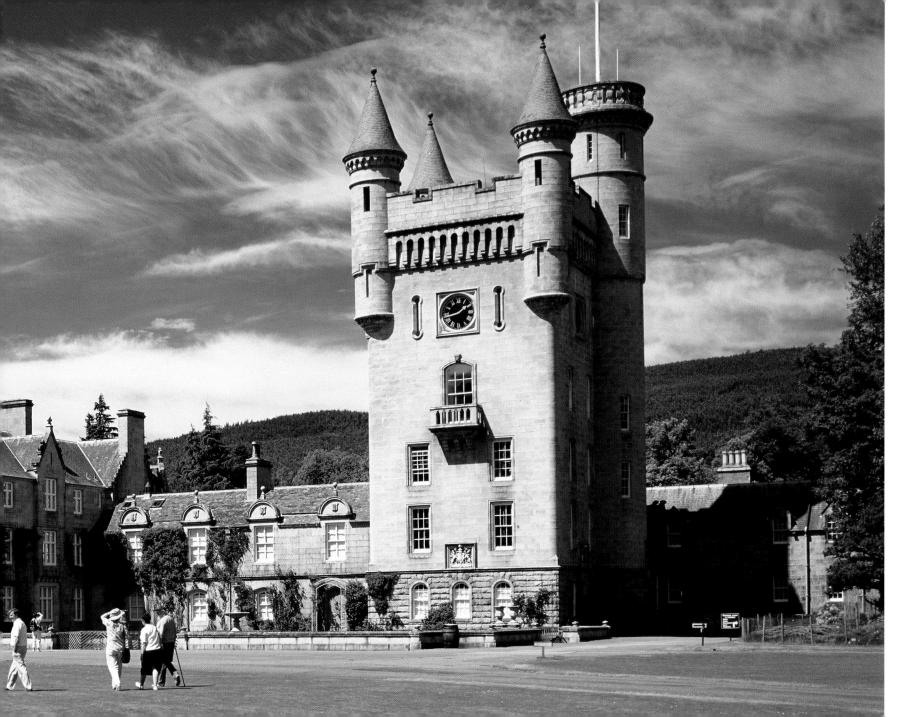

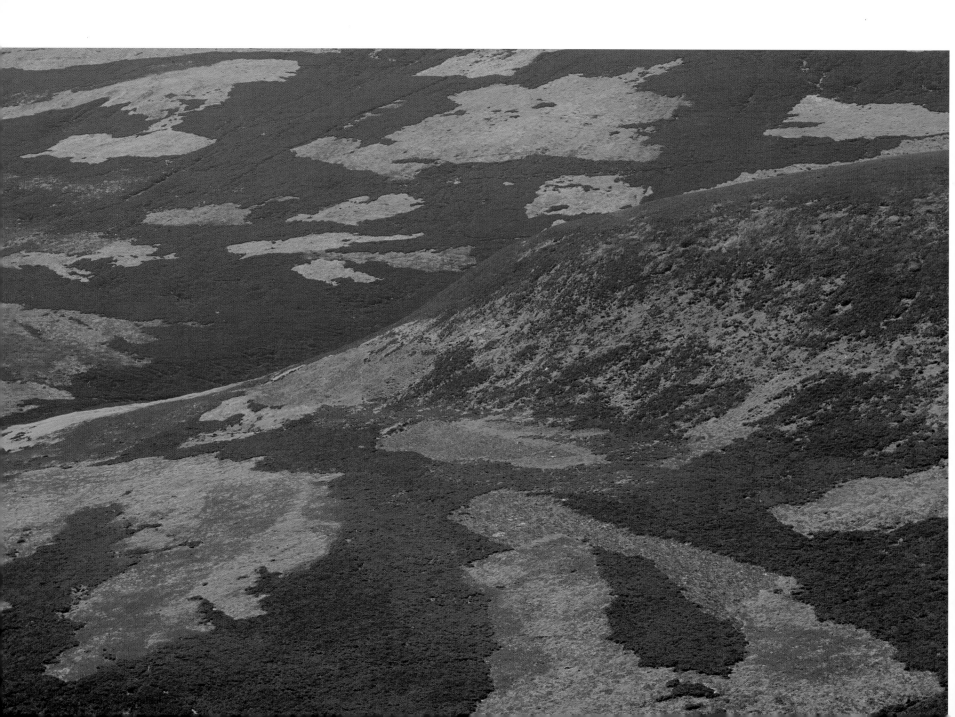

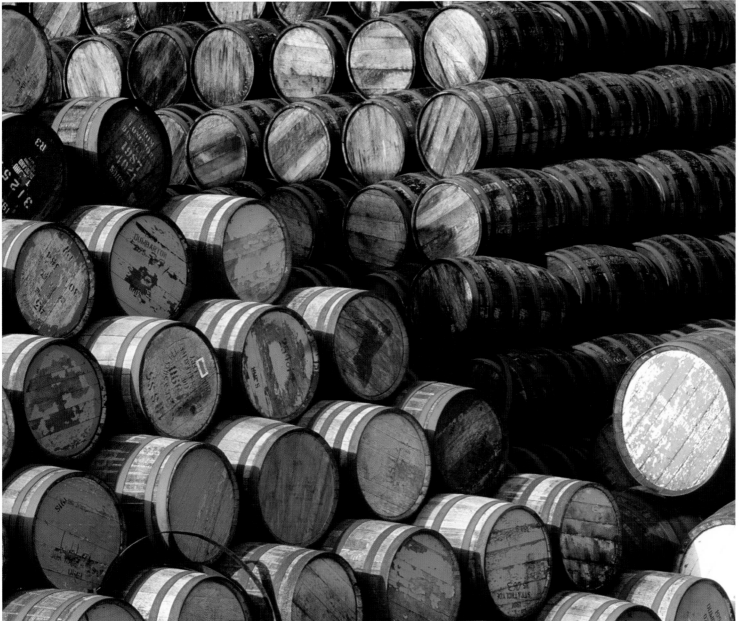

LEFT: Scotland's malt whisky capital is Dufftown—"Rome was built on seven hills, Dufftown stands on seven stills"—as the stacked barrels testify here.

FAR LEFT: View of the dramatic landscape south east of Tomintoul. The strange patination is created by the patch burning of the heather moorland to improve the habitat for grouse.

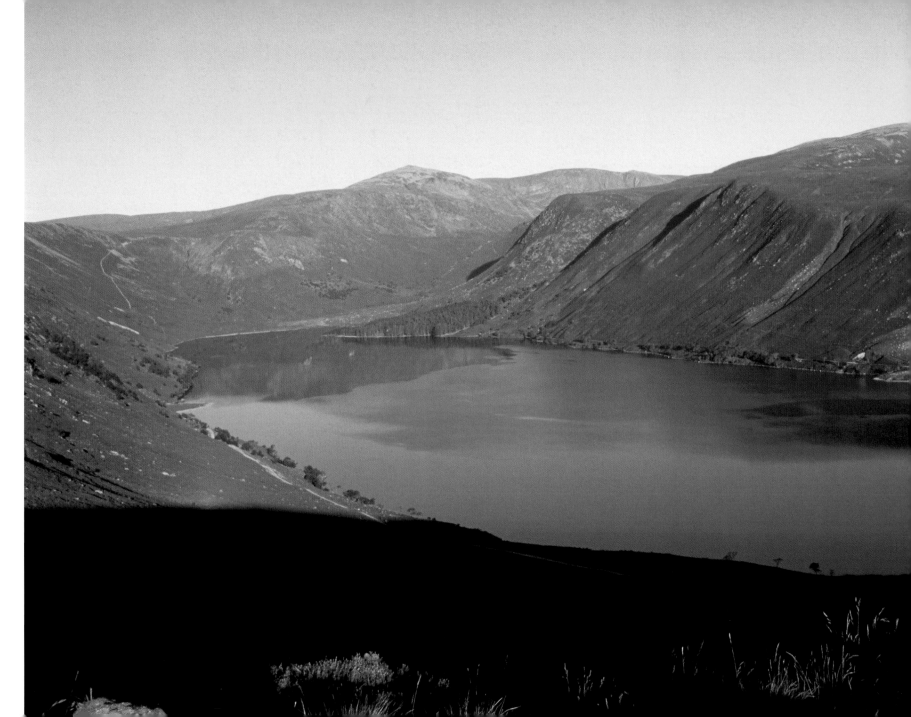

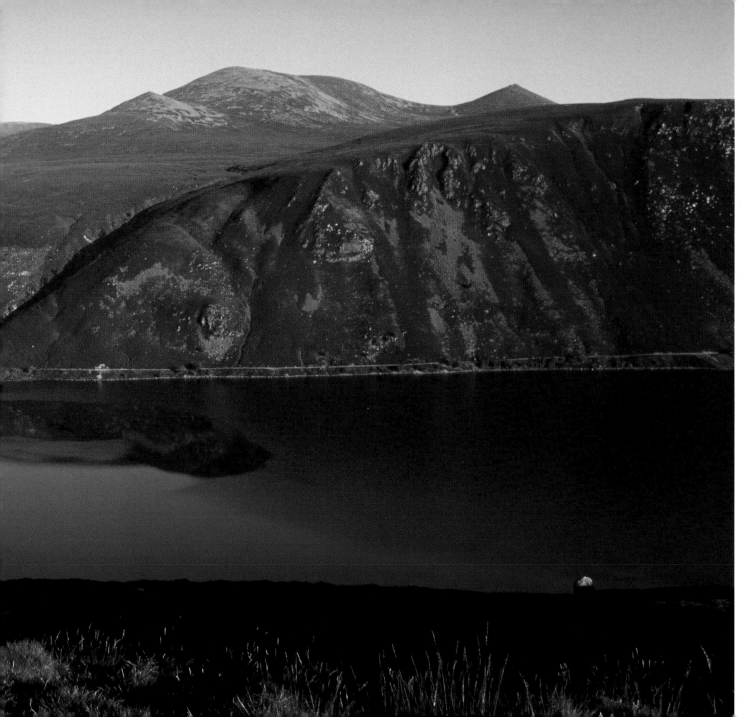

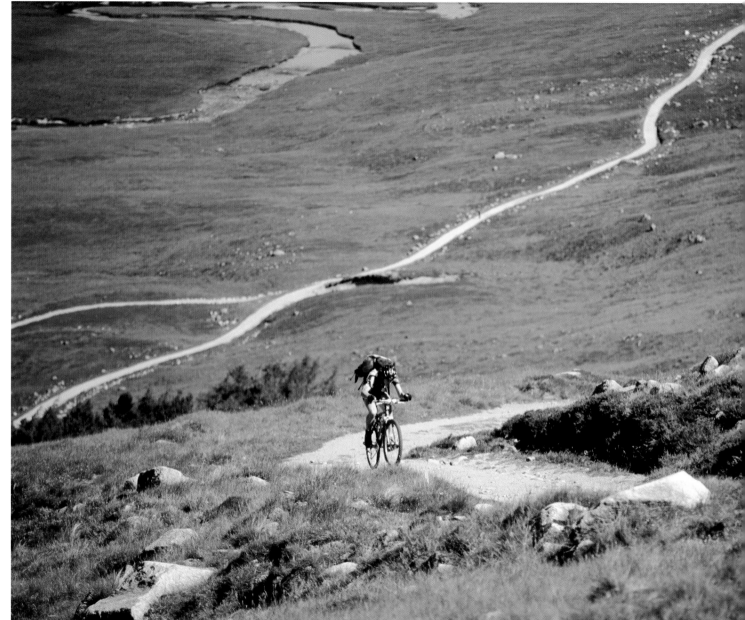

RIGHT: One of the best ways to get right into the heart of the countryside is to take to two wheels. However, the right equipment, a sturdy bicycle and a reasonable level of fitness are all essential.

FAR RIGHT: On the hills around Glen Muick are numerous steep paths ideal for fit mountain bikers to enjoy.

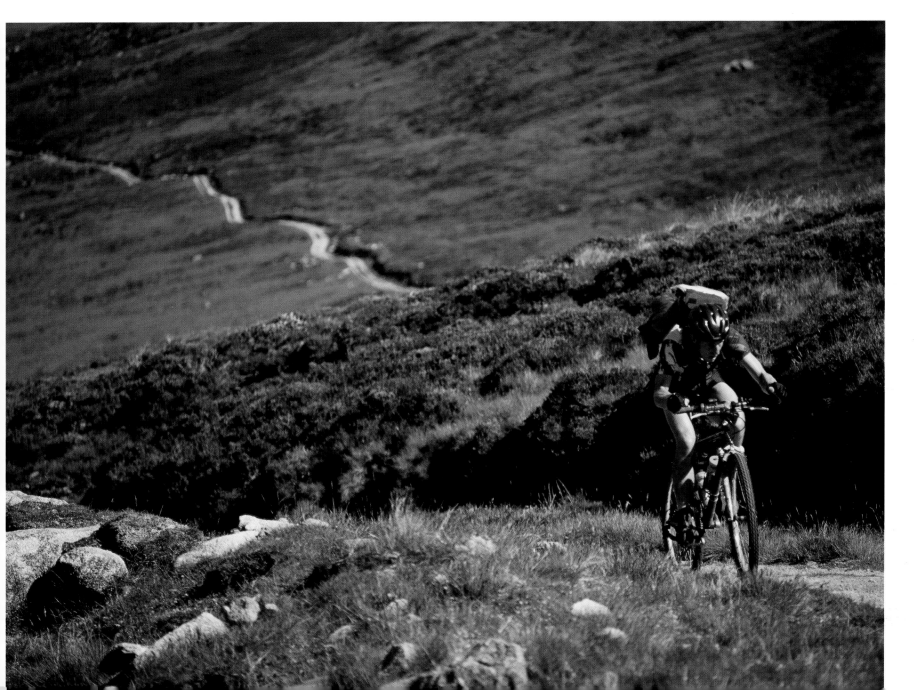

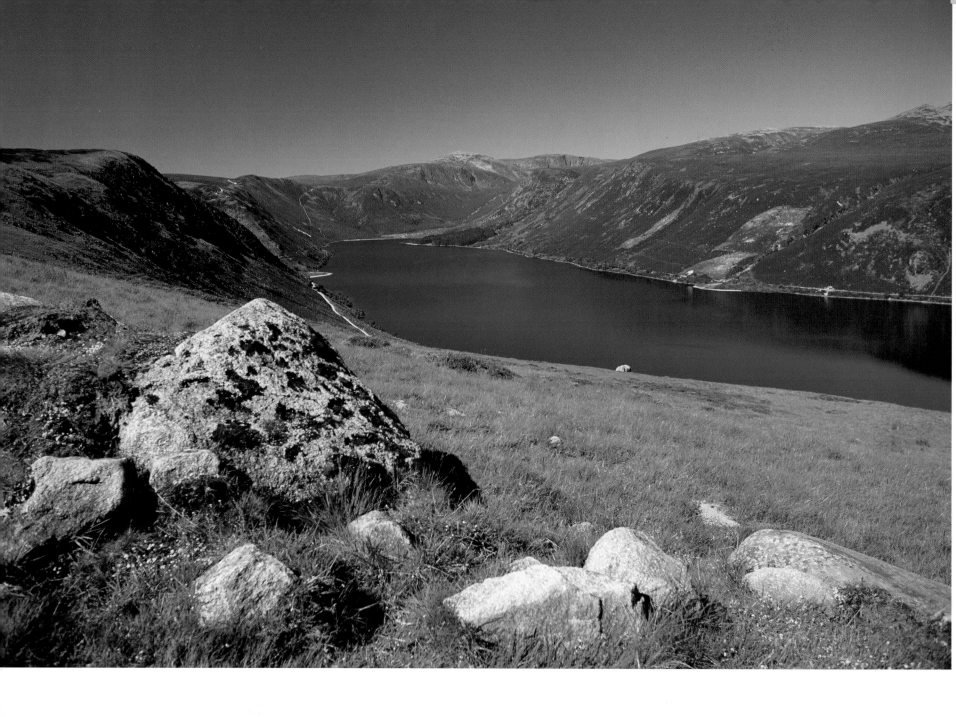

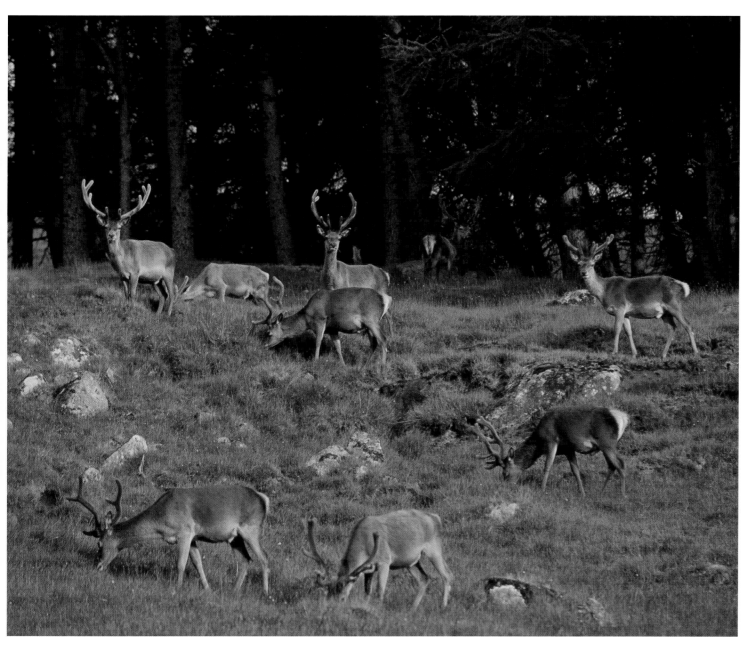

LEFT: Real "Monarchs of the Glen"—Red Deer (*Cervus elaphus*)—are some of the fantastic wildlife to be seen around Glen Muick. Mature males grow magnificent antlers which grow between April and July with which they assert their masculinity before shedding them in February.

FAR LEFT: On the Balmoral royal estate and surrounded by the steep sides of Lochnagar nature reserve lies Loch Muick, a popular spot for hill walkers, ramblers, bird watchers, and cyclists. Queen Victoria loved it so much that she built a royal lodge—Glas-Allt Shiel—by its shores.

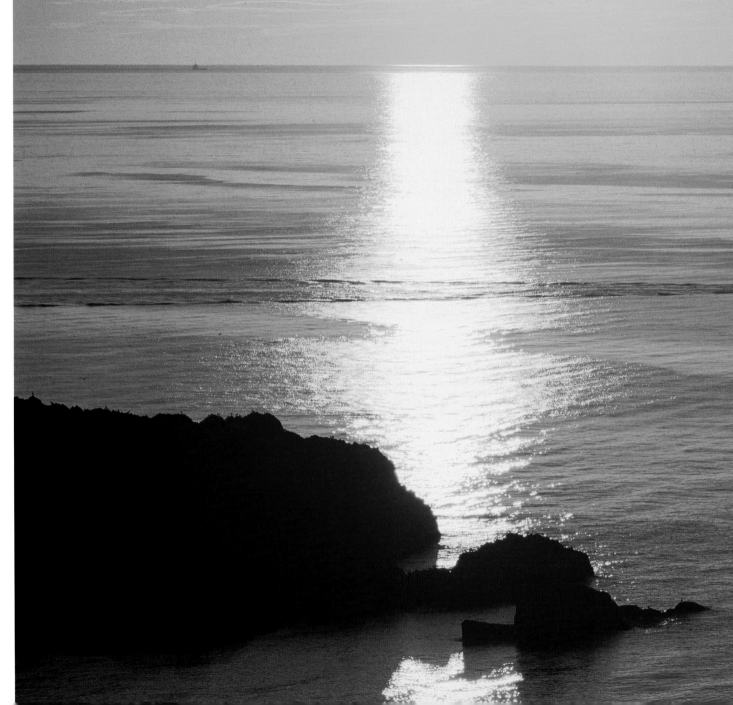

RIGHT: Sunset over thesea near Stonehaven. Situated on the east coast of Scotland half way between Aberdeen and Dundee, Stonehaven is a pretty seaside town and an excellent base for exploring the coastal trail that runs for more than 150 miles.

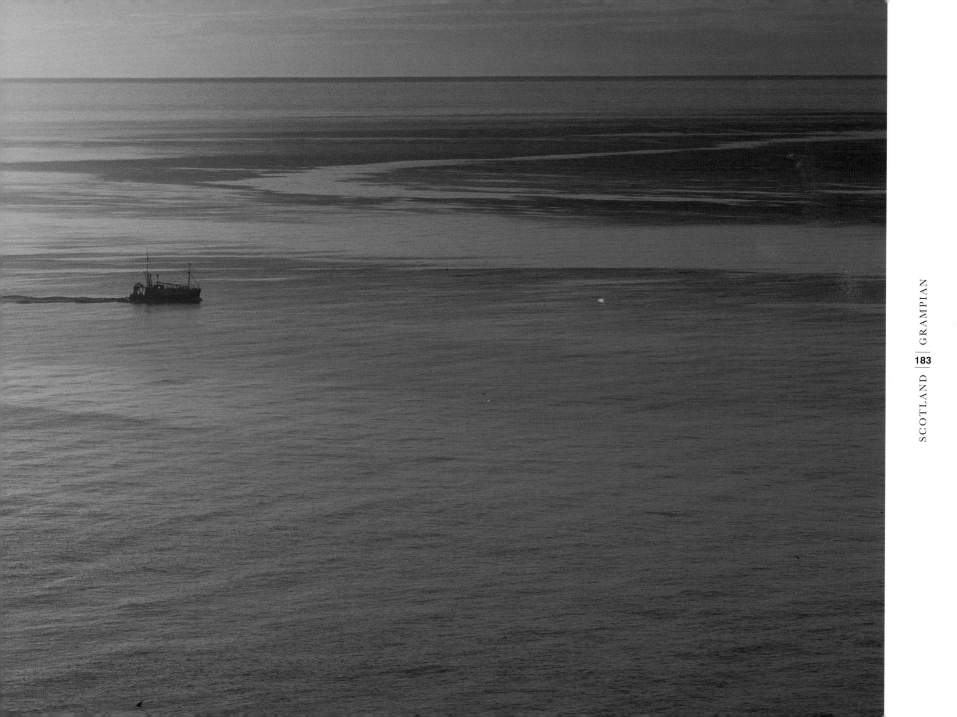

The Highlands

The Scottish Highlands are a spectacular mixture of high mountains, lochs, heather, and tumbling streams. It is an ancient landscape formed by volcanic and glacial activity millennia ago. The mountains attract extreme weather conditions and it takes a particularly tough people to live off the land here, and particularly hardy and rugged animals as well. Most crofters eke little more than a subsistence living from the land, lochs or seas.

Although fiercely independent, Highlanders have been inextricably linked with Scottish history, often to their own detriment as their ambitious clan leaders pulled them into battle. However, the event which most shaped Highlanders were the Highland Clearances which started in the late eighteenth and continued into the early nineteenth centuries. Broadly this was when ambitious land owners cleared the land of people in favor of sheep farming; the actuality was vastly more complex of course, but the upshot was that thousands of poor framers and crofters were thrown off their ancestral lands or out of their townships to fend for themselves with little or no resources to help them. Thousands starved, some managed to make a subsistence living out of the sea or with new smallholdings on marginal land, but many made their way to the new countries across the oceans that were opening up to new pioneers and settlers — America, Australia, and New Zealand.

The result was to turn the Highlands into one of the most deserted landscapes in Europe. Sheep were brought in for their meat and wool but in under a century the sheep had gone as foreign imports proved cheaper and better. Instead great shooting estates partitioned the Highlands with entire areas given over to grouse moors or deer forests.

RIGHT: The head of Glencoe looking east over Rannoch Moor. A typical glaciated valley formed in the last ice age, Glencoe is a major walking and climbing center— although global warming has reduced the marketability of its ski center.

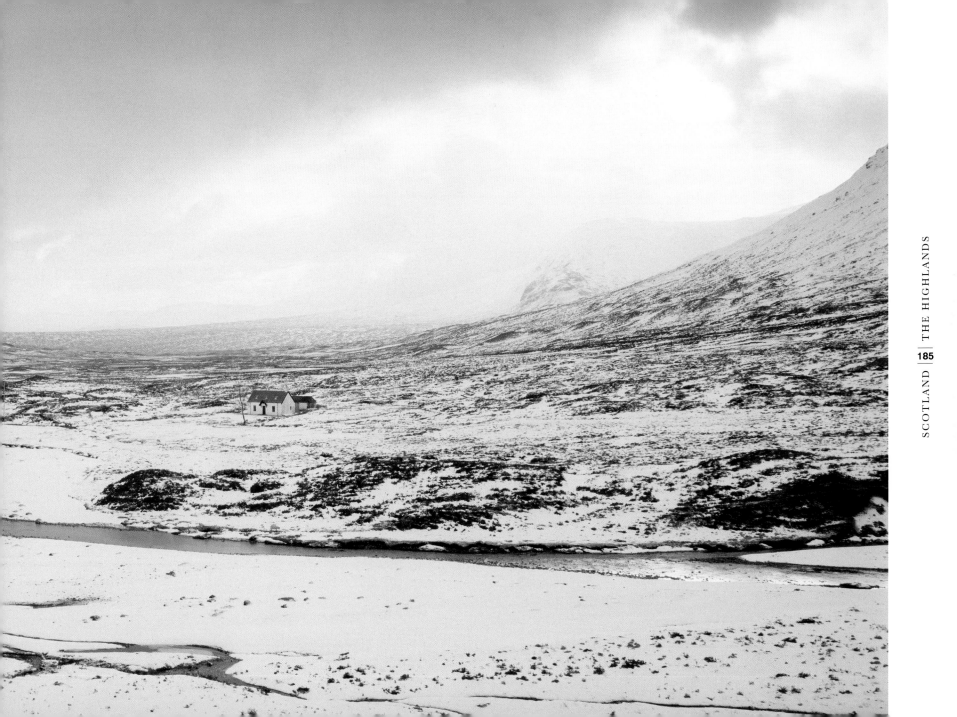

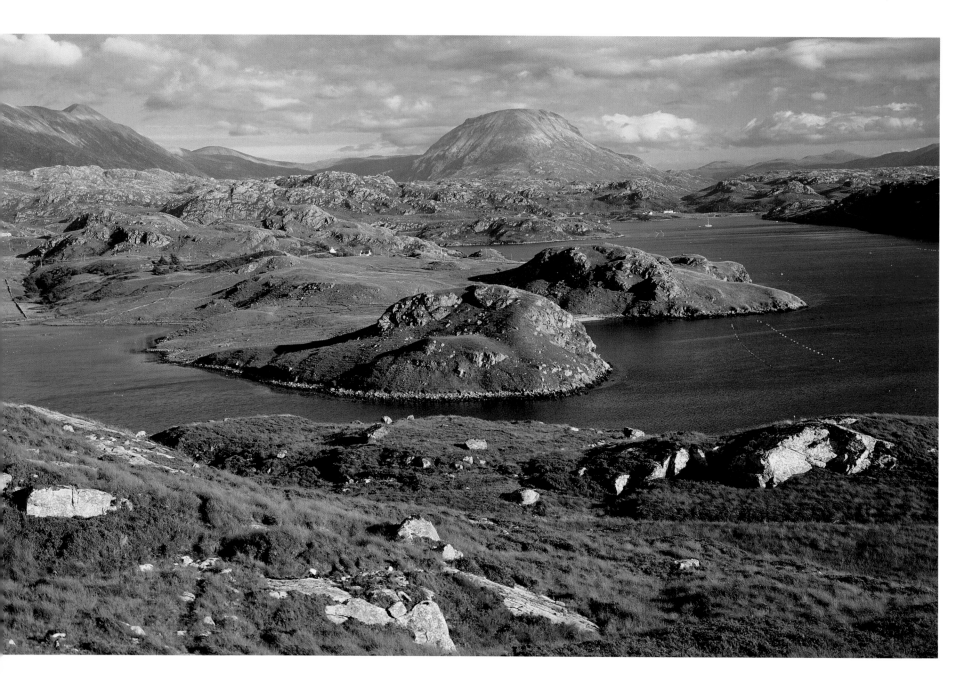

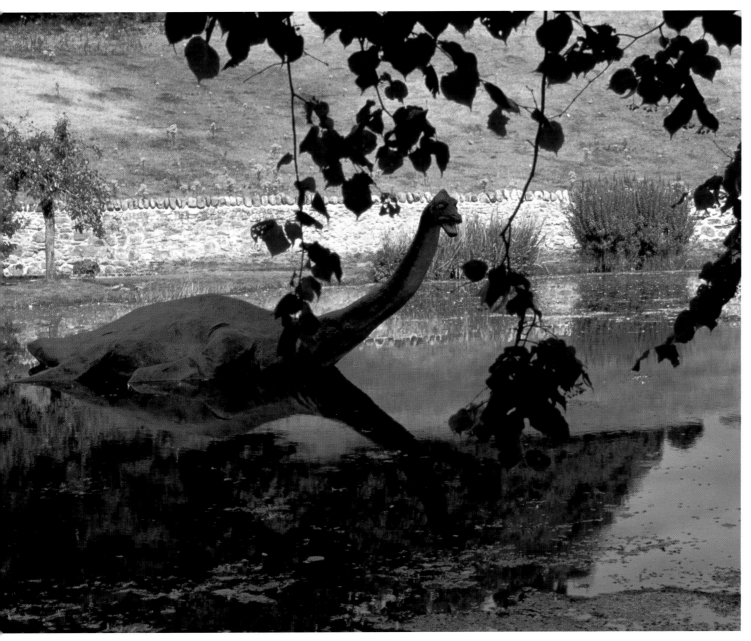

LEFT: A statue of Nessie at the official Loch Ness Monster Visitor Centre at Drumnadrochit. Despite numerous and repeated attempts over the years nobody has, as yet, managed to establish Nessie's existence.

FAR LEFT: View around Loch Inchard. Located just south of Cape Wrath, Loch Inchard is the most northerly large sea loch on the northwest coast of Scotland. The little fishing port of Kinlochbervie sits on its shores near the Atlantic. At just over four miles long the loch is set in stunning glaciated low rocky hills dotted with small crofts.

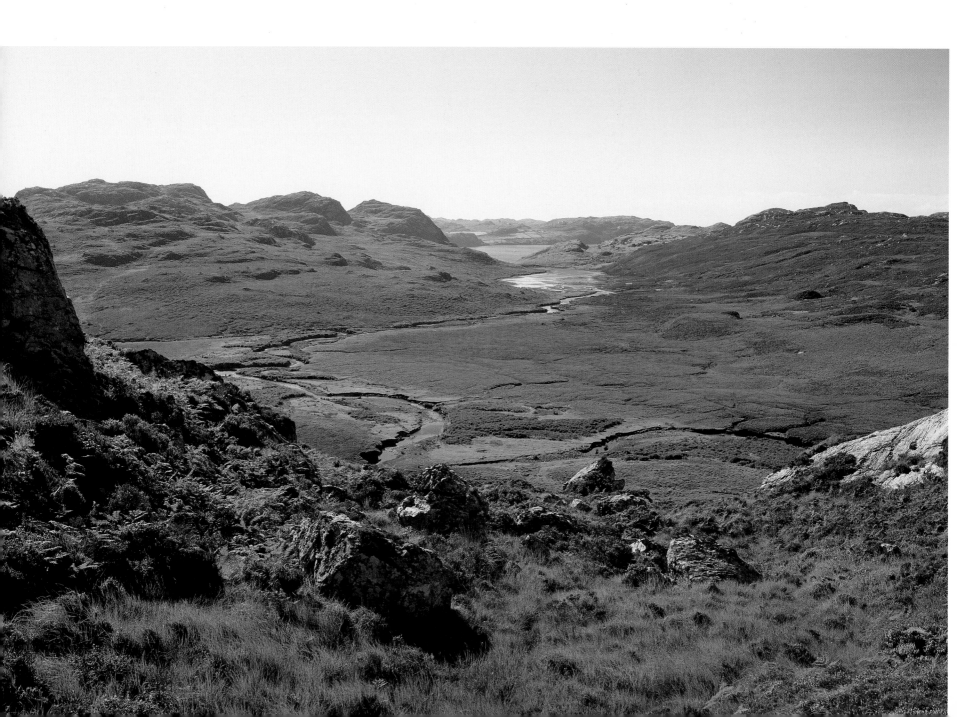

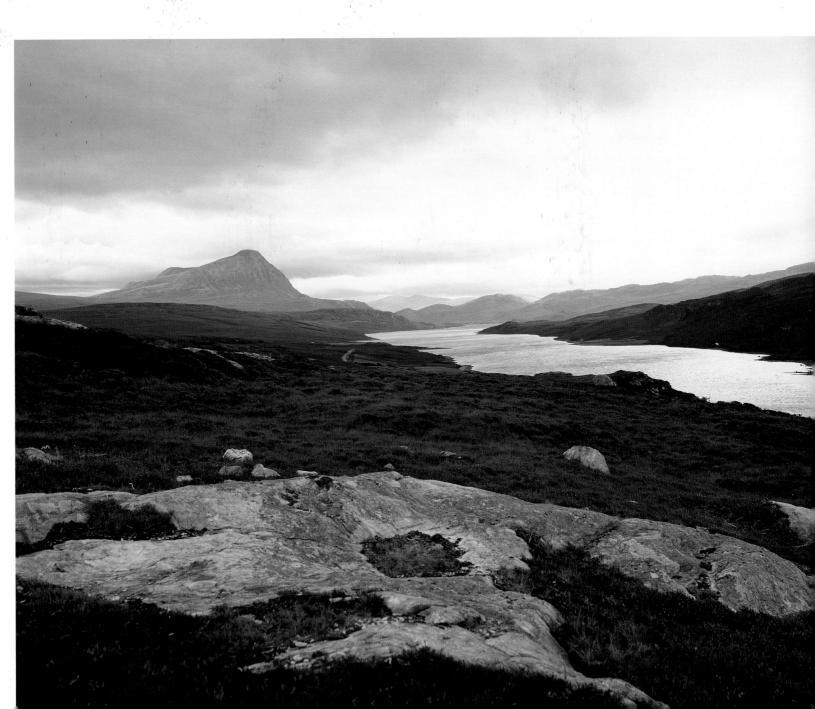

LEFT: Achriesgill, Loch Inchard, Sutherland. At the head of Loch Inchard lies the settlement of Achriesgill.

RIGHT: Loch Hope is perhaps best known for its wonderful sea-trout fishing, although salmon and grilse are also regular catches. The loch is about six miles long by a mile wide and set in remote but spectacular scenery.

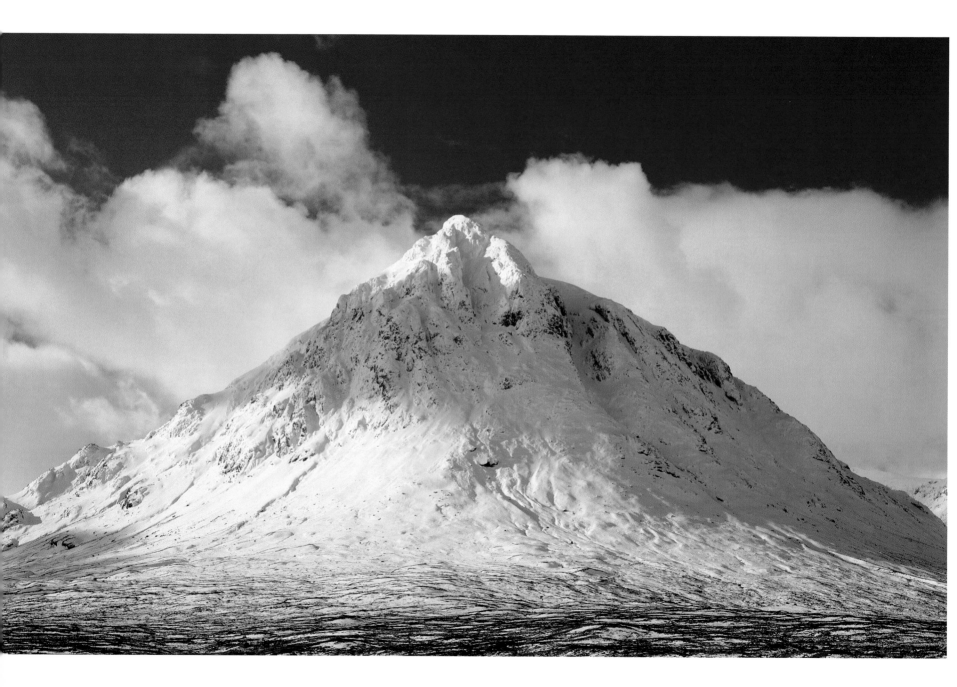

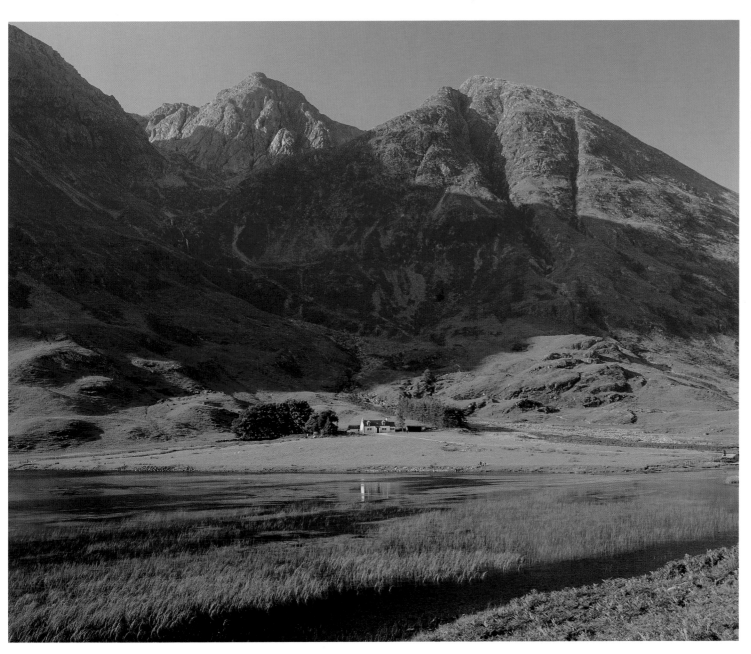

LEFT: The awesome heights of Glencoe look forbidding even in summer. Situated in the north of Argyllshire, Glencoe is a part of the designated National Scenic Area of Ben Nevis and Glen Coe.

FAR LEFT: Glencoe. Guarding the southern approaches to the valley of Glencoe stands the imposing presence of Buchaille Etive Mor. Affectionately known as the "Boockle," the mountain is a magnet for climbers all year around, especially in winter, but must always be treated with the greatest respect.

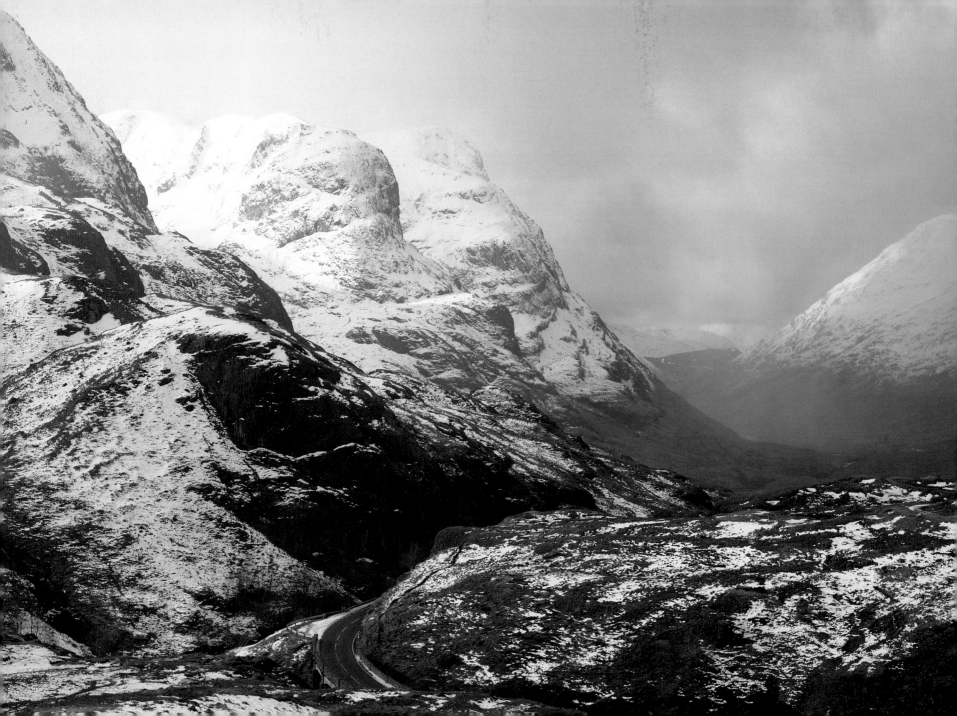

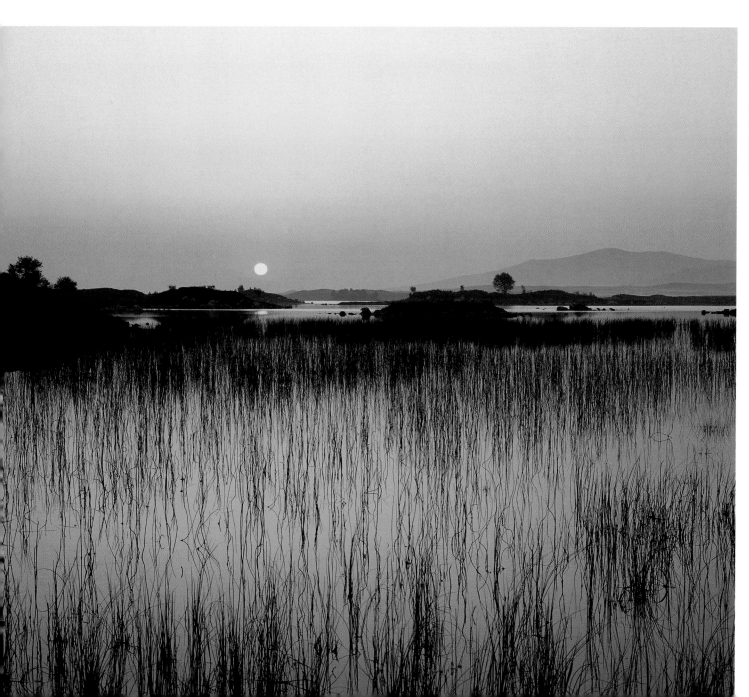

LEFT: Rannoch Moor at sunset. Located at the mouth of Glencoe, the Moors are approximately 50 square miles of high rugged moorland plateau dotted with streams, lochs, lochans, heather, and peat bogs, the whole almost encircled by high mountains.

FAR LEFT: The Three Sisters guarding the road into Glencoe. The hills are the remains of a volcano which collapsed in on itself during a series of violent eruptions. As well as being important geologically, Glencoe is also an area of international botanical importance, particularly for the woodlands and arctic alpine flora.

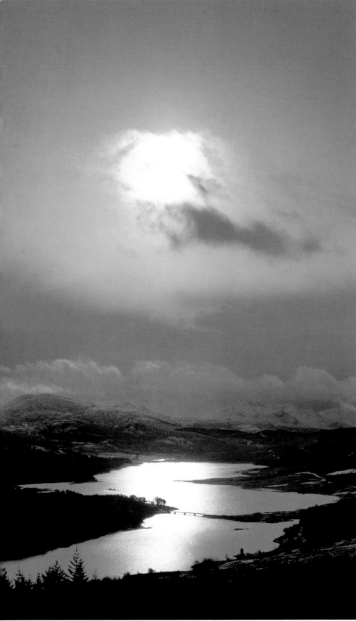

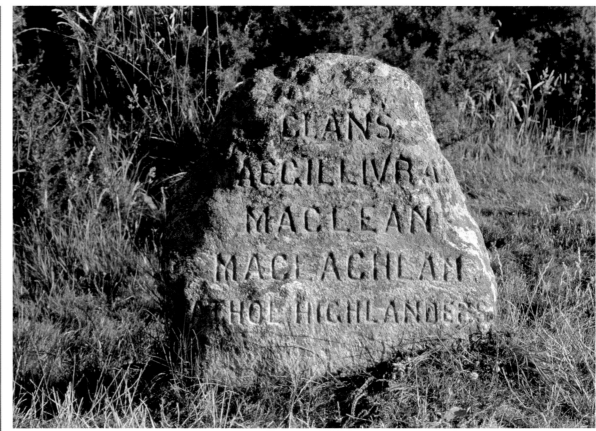

LEFT: Winter light southwest over Loch Garry. 150 displaced crofters left Loch Garry in 1792 and emigrated to Canada where they founded Glengarry County, Ontario.

ABOVE: Clan burial stone at Culloden battlefield, Drumossie moor, near Inverness. The battle of Culloden took place in April 16, 1746, between Highland clansmen fighting for the Stuart cause and a far greater number of government redcoat troops, many of them Scottish. The battle lasted under an hour with the soldiers' muskets ripping the Highlanders apart. Culloden was the last battle on mainland Britain.

RIGHT: The high road across Dundonnell Forest running straight towards the imposing mass of the grey slopes of An Teallach. The central ridge has six main tops all over 3,000ft, with two of them counting as Munros.

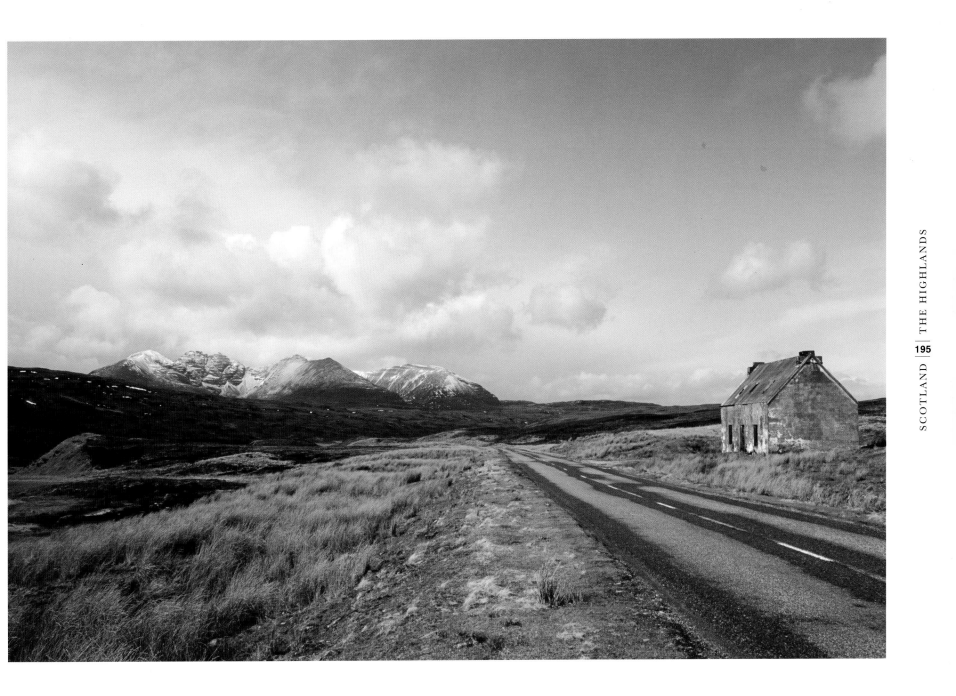

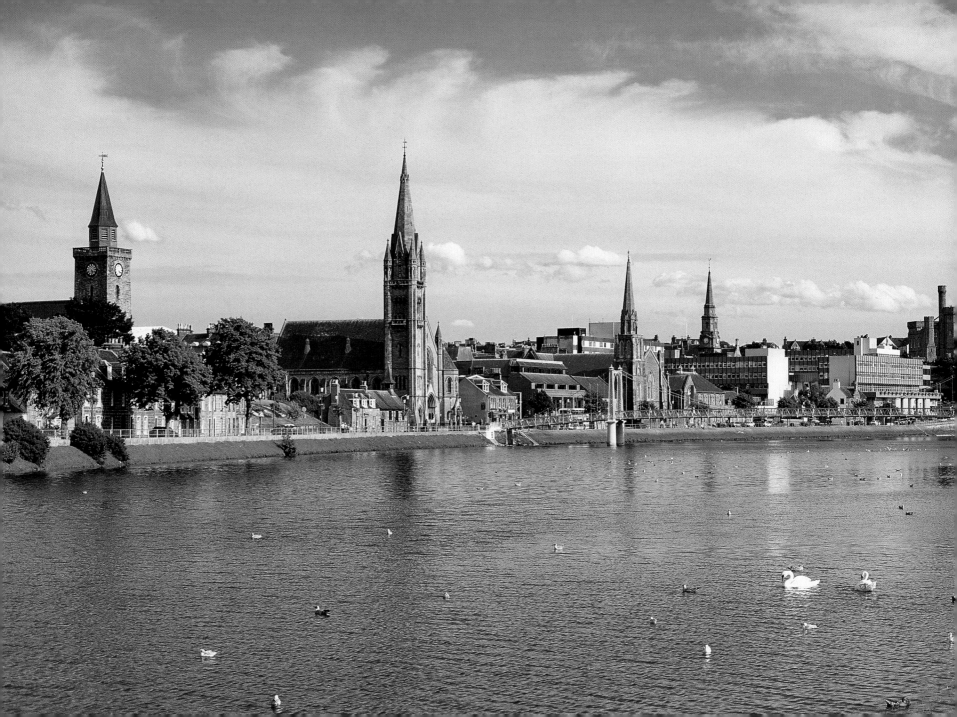

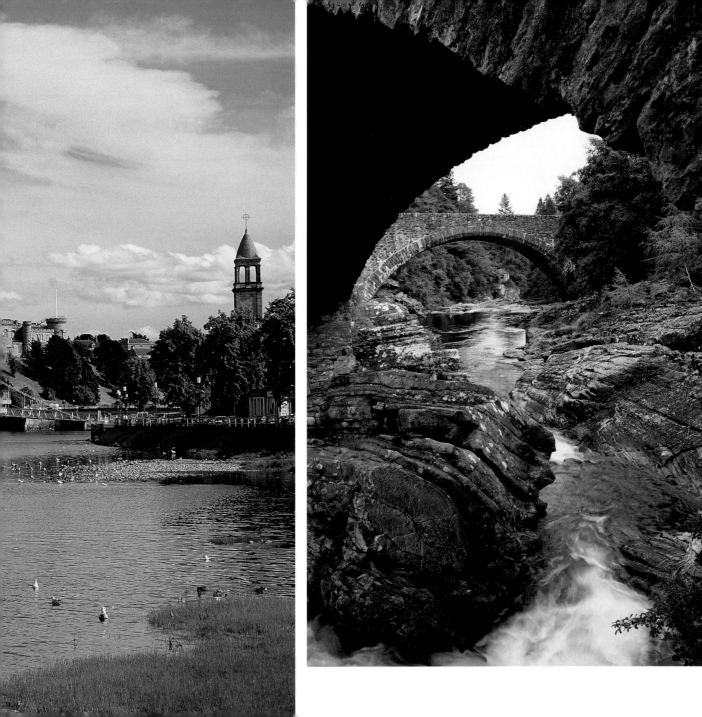

197

LEFT: On the west side of Loch Ness lies the tiny village of Invermoriston where over the River Moriston is a bridge (foreground) designed by the Scottish engineer Thomas Telford in 1813. Built as part of the Caledonian Canal which itself was an employment scheme during the Highland Clearances, although now part ruined it can still be crossed by foot.

FAR LEFT: Inverness Castle sits on a low bank overlooking the river. It was possibly built by Macbeth, High King of Scotland in the mid-eleventh century and then destroyed by Malcolm Canmore in 1057. The present castle dates from the late 1830s and now houses the principal law courts for the Inverness area.

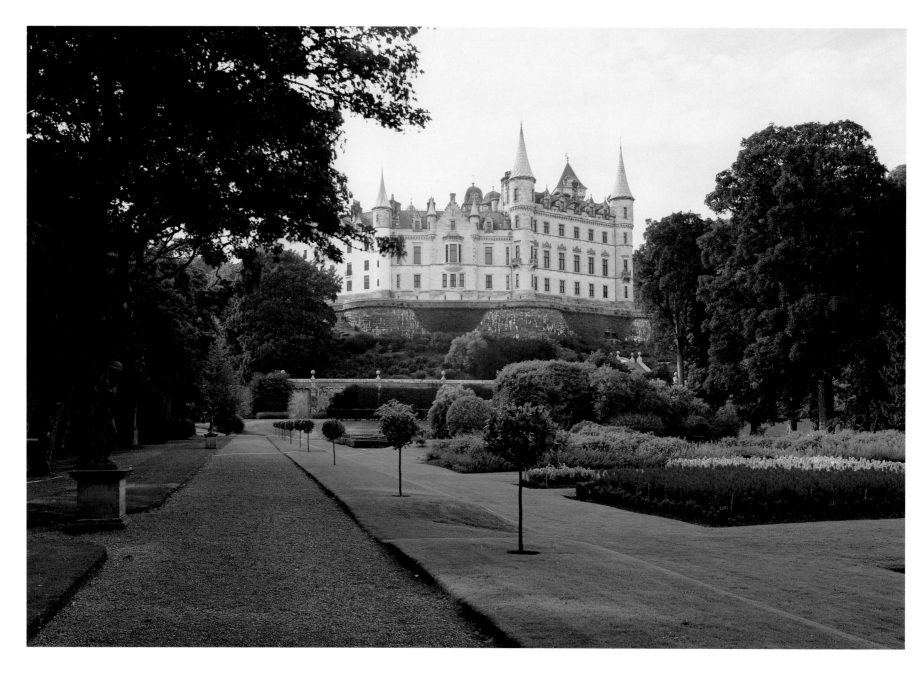

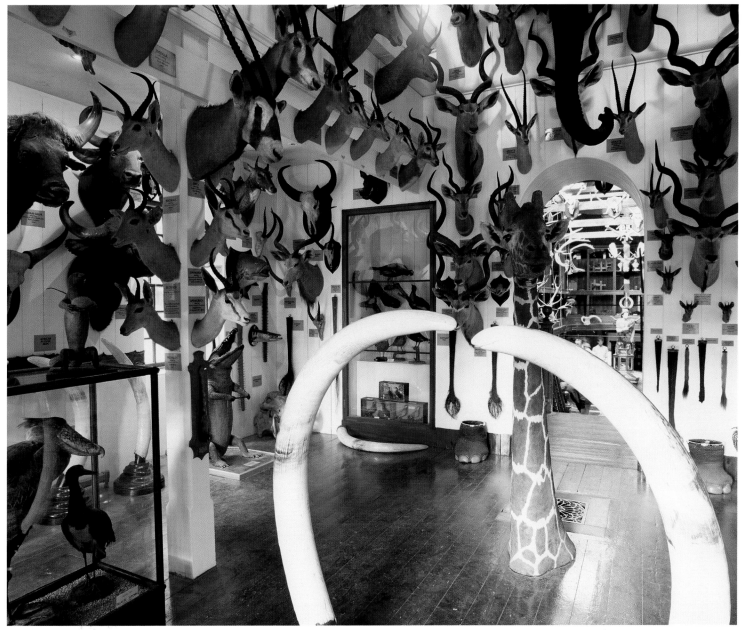

FAR LEFT: Dunrobin Castle, Sutherland. On the east coast of north Scotland with views out to the North Sea lies Dunrobin Castle—the seat of the earls and dukes of Sutherland. It is the most northerly of the great houses of Scotland and the oldest parts date back to the 1300s. The French-influenced architecture was surrounded by formal gardens laid out in 1850 which were designed by Sir Charles Barry, best known for designing the Houses of Parliament in London.

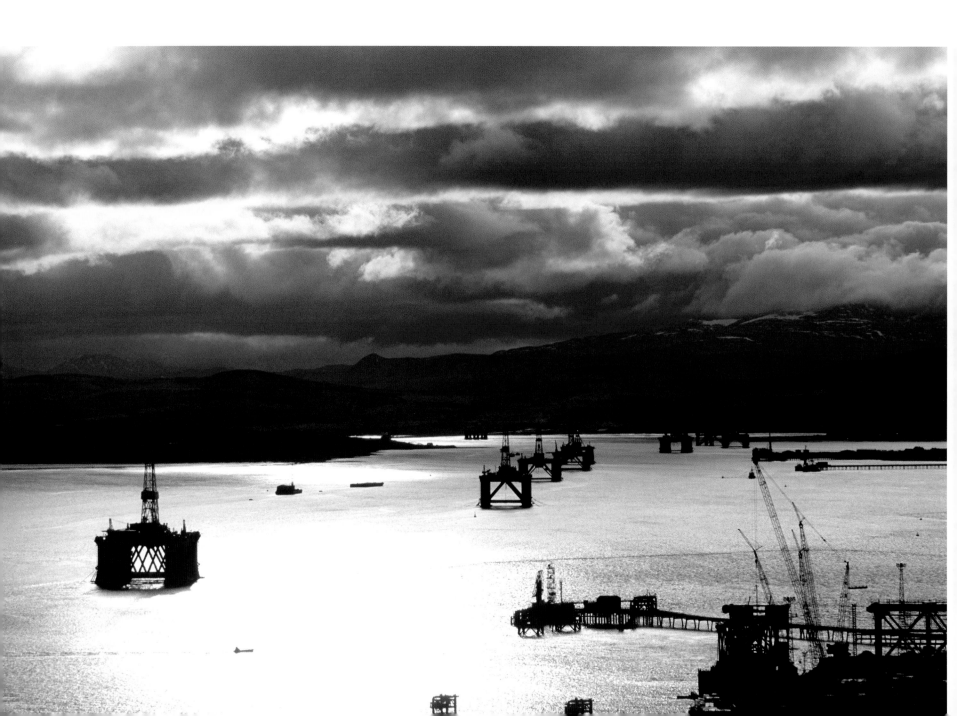

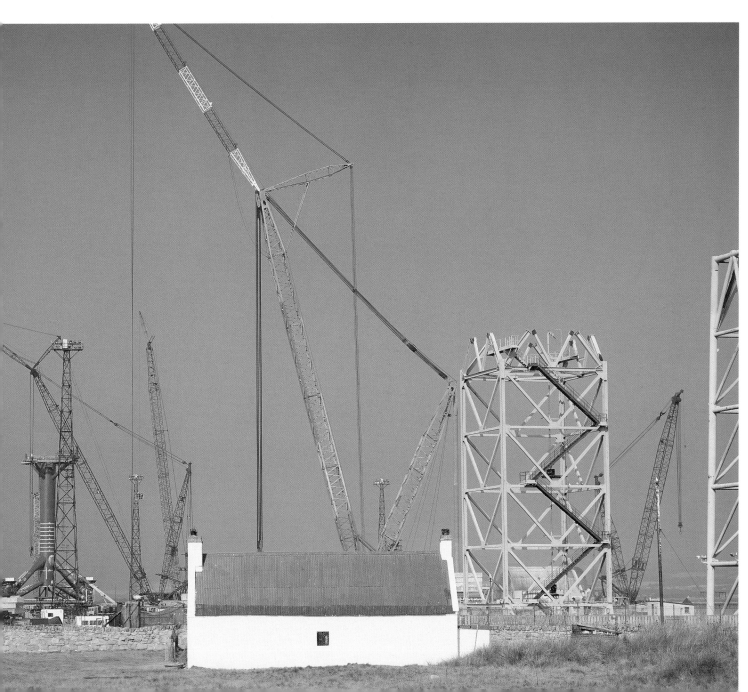

LEFT AND FAR LEFT: North Sea oil rig base on Cromarty Firth. The Firth is very deep and provides welcome sheltered mooring on this otherwise dangerous coast and so is ideal for these massive oil rigs. The rigs are moored along the length of the Firth near Nigg and Invergordon service and construction yards before being moved to their drilling sites.

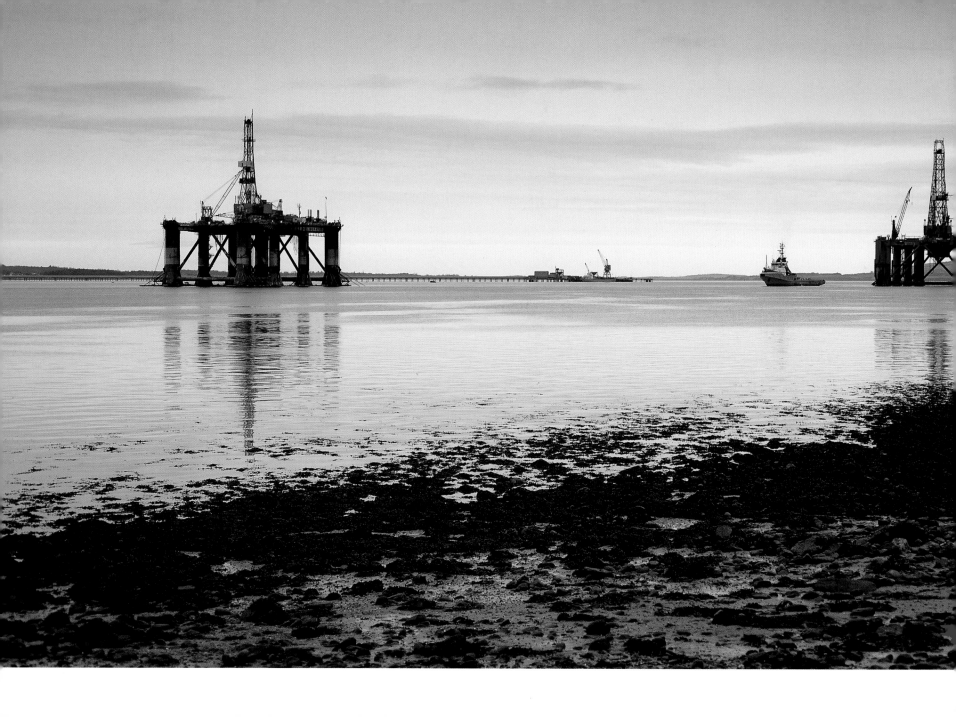

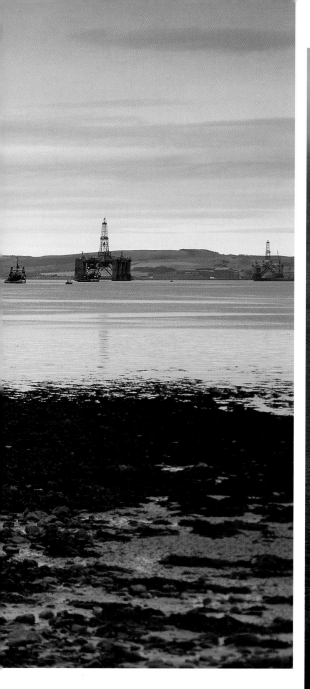

LEFT: The most northerly point on mainland Britain, Dunnet Head sits high above the Pentland Firth. On a clear day the view is clear for miles, outwards to Hoy and Orkney, north-west to Cape Wrath, and inland to the peaks of Morvern and Maiden Pap.

FAR LEFT: Another view of the North Sea oil rig base on Cromarty Firth.

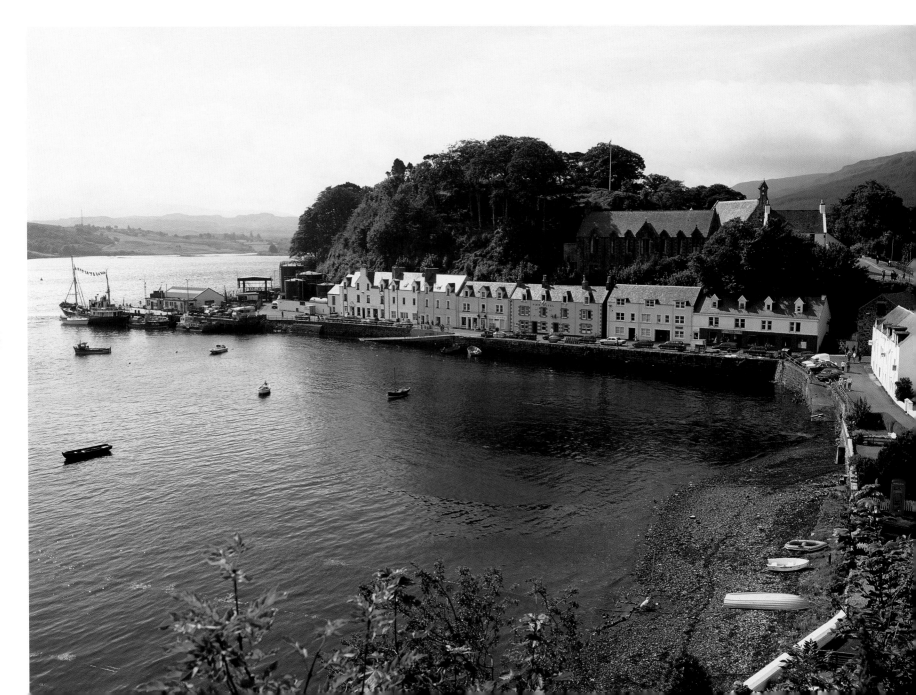

LEFT: The small fishing port of Portree, is the main town on the Isle of Skye. From the Gaelic Port-an-Righ, meaning King's Port, the name is attributed to a visit from King James V in 1540 when he came to Skye in an attempt to gather support from the island clans. Until then, the town was called Kiltraglen.

RIGHT: Looking across Loch Scavaig at the Cuillin Hills on the Isle of Skye. The range includes fifteen peaks over 3,000ft. The Cullins form two main ridges, the jagged Black Cuillins are the remains of ancient volcanic activity and the granite and more rounded Red Cuillins to the east.

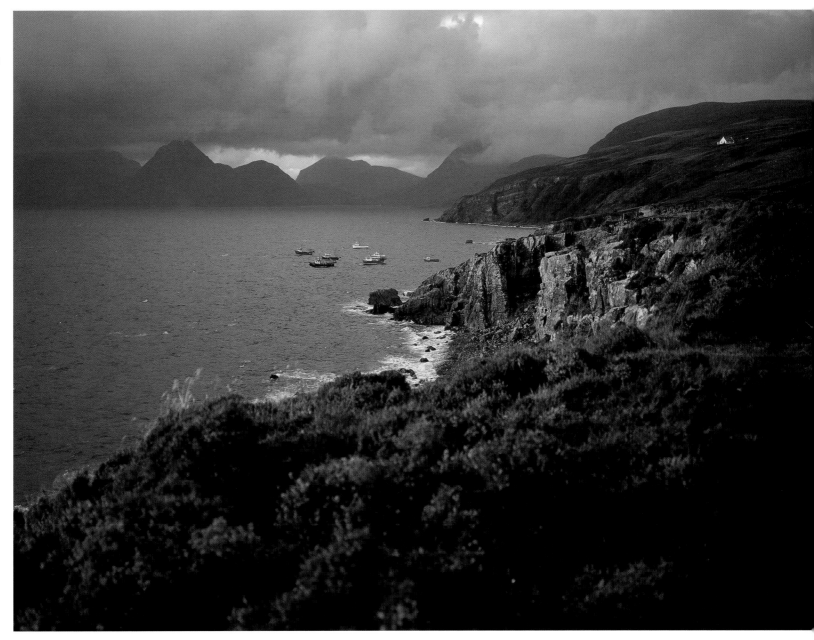

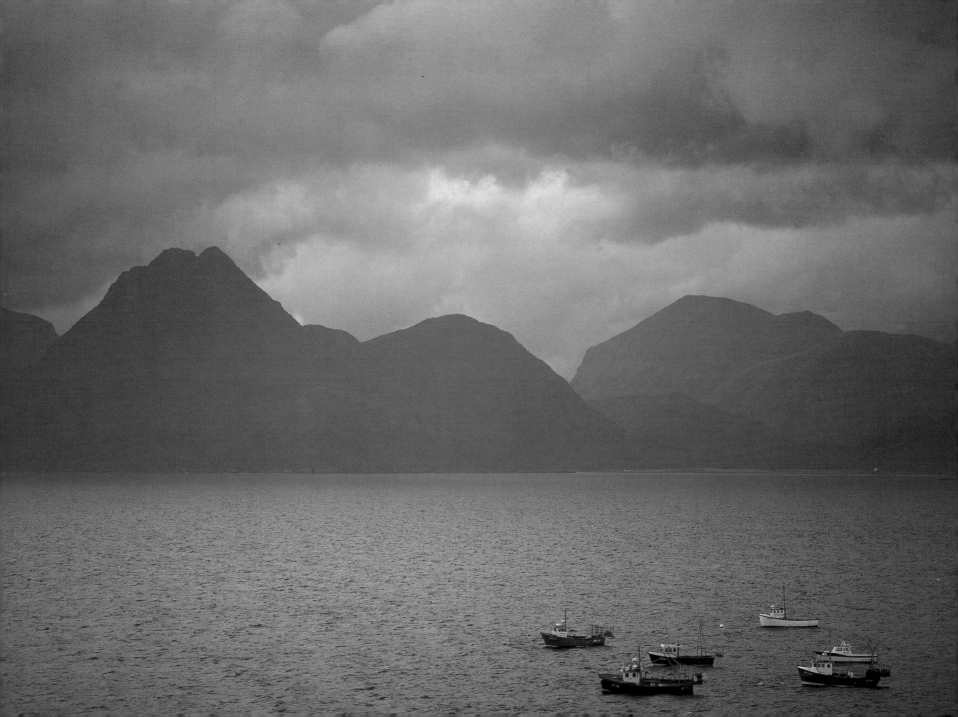

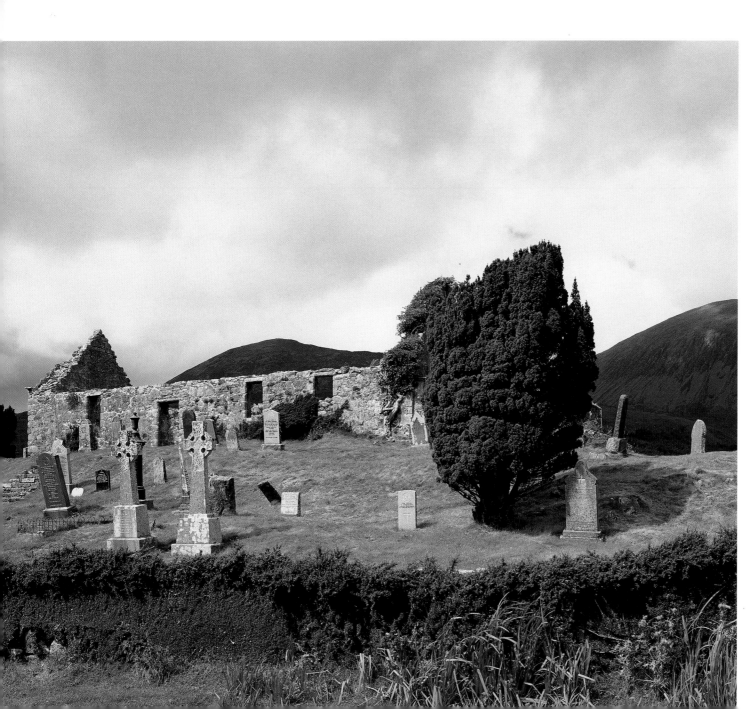

LEFT: The old church and burial ground of Cill Chriosd ("Christ's Church"), near Broadford, Isle of Skye. The church was built around 1505; it was in use until it was superseded by a newer church in nearby Broadford in 1840.

FAR LEFT: Looking across Loch Scavaig at the Cuillin Hills on the Isle of Skye.

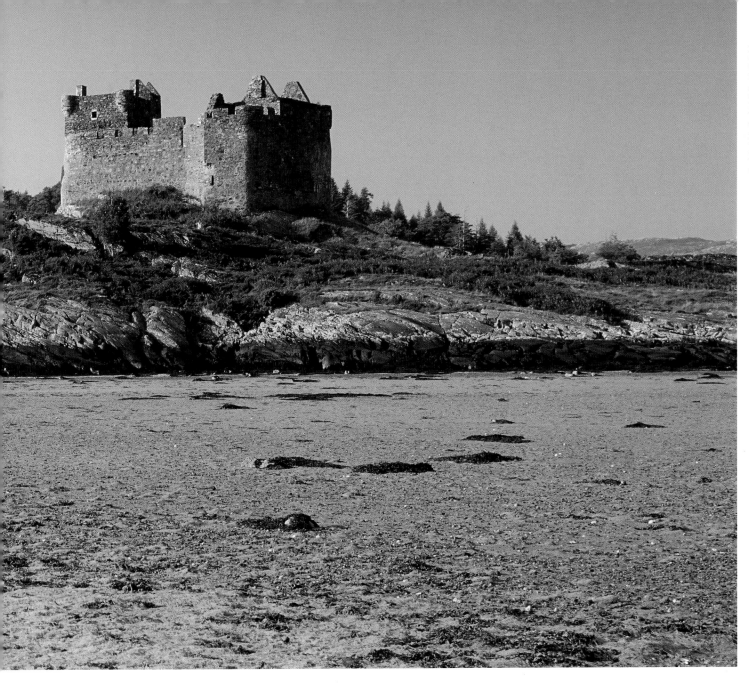

LEFT: Tioram (pronounced "Cheerum")
Castle at the head of Loch Moidart has
been an impressive ruin since the Jacobites
burned it during the first rising (in 1715) to
stop it from being held by the enemy. The
former seat of the MacDonalds of Clan
Ranald, the curtain wall dates from the
thirteenth century; the tower and other
interior buildings are fourteenth–sixteenth
century. Situated on the coast south of
Mallaig, some 50 miles from Fort William,
it is only possible to cross to it on foot at low
tide when a small spit of land becomes
obvious.

SCOTLAND | THE HIGHLANDS

211

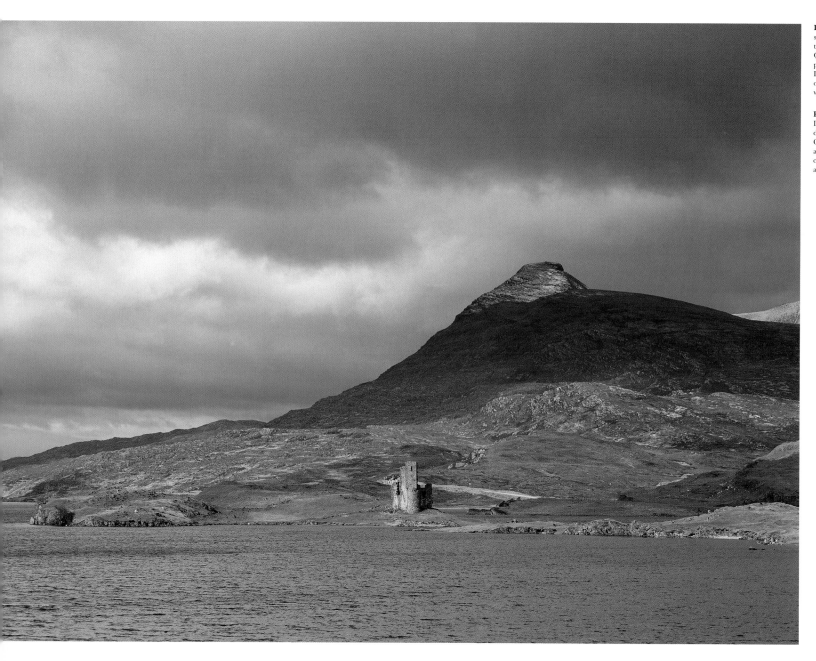

LEFT: Ardvreck Castle, Sutherland. Set in splendid isolation, Ardvreck Castle sits on the shore of Loch Assynt with the peak of Quinag rising behind. The castle was probably built in the 1590s by the Macleods. It was destroyed by fire in the eighteenth century thanks, legend has it, to an old woman's curse.

RIGHT: Quinag mountain as seen across Loch Cairnbawn. Quinag comprises three distinct peaks, the highest of which is Sail Gharbh which rises to 2,650ft. The entire area is fascinating geologically as it is composed of quartz, Torridonian sandstone, and Lewisian gneiss.

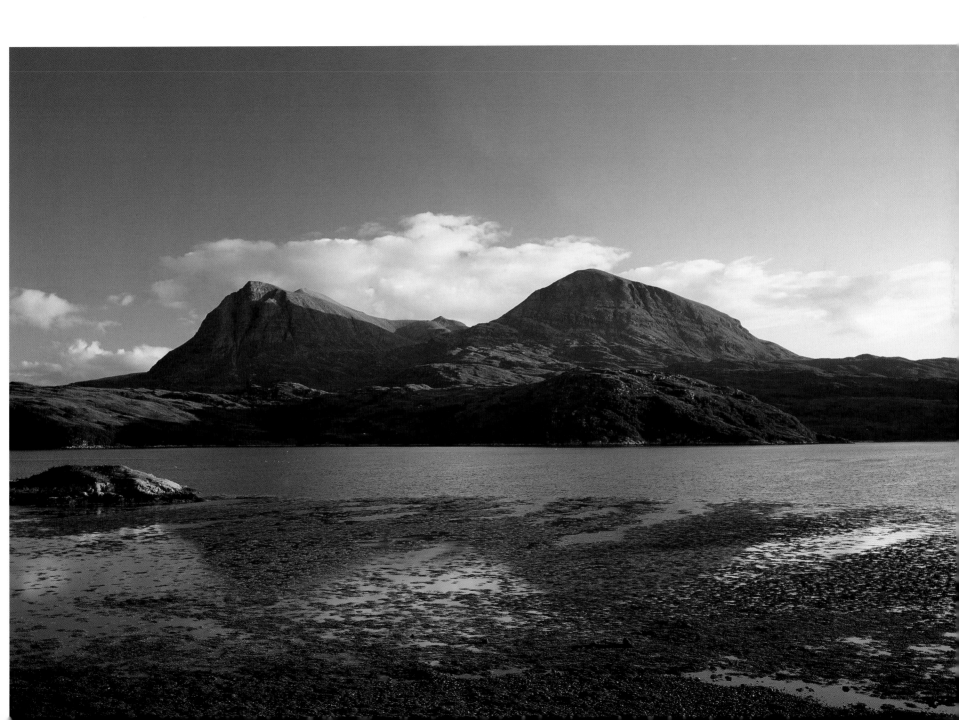

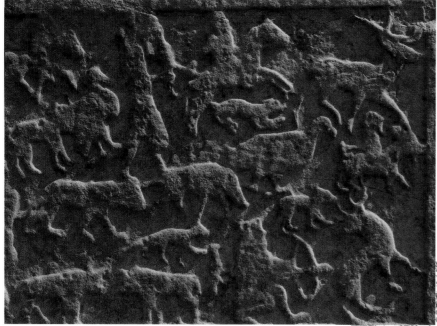

LEFT: Shandwick, Ross and Cromarty. On top of a hill just beyond the small village of Shandwick is an almost 9ft tall Pictish stone slab covered with carvings known as the "Clach a' Charridh" or Shandwick Stone. Dating from 780 AD the stone was used as a beacon for local fisherman until it was blown down in a gale in 1846 and broken in half. It is now restored and protected within a large glass case on its original site.

RIGHT: Rain squall over Gruinard Bay, Wester Ross. While most of the surrounding coastline is rocky, Gruinard Bay has three beautiful sandy beaches made from the pink Torridon rocks.

BELOW: In Glen Beag, near Glenelg are three Iron Age brochs. The Upper Broch, also known as Dun Troddan, has a circular interior and massive 7.5m high double walls. The double shell walls are 3ft apart which gives added strength to the structure.

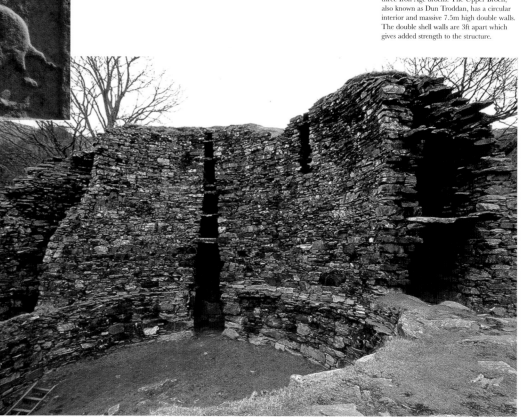

OVERLEAF

LEFT: On a formidable stretch of coast characterized by high, sheer cliffs is the small settlement of Durness, the most northwesterly village on mainland Scotland.

BELOW: The beach at Traigh na Uamhag, east of Durness, is just one of many stunning beaches in the area. In 1841 the village is also notable for being the first place whose inhabitants refused to move off the land for sheep when their landlord tried to evict them.

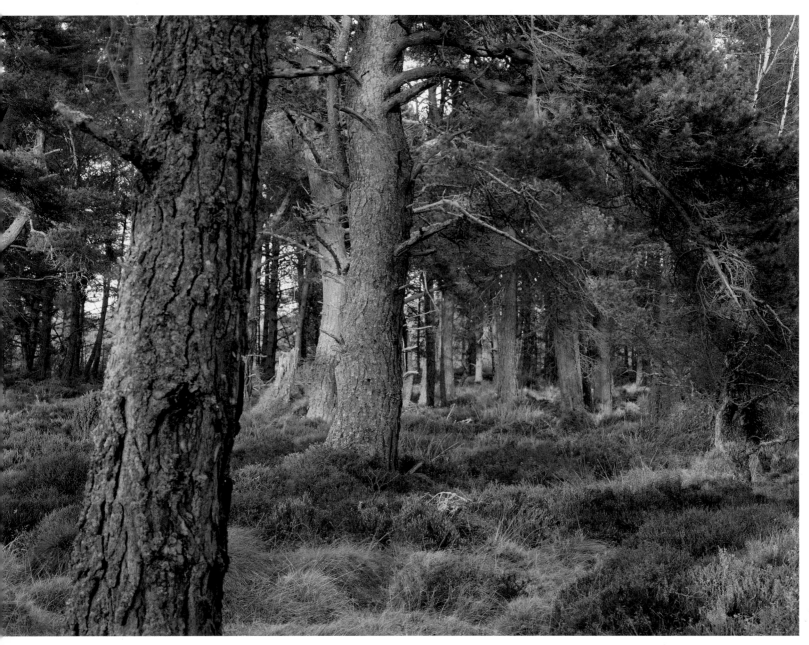

LEFT: The rare indigenous forest around Loch Garten in the Abernethy Forest Nature Reserve. The forest is made up of Scots pine trees with an undergrowth of heather and bilberry. The reserve is famous for its ospreys and red squirrels, but capercaillies, crested tits and Scottish crossbills are also forest residents.

RIGHT: Glenfinnan and Loch Shiel. View looking down towards the statue of an anonymous Highlander which marks the spot where the standard was raised for Bonnie Prince Charlie and the 1745 Jacobite Rebellion.

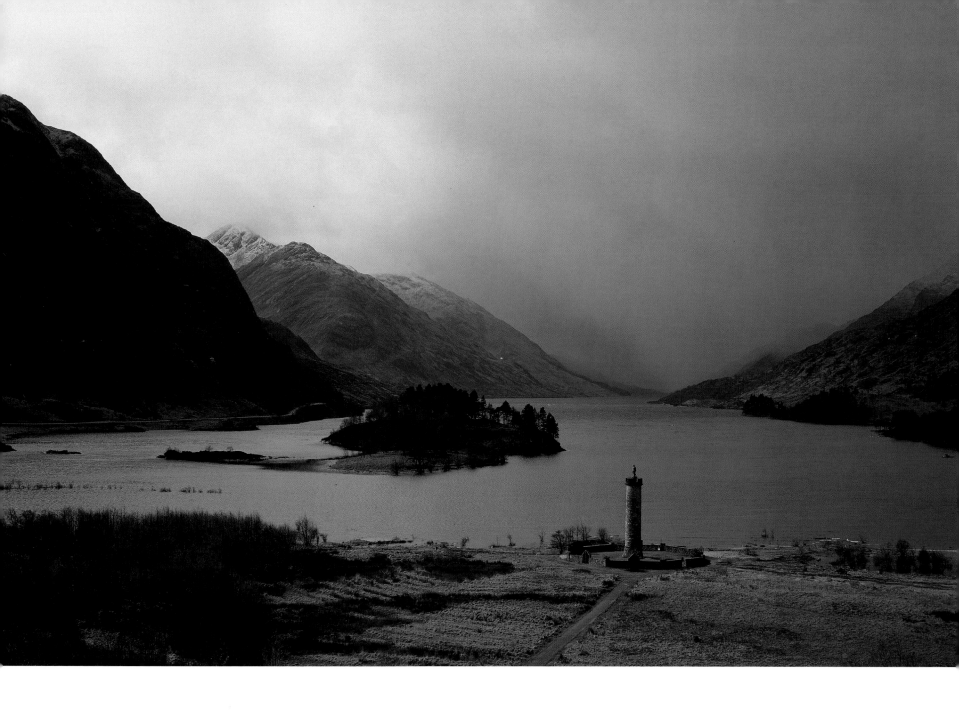

RIGHT: The Spean Commando Memorial near Spean Bridge is backed by their training grounds around the slopes of Ben Nevis and Aonach Beag. The bronze memorial was erected here in 1952 to commemorate the elite units who trained here in preparation for the Normandy Landings during World War II. The memorial was designed by Scott Sutherland.

FAR RIGHT: Eilean Donan Castle on the shore of Loch Duich. The island has been a fortified site for at least 800 years; however, the present castle was rebuilt between 1912–32 by Lt Col John MacRae-Gilstrap.

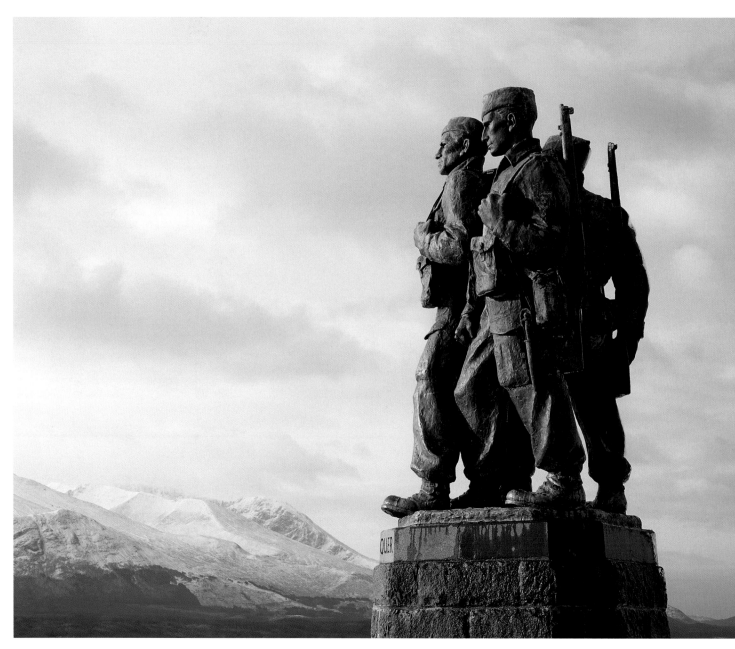

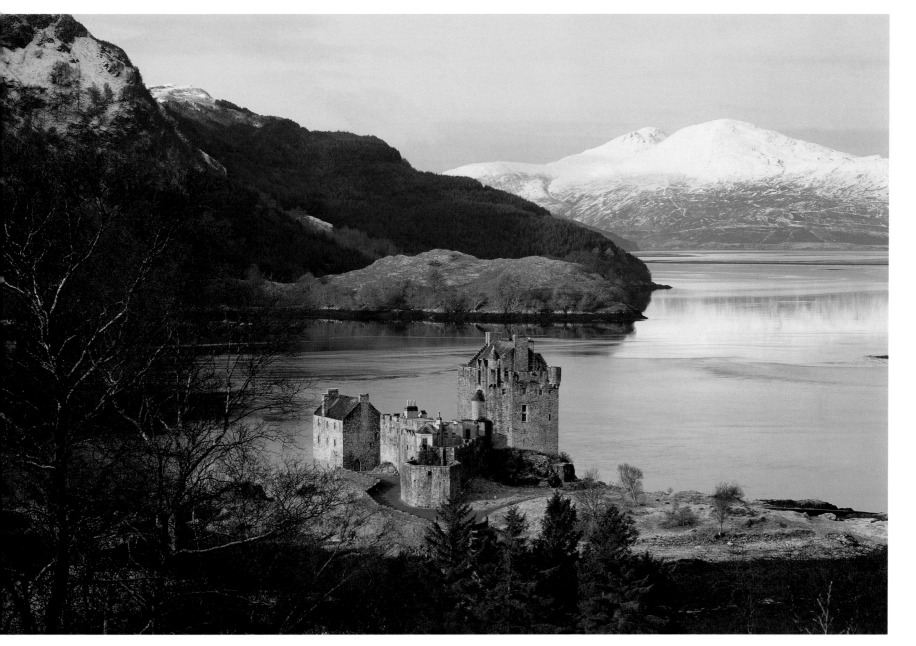

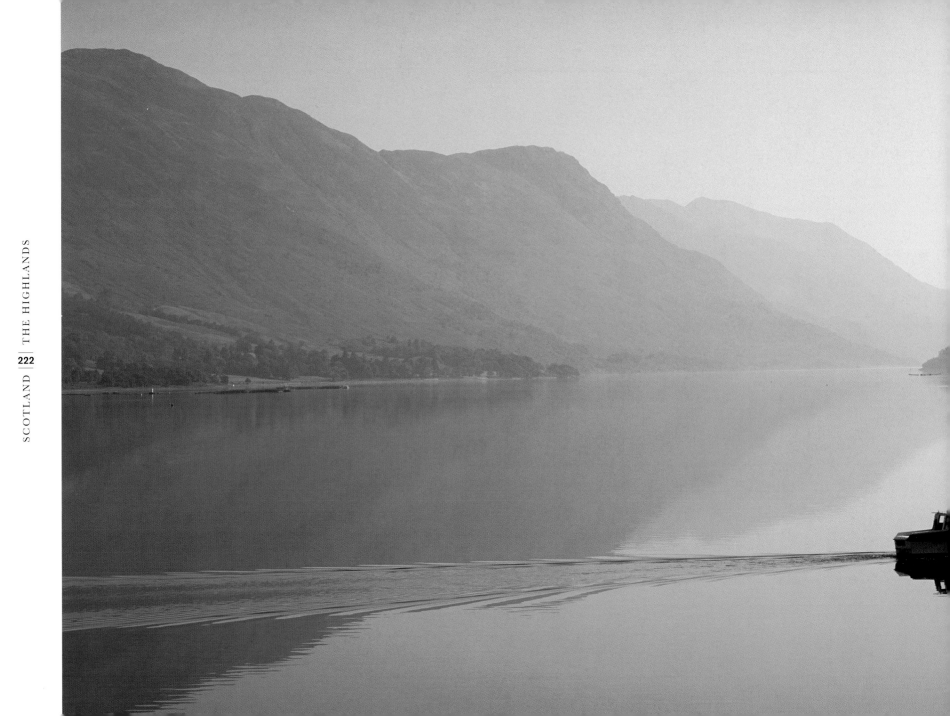

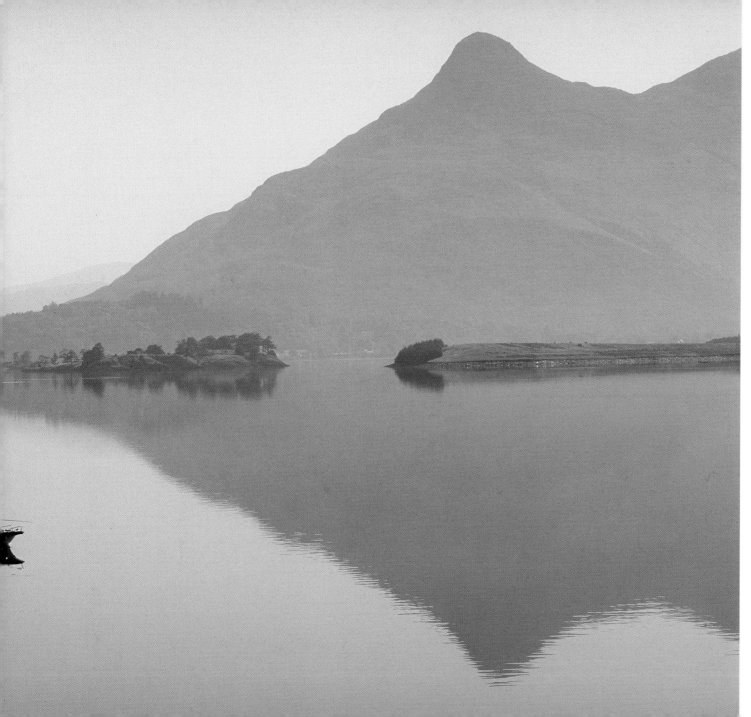

LEFT: The limpid waters of Loch Leven reflect the dawn and *Sgorr na Cich*—the Pap of Glencoe (right). At 2,435ft it is not the toughest of Glencoe's peaks—indeed, it isn't even a Munro—but it presents an interesting scramble, excellent views in all directions, and it is the final part of the famous Aonach Eagach Ridge that runs down the north side of the glen.

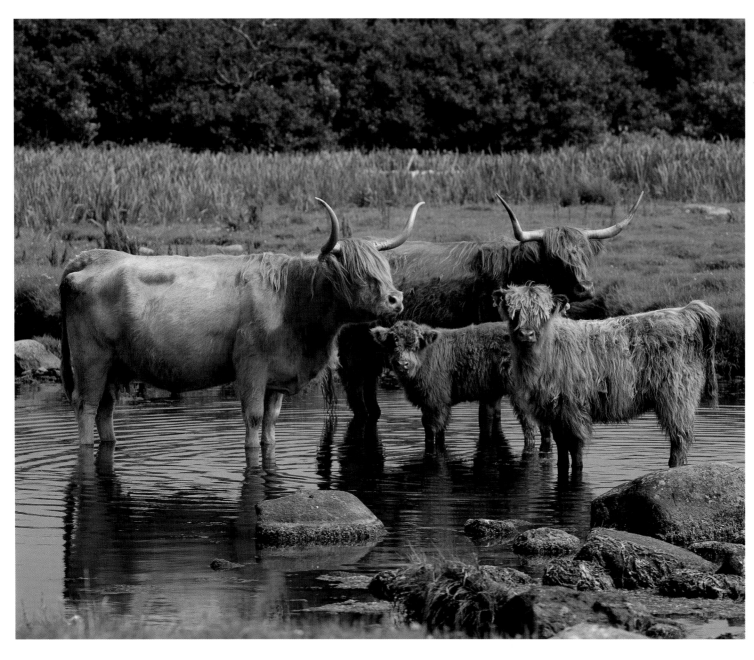

LEFT: It is hard not to fall for the wonderfully shaggy Highland cattle. The breed has remained much the same for centuries. They are exceptionally rugged being able to withstand the worst weather are uniquely able to graze effectively off the poor highland grass. Yet they live longer than most breeds with the cows able to calf until they are 18 or more years old.

RIGHT: The Falls of Rogie on the Blackwater in Ross and Cromarty. Much of the surrounding mixed woodland is a working forest but the area is provided with a number of nature trails from which can be seen red squirrels, and occasionally pine martins and even the rare Scottish wildcat.

OVERLEAF

LEFT: Loch Maree, Ross and Cromarty. View across the loch to the towering mass of Slioch which reaches a height of 3,215ft. Remote Loch Maree at over 12 miles long is the fourth largest freshwater loch in Scotland. It contains over 30 islands including Isle Maree with the remains of an ancient chapel and the seventh century hermitage of saint Maelrubha.

RIGHT: Loch Moidart is a western sea loch that opens out in two channels (north and south) around the island of *Eilean Shona*—the "island of the ford"—at the northern edge of the Ardnamurchan peninsula.

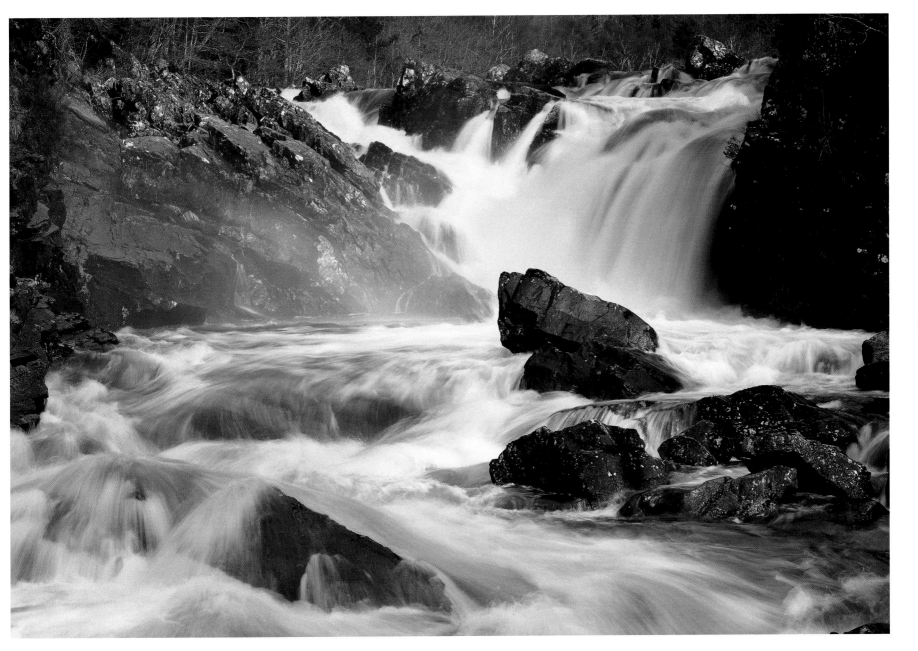

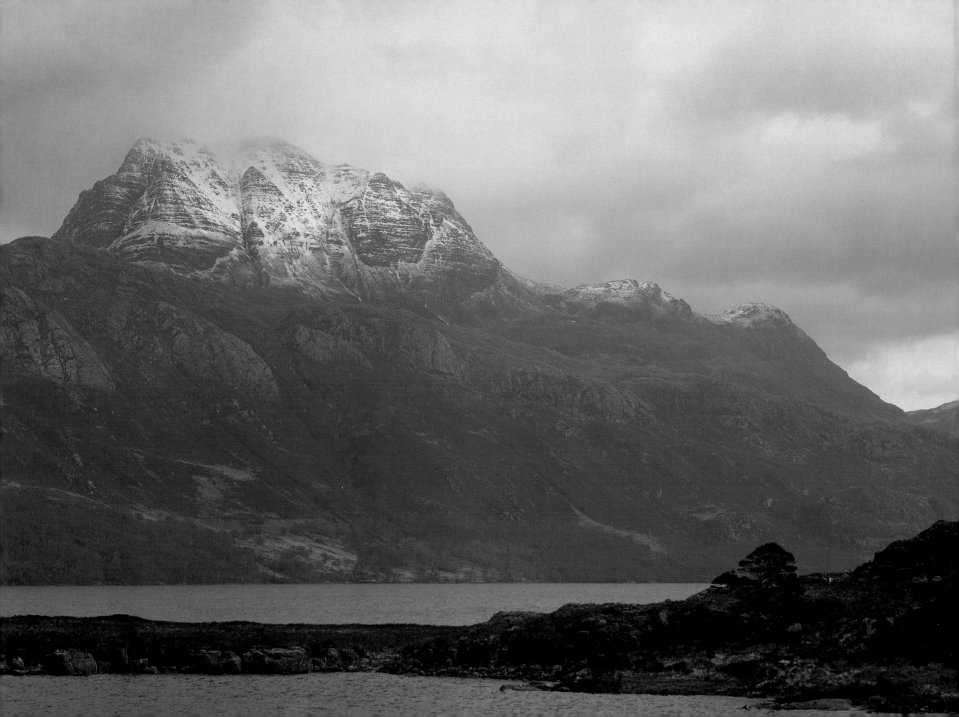

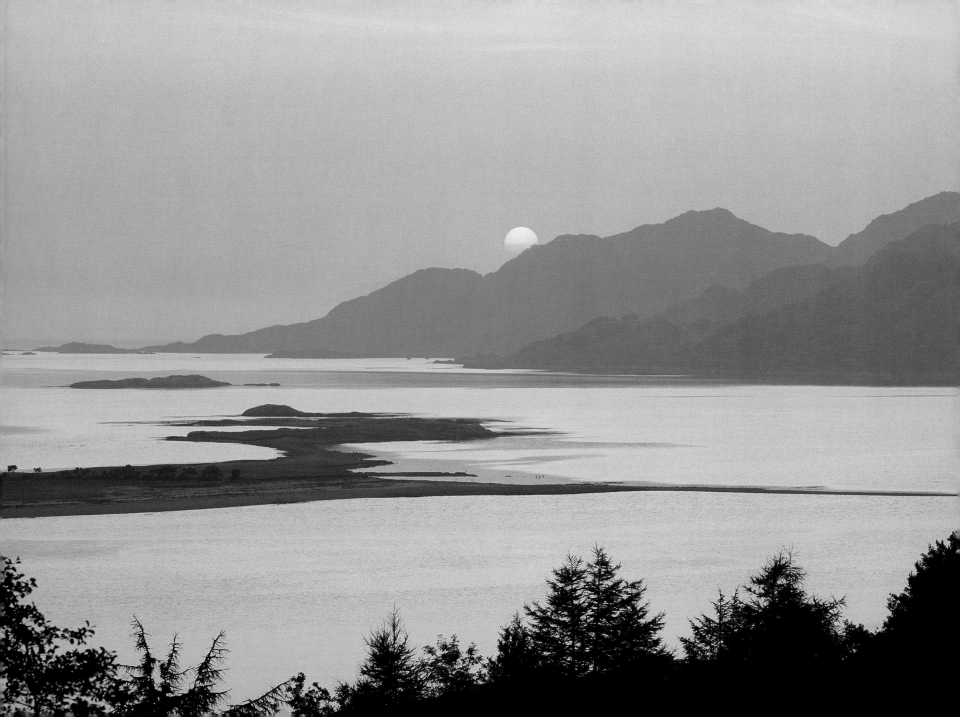

The Western Isles, the Orkneys and the Shetlands

The remotest places in Scotland are found on some of the many islands that sit off the mainland. Off the northwest coast lie the Western Isles, also known as the Outer Hebrides, an archipelago made up of over 200 islands, the vast majority uninhabited except for seabirds and marine life, plus the occasional fisherman. The best known are the Isle of Lewis, North and South Harris, North and South Uist, and Benbecula.

Only six miles off the extreme north coast of Scotland lie the 70 or so Orkney islands, also known as the Outer Isles. The best known of the Orkneys is Mainland, to the south of which is the famous sound of Scapa Flow, so important as an anchorage during World War I in particular. Across the water lies the island of Hoy, the second largest Orkney island. Of more ancient heritage are the many neolithic remains scattered around the islands.

A long way further north lie the hundred plus Shetland Islands which did not become part of Scotland until the late fourteenth century when it was part of the dowry of Margaret, daughter of the king of Denmark, who married King James III of Scotland. Before then Shetland was a mixture of Norse and Viking elements which are still strong in the character of the islands today. Only fourteen of the islands are inhabited and the biggest by far is Mainland. Due to the extreme weather conditions there are virtually no trees on Shetland but there are many ancient remains and the entire collection of islands comprise one of the most interesting and significant geological areas in the world.

RIGHT: South Uist, Western Isles. Looking southwest across Loch Bee. The loch is connected to the Atlantic Ocean and via a flood gate to the Minch, making the waters a mix of salt and fresh water. This attracts wildlife that flourishes on brackish water, most notably a resident population of mute swans but also migrating whooper swans in winter.

RIGHT: South Uist, Western Isles. Croft near Loch Sgioport. The small and remote hamlet of Loch Sgioport is at the head of the loch on the isolated east coast of South Uist.

FAR RIGHT: South Uist, Western Isles. Sheep beside the B 890—the road to Loch Sagioport. Many of the roads in the Outer Hebrides are single track with passing places; straying off the road can be risky as they are often flanked by rocky ditches on either side. Furthermore, the sheep wander wherever they choose and that is often all over the road.

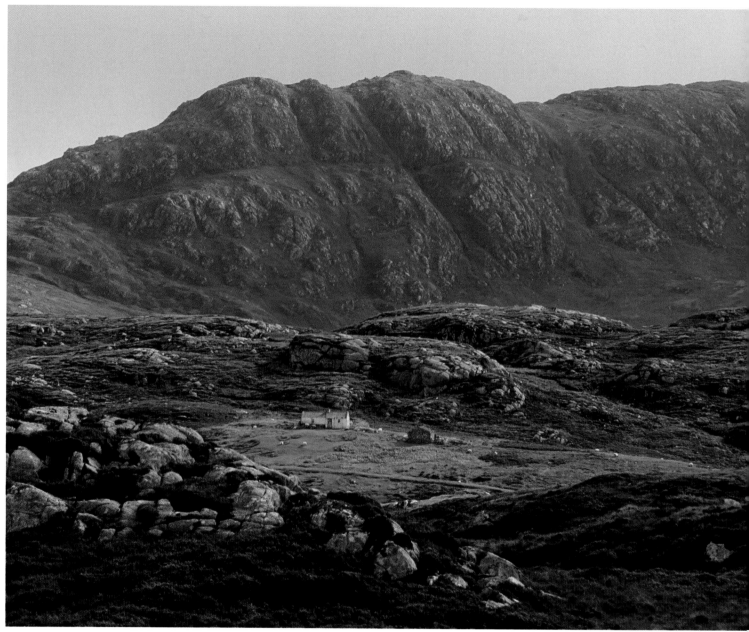

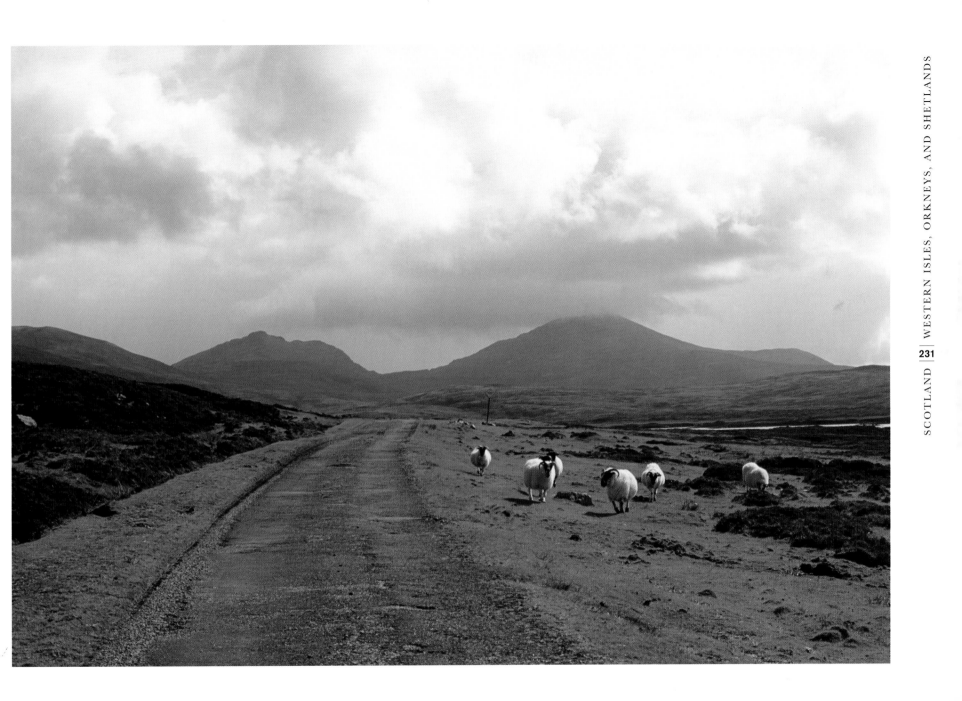

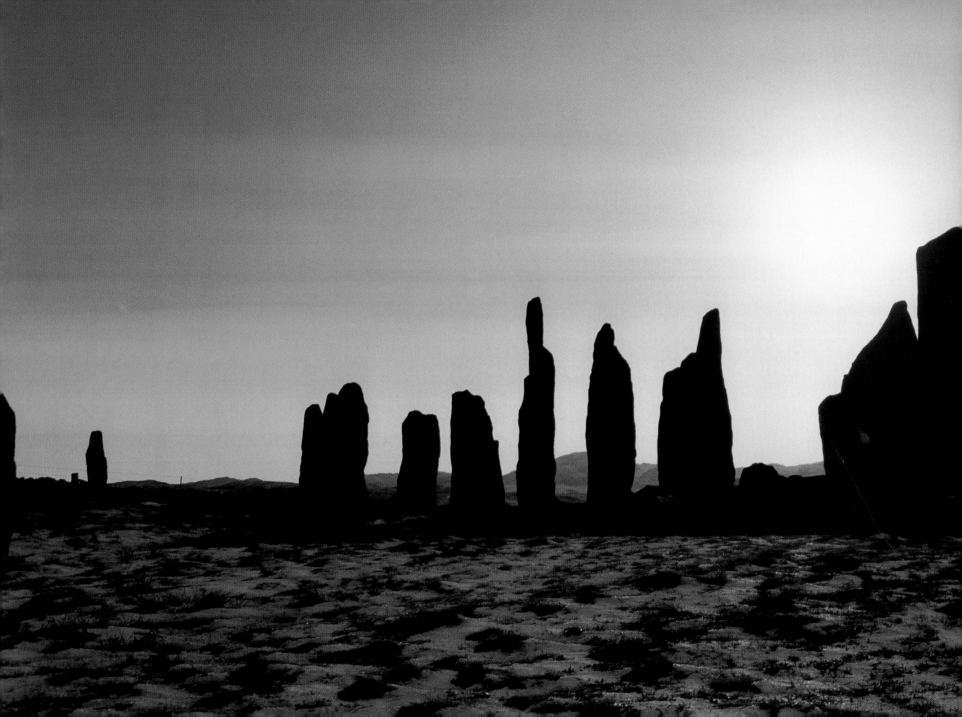

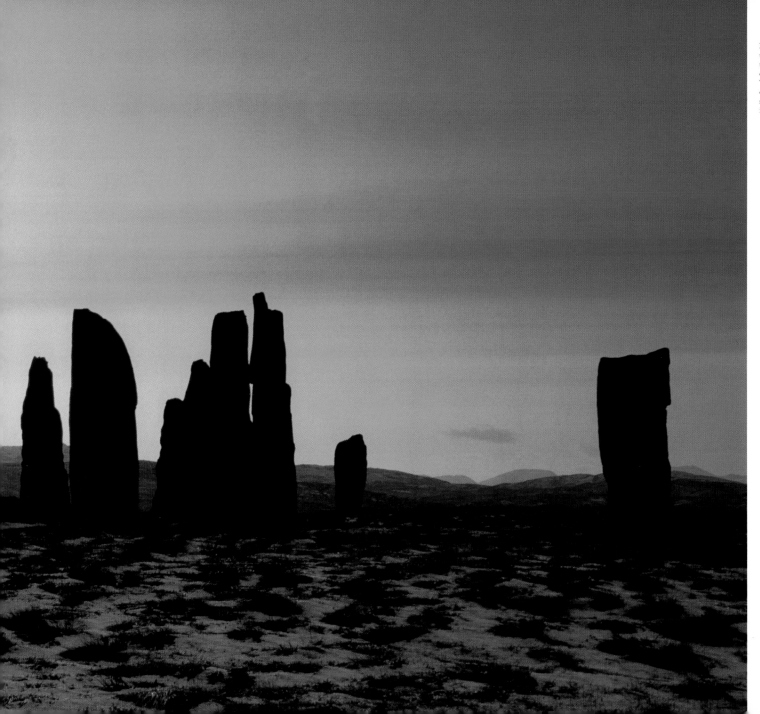

LEFT: Lewis, Western Isles. Sunset behind the prehistoric stone circle at Callanish on the isle of Lewis. The 50 or so stones form a circle with four avenues of standing stones. They date from 2000-1500 BC. The area was excavated in 1857 by which time the surrounding peat was almost 6ft deep. Lewis is the largest island in the Outer Hebrides.

SCOTLAND | WESTERN ISLES, ORKNEYS, AND SHETLANDS

233

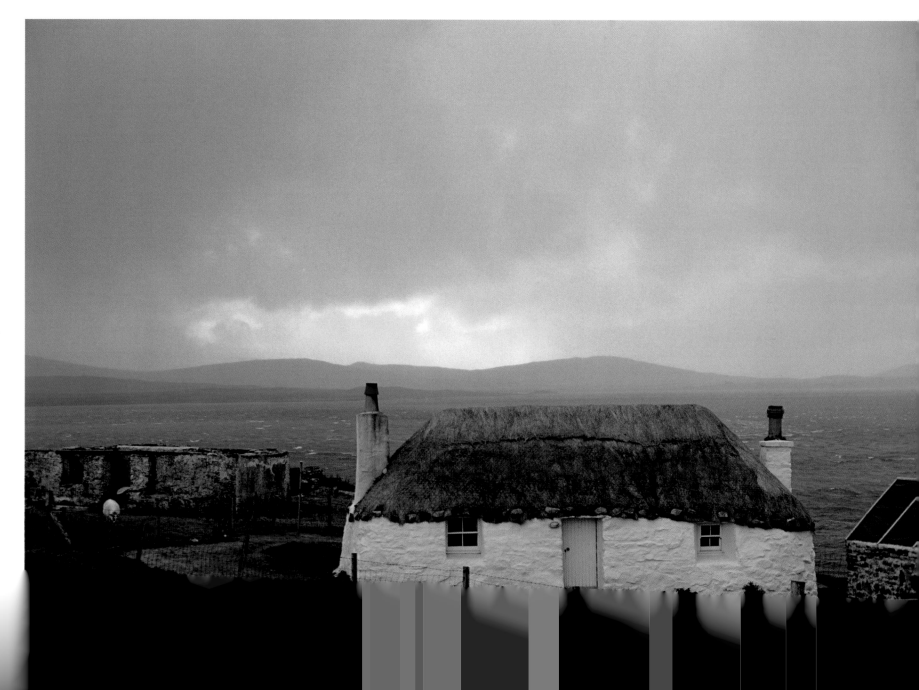

LEFT: North Uist, Western Isles. Croft at Malacleit. The island is only 12 miles from north to south and 18 miles from east to west. Much of the east is taken up with freshwater lochans that attract huge numbers of birds. The Royal Society for the Protection of Birds has a reserve at Balranald.

RIGHT: North Uist, Western Isles. A rainbow shows the way eastward to Malacleit. The quiet roads offer access to stunning views of unspoilt beauty and a huge range of flora and fauna. One of the ubiquitous highlights of the Uists is the rasping sound of the Corncrake, so rare everywhere else.

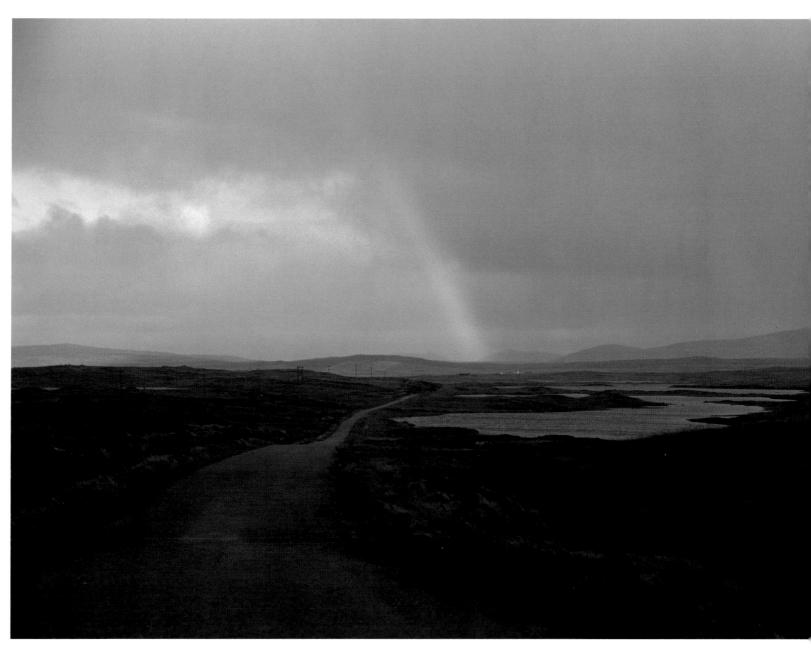

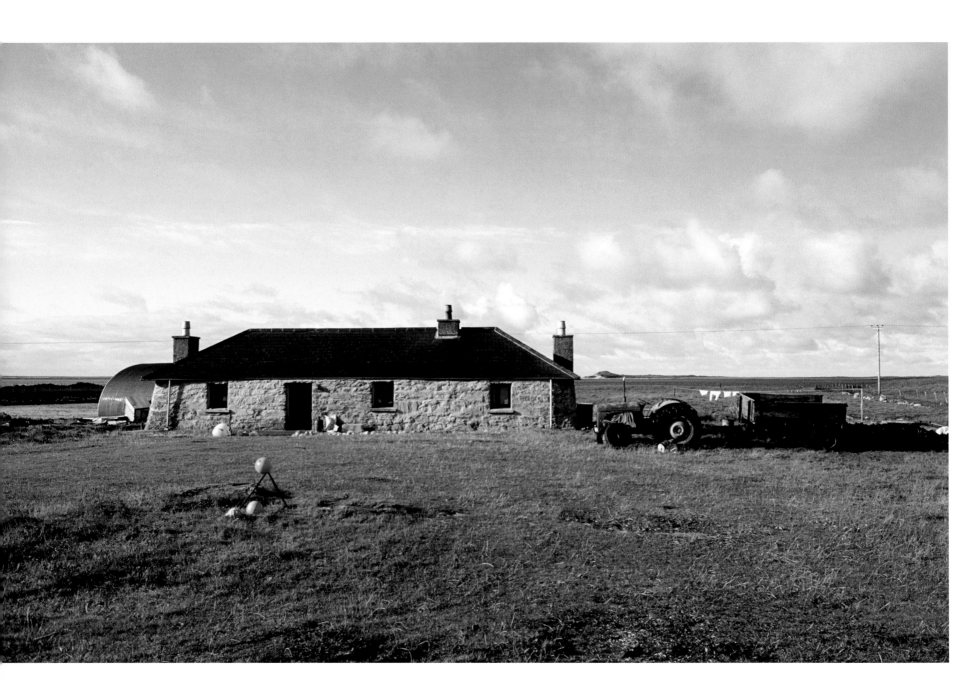

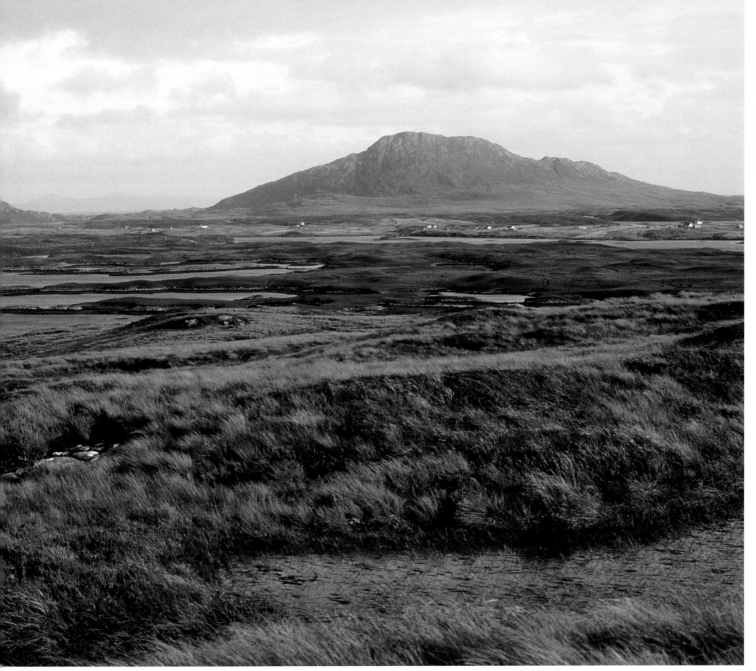

LEFT: North Uist, Western Isles. The view from Bea Langass toward Eaval. The highest point of North Uist is the wedge-shaped mountain of Eaval at the southern end of the island which soars to a height of 1,138ft.

FAR LEFT: North Uist, Western Isles. A fisherman's croft near Claddach Chirceboist. The island contains thousands of freshwater lochs teeming with trout and of course the surrounding ocean offers a wide variety of species as well as a thriving seal colony on the Monach Islands.

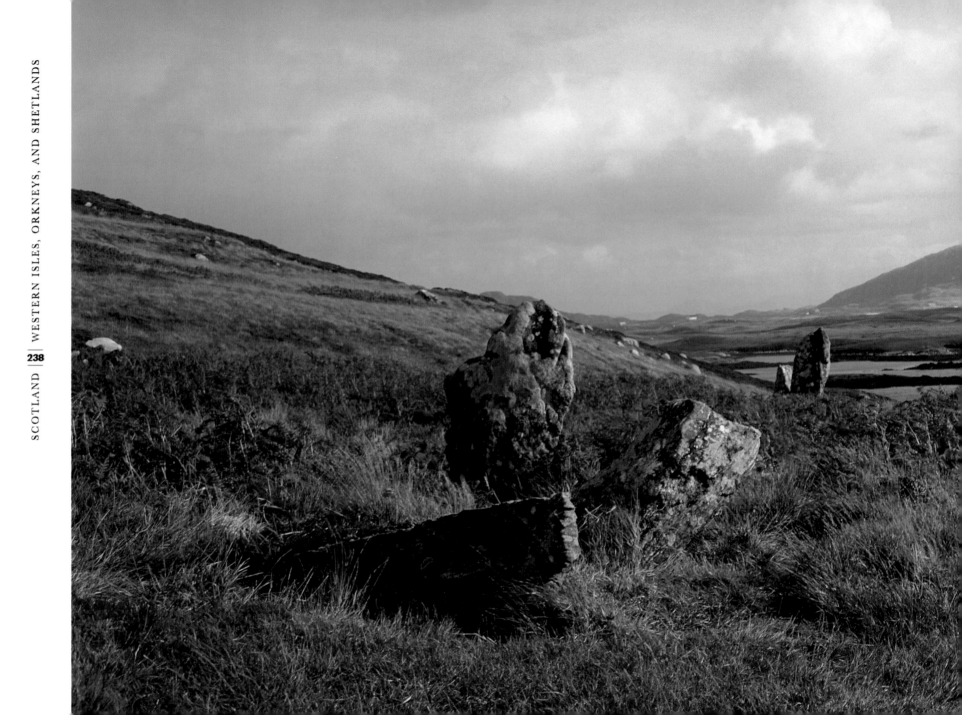

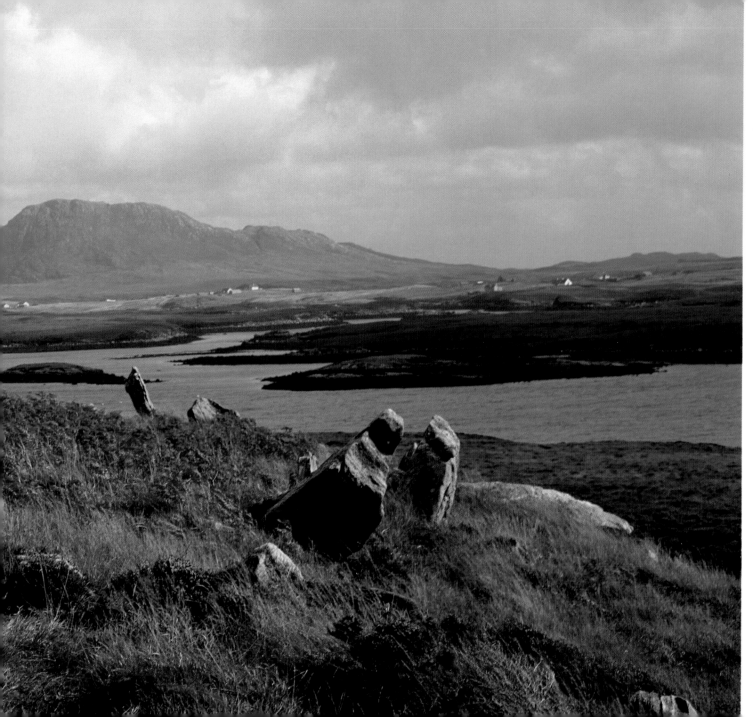

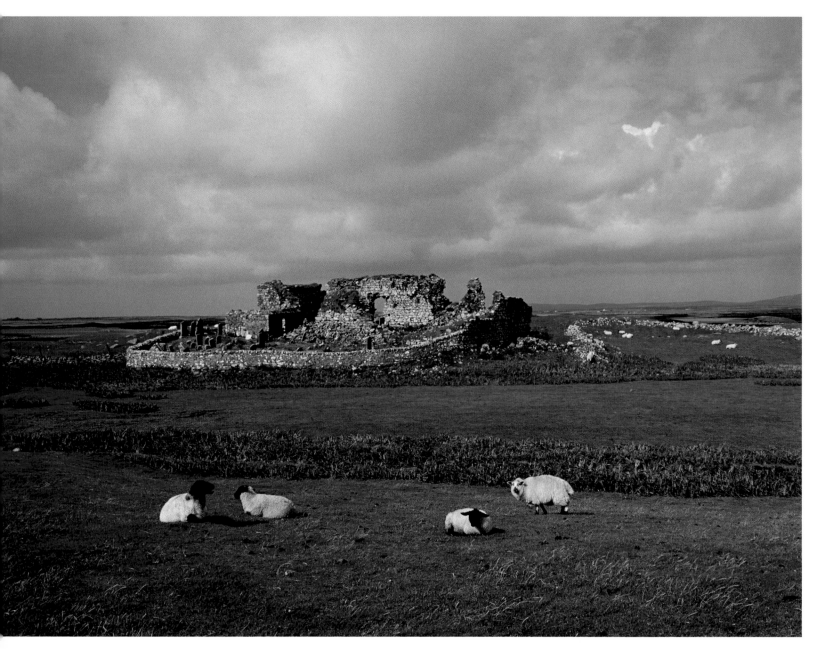

LEFT: North Uist, Western Isles. Ruins of the thirteenth century church of Teampull na Trionad at Carinish. The unspoilt beauty of the Western Isles is encapsulated in the Uists with their remote beauty, miles of beautiful sandy beaches and wonderful wildlife: yet making a living can be very hard for the islanders as the pictuaresque ruins testify. Many tenants were moved from their homes in the mid-nineteenth century by the Macdonalds of Sleat to allow sheep to roam the islands and the human population dropped dramatically all through the twentieth century.

RIGHT: Little Minch, Western Isles. The waters of the Little Minch separate the Isle of Skye from the Western Isles. At its narrowest it is 15 miles across and it can be treacherous with strong currrents and underwater rocks as well as a number of rocky islets.

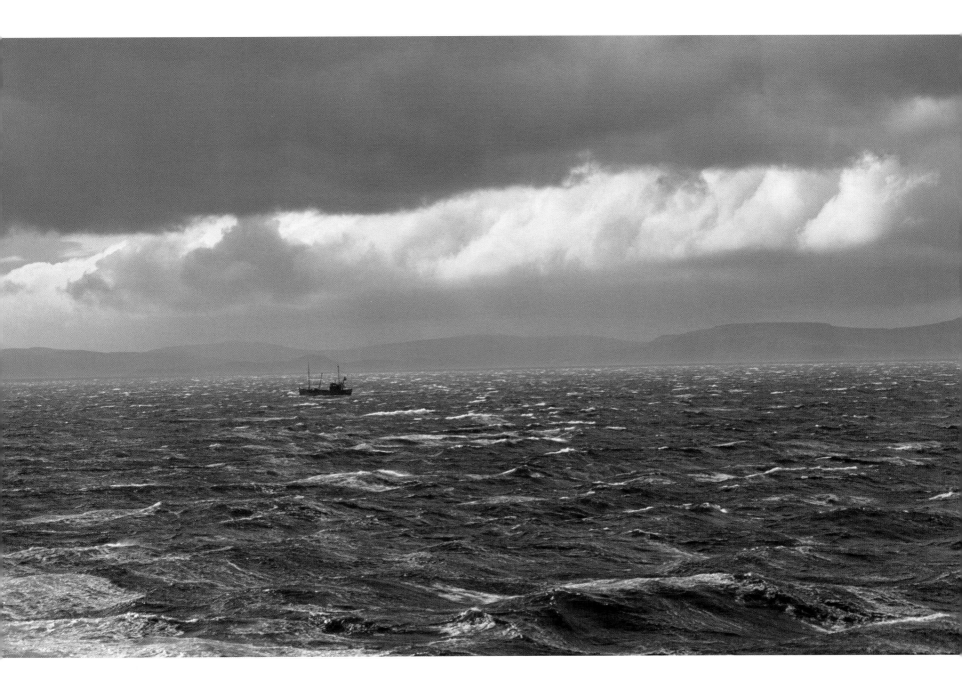

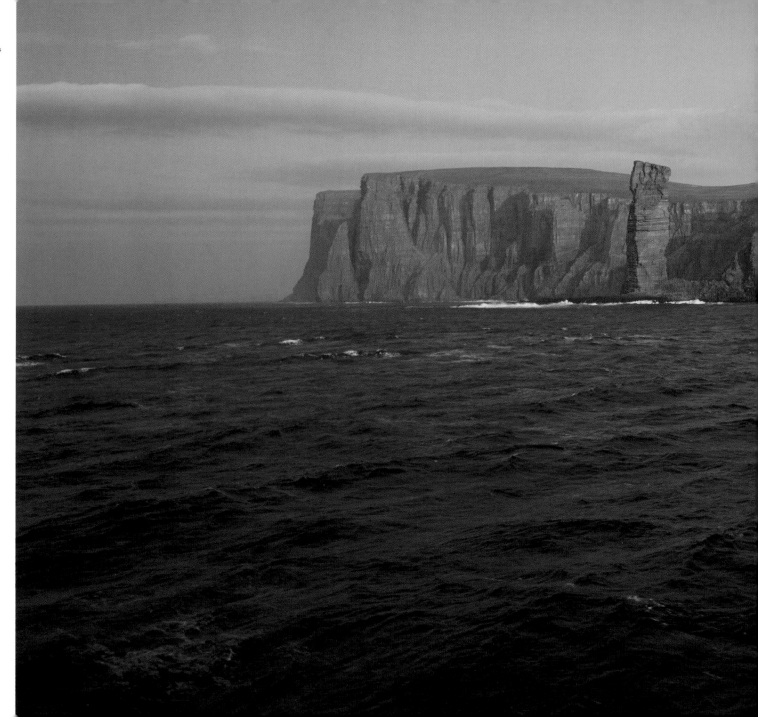

RIGHT: The Old Man of Hoy, Orkney. This sea stack is almost 500ft high but only 98ft wide at the base. It is made from layers of old red sandstone which has eroded from what was a headland as recently as 1750. Soon the entire structure will collapse altogether. The hoy means "high island" from the Old Norse *haey*.

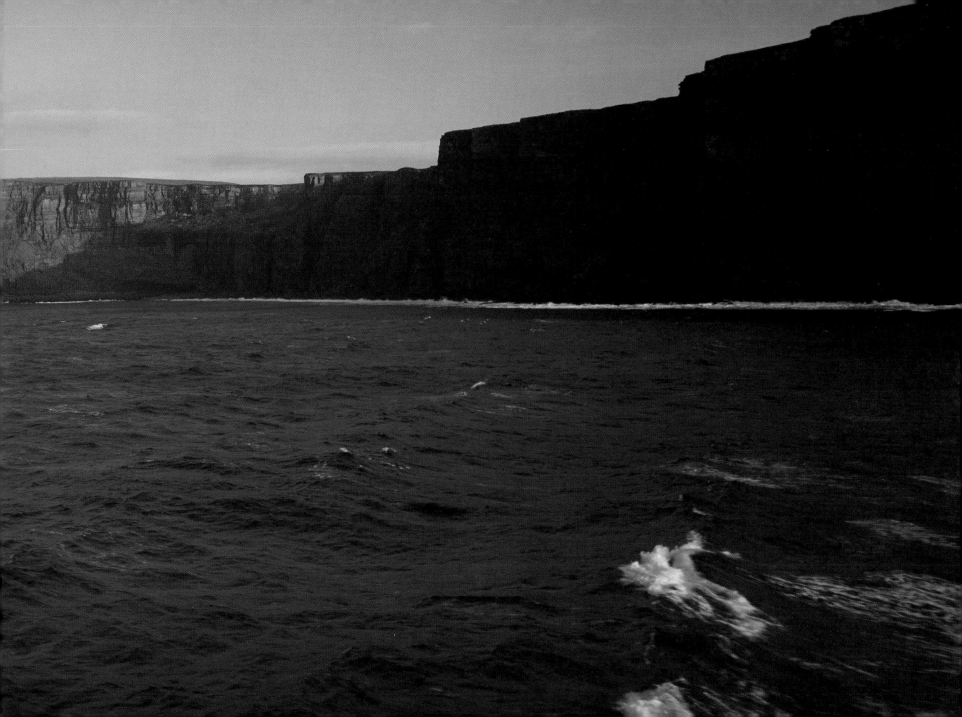

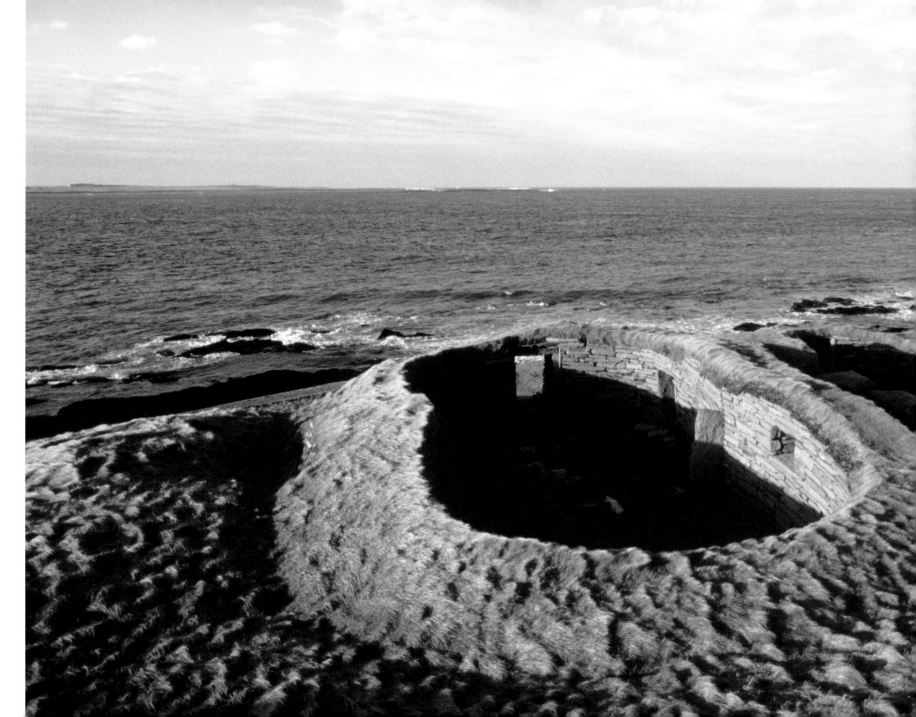

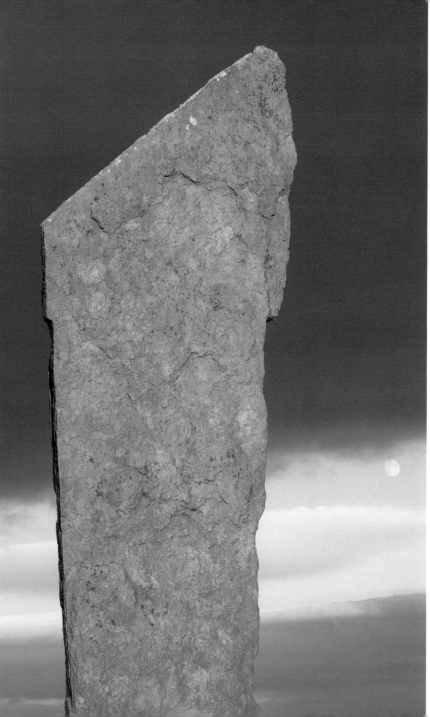

LEFT: Stenness, Orkney. Close up of one of the Stones O' Stenness with a three-quarter moon rising.

FAR LEFT: Knap of Howar, Papa Westray, Orkney. Neolithic farmstead. The tiny island of Papay contains some 60 archaeological sites including the earliest known dwellings on Orkney. Two oblong passage-linked side-by-side stone houses were discovered in the 1930s on the west coast of the island which were dated to around 3,600 BC and discovered to be continuously occupied for about 500 years by Neolithic farmers.

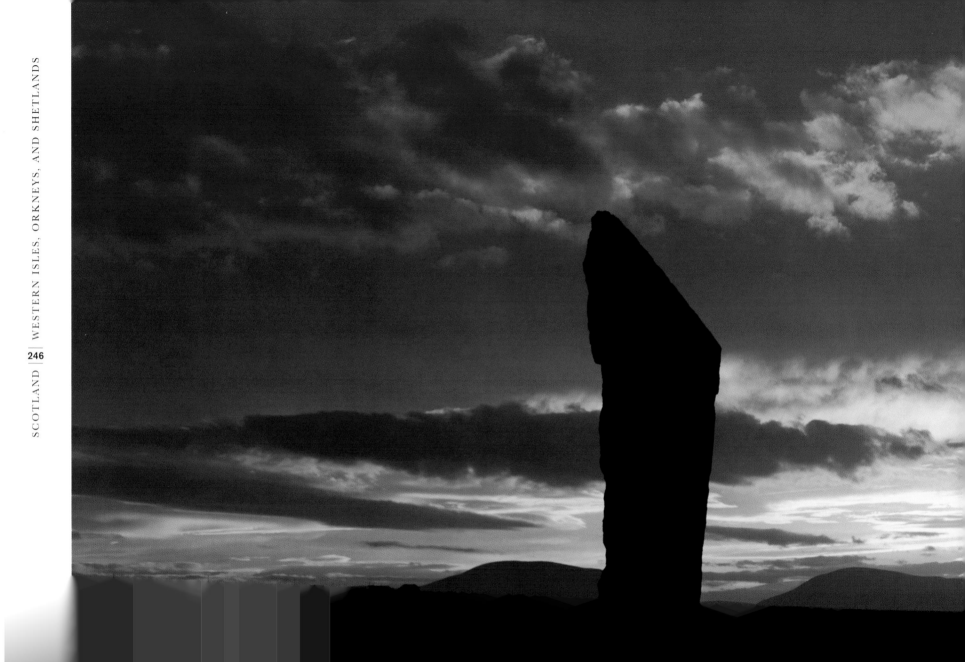

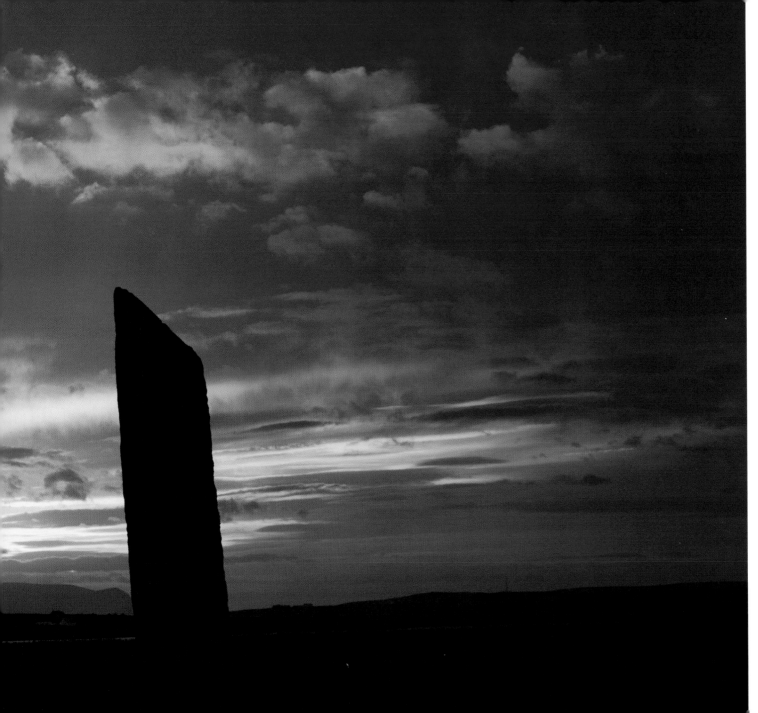

SCOTLAND | WESTERN ISLES, ORKNEYS, AND SHETLANDS

RIGHT: Ring of Brodgar, Orkney. Aerial view of the Ring of Brodgar seen from the south. Legend says that a band of fearsome giants crossed the causeway onto the Ness of Brodgar where they decided to dance to the music of a fiddler. They joined hands and danced in a ring whirling round faster and faster. Time passed as they danced on with the ground trembling beneath their feet until the morning sun caught them and instantly turned them to stone. The solitary stone outside the ring is that of the fiddler.

FAR RIGHT: St Magnus's Cathedral, Kirkwall, Orkney. The cathedral was built on the instructions of Earl Rognvald Kolsson and work started in 1137 but took three centuries to complete. It is built from alternating bands of local red and yellow sandstone.

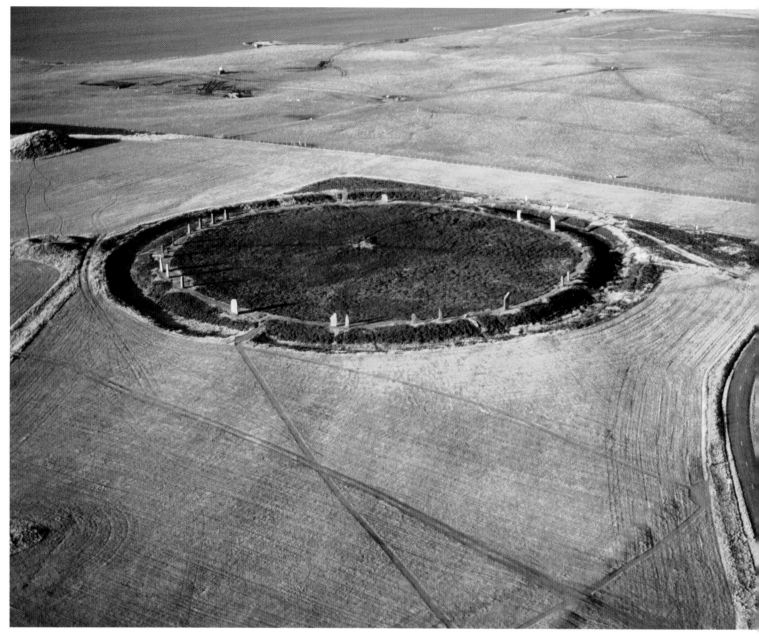

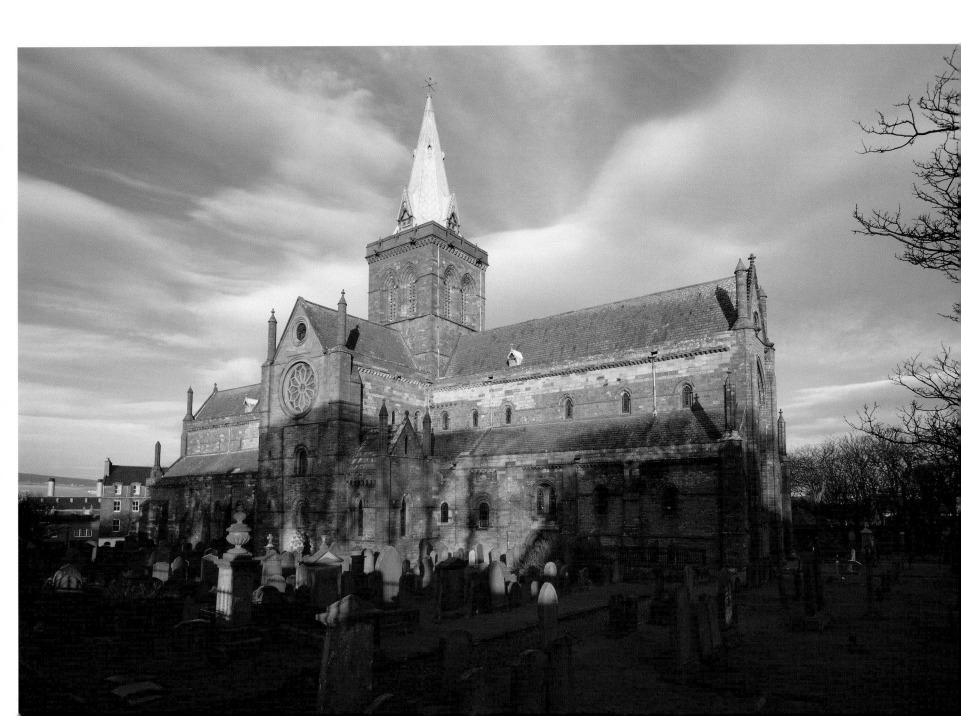

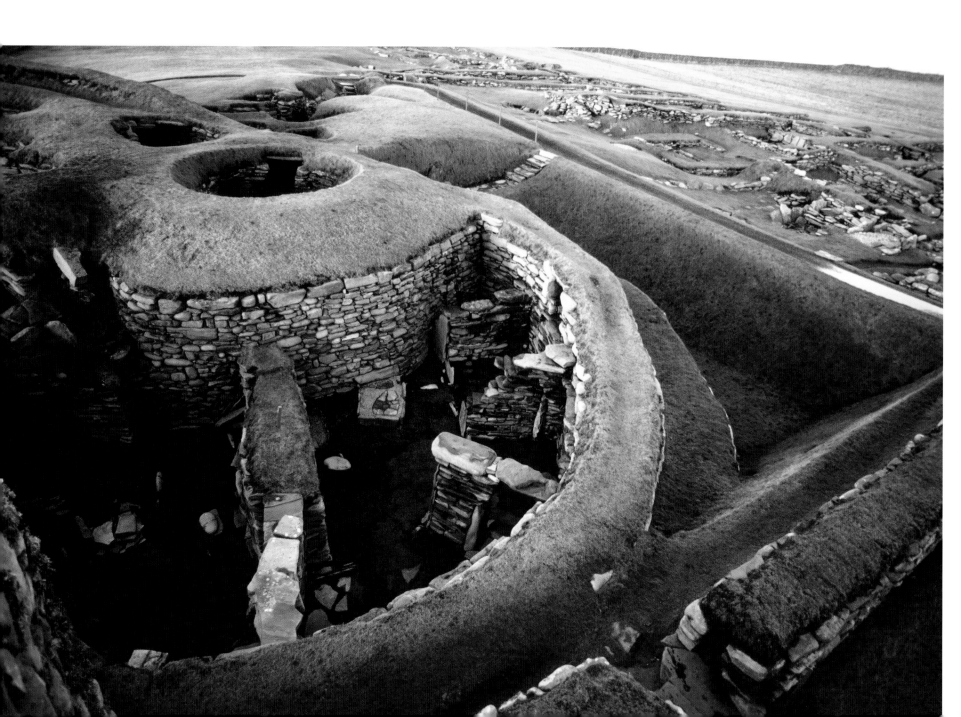

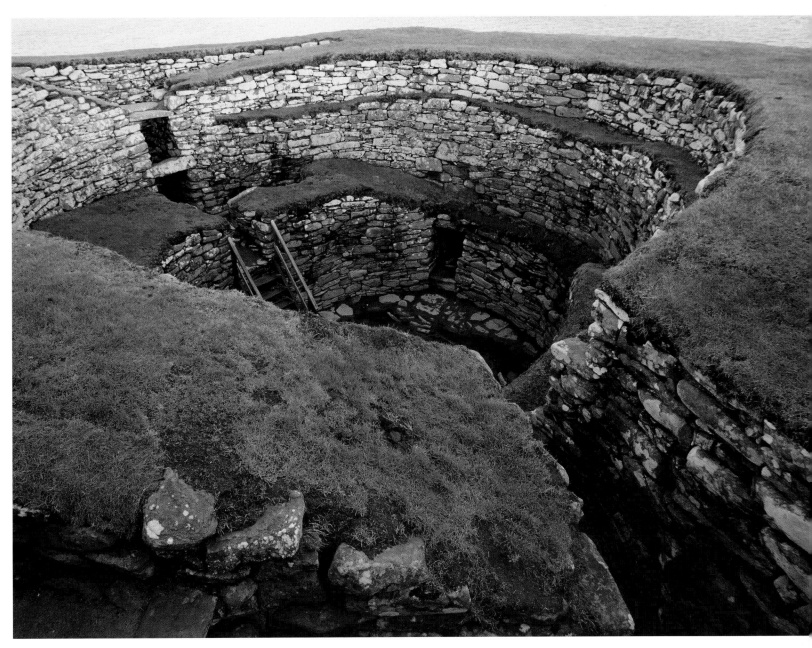

RIGHT: Jarlshof, Shetland. View over the wheelhouse structures. There are over three acres of prehistoric as well as Norse remains at Jarlshof which span around 3,000 years of occupation from the Stone Age. As well as wheel houses there are Viking long houses, an Iron Age broch, Bronze Age houses, and medieval farmhouses.

LEFT: Clickhimin, Shetland. Looking at Clickhimin broch from the top of its massive—over 20ft-high—walls.

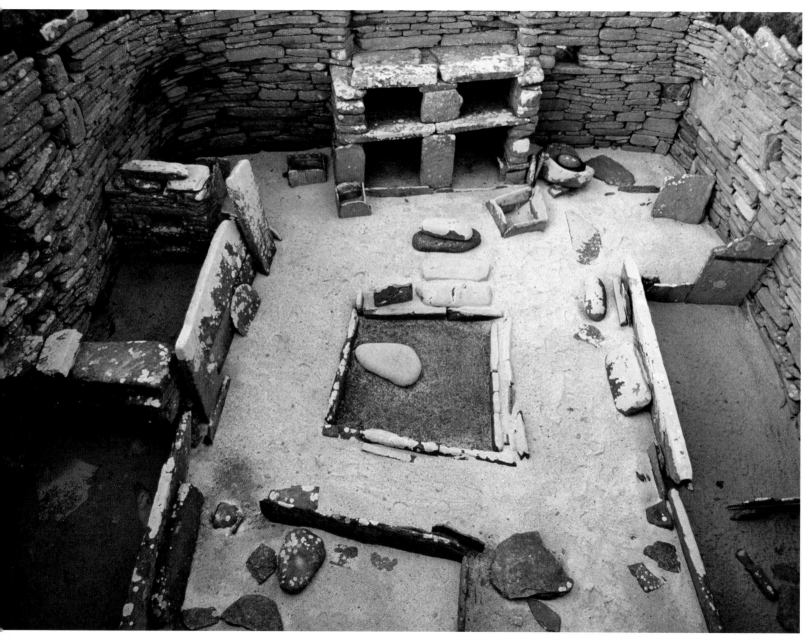

LEFT: A Stone Age house at Skara Brae, Orkney. Every house is built to the same basic square design with a central fireplace, a dresser opposite the door and a bed on either side.

RIGHT: View of the settlement of Skara Brae showing the layout of the huts and the streets; now right next to the sea, originally the settlement was well set back but erosion has brought it to the edge. Skara Brae was hidden for 4,000 years until 1850 when a particularly severe winter storm and high tides stripped the top off a large mound known as Skerrabra and the settlement was discovered. Radio-carbon dating shows Skara Brae was inhabited between 3200 BC and 2200 BC, making it late Neolithic.

OVERLEAF: Broch of Gurness, Orkney. The broch and surrounding houses at Gurness look across the Eynhalow Sound to Rousay and Eynhallow. The broch was discovered in summer 1929 on a grassy mound known as Knowe of Aikerness. The broch itself was a tower 26ft high with an internal diameter of 65ft. It had up to 40 small houses clustered around it and the whole was enclosed by three ramparts and three ditches. The settlement has been dated to between 200 BC to 100 BC.

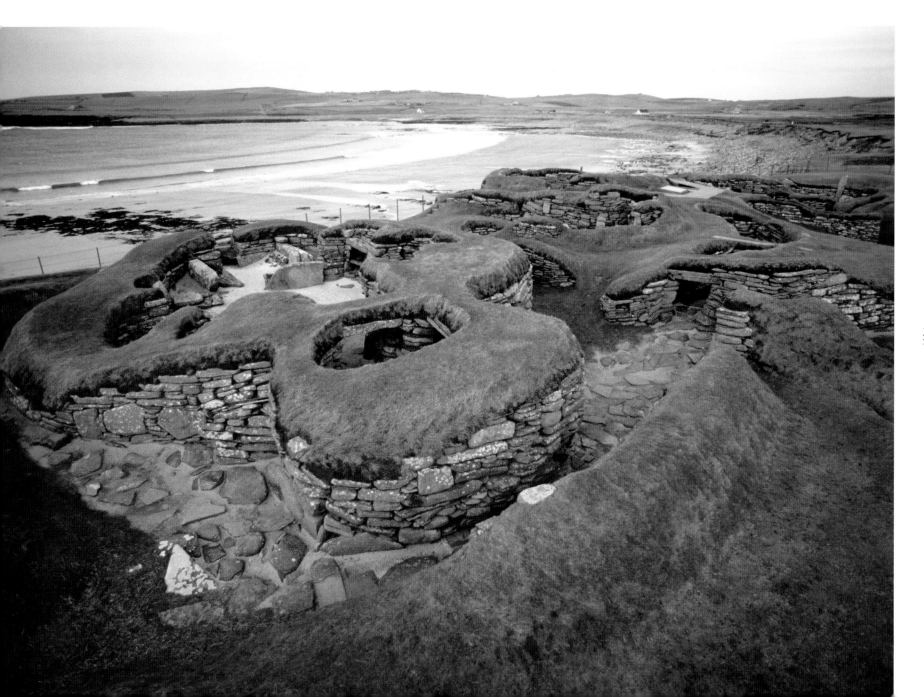

SCOTLAND | WESTERN ISLES, ORKNEYS, AND SHETLANDS

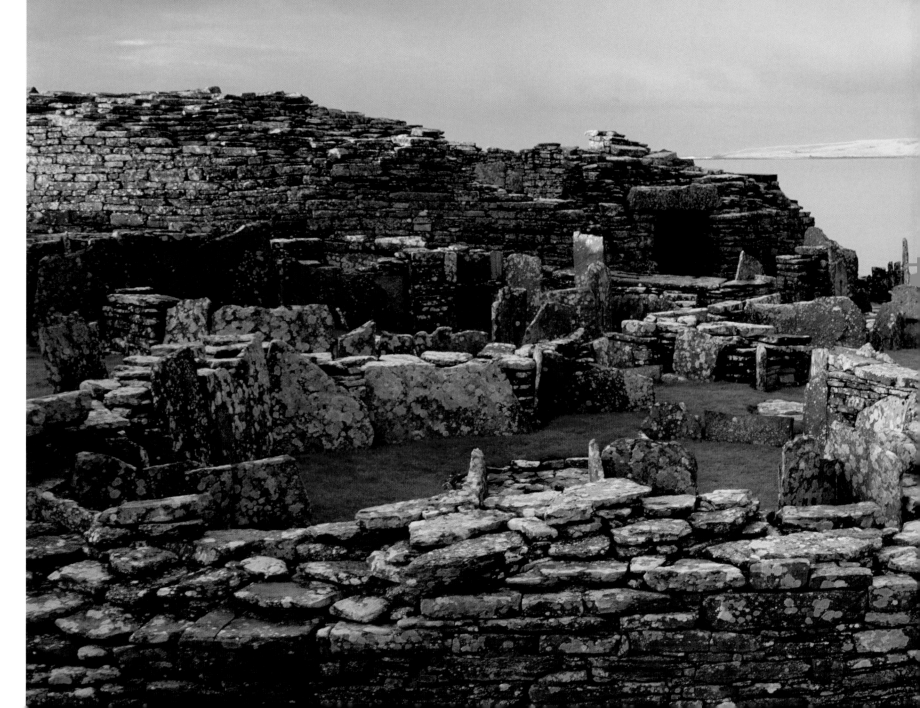